FORGOTTEN MOVIES ON MUSLIM CULTURE 1933 – 1947

KAMALAKAR PASUPULETI

TABLE OF CONTENTS

Forgotten movies on Muslim culture 1933 – 1947 1
Kamalakar Pasupuleti ... 1
Table of contents .. 3
Dedication ... 8
Acknowledgements .. 1
About Bushra Rehman – .. 11
Foreword ... 12
Preface .. 13
Introduction .. 16
Afzal – Hoor -e – Harem - 1933 .. 34
 Synopsis .. 35
 Reviews – .. 36
Alibaba – 1946 .. 37
 Introduction – ... 38
 Synopsis – ... 39
 Reviews – .. 43
Anarkali - 1935 .. 44
 Synopsis – ... 44
 News - ... 46
Reviews - ... 48
Arab ka Sitara - 1946 .. 49
 Synopsis – ... 50
 Reviews - ... 51

- Bare Nawab Saheb - 1944 .. 52
 - Synopsis – .. 54
- Bhaijan – 1944 .. 58
 - Synopsis – .. 60
 - Reviews – ... 61
- Bulbul-e-Baghdad – 1941 .. 63
 - Introduction – .. 63
 - Synopsis – .. 64
 - Reviews – ... 69
- Dil – 1946 ... 69
 - Booklet Synopsis .. 69
 - Story outline – ... 71
 - Reviews – ... 72
- Fashion – 1943 ... 74
 - Introduction – .. 74
 - Synopsis – .. 76
 - Reviews – ... 80
- Hoor-e Baghdad – 1934 .. 84
 - Synopsis – .. 85
 - Reviews – ... 87
- Ismat - 1944 ... 87
 - Synopsis – .. 89
 - Reviews – ... 92
- Judgement of Allah – 1935 (Al Hilal) ... 94
 - Synopsis – .. 96
 - Reviews – ... 101

Masoom – 1941 ... 102
 Introduction - .. 102
 Synopsis – ... 102
 Reviews – .. 102
Mulaqat – 1947 ... 106
 Introduction – ... 106
 Synopsis - ... 107
 Reviews – .. 109
Mumtaz Begum – 1934 ... 110
 Moral – .. 111
 Synopsis – ... 112
Muslim ka Lal – 1941 ... 114
 Introduction – ... 114
 Translation ... 114
 Translation ... 117
 Theme – .. 118
 Reviews – .. 118
Paak Daaman – 1940 AKA Shaheed Naaz 119
 Introduction – ... 119
 Translation ... 121
 Synopsis – ... 122
 Reviews – .. 124
Pehli Nazar - 1945 .. 126
 Synopsis – ... 127
 Reviews – .. 132
Phool – 1945 ... 133

- Introduction – 134
- Synopsis – 134
- Reviews - 135
- Correction – 139
- Qaidi – 1940 (Muflisi ka Shikaar) 140
 - Translation 141
 - Notes – 143
 - Synopsis – 144
 - Reviews – 148
- Rashida – 1935 (Turki Hoor) 149
 - Cast- 150
 - Synopsis – 151
 - Reviews – 153
 - Criticism – 155
- Rehana – 1946 156
 - Synopsis – 158
 - Reviews – 160
- Salma - 1943 161
 - Cast and Crew 161
 - Synopsis – 163
 - Reviews – 165
- Shahanshah Babar - 1944 169
 - Synopsis – 171
 - Historical facts – 172
 - Reviews – 173
 - Translation 174

- Shalimar – 1946 .. 179
 - Introduction - ... 180
 - Synopsis – ... 180
 - Faqir as a witness – ... 181
 - Nurjehan's request – .. 182
 - Notes- ... 184
- Shamsheer-e-Arab – 1935 .. 184
 - Translation .. 187
 - Introduction – ... 188
 - Synopsis – ... 188
- Sultana – 1934 ... 191
 - Synopsis - .. 193
 - Reviews – .. 195
- Yasmin – 1935 AKA – Bawafa Ashiq .. 197
 - Synopsis – .. 198
 - Reviews – .. 200
- Zahr-e-Ishq – 1933 ... 200
 - Synopsis – .. 201
 - Reviews – .. 203
- Bibliography .. 205
- Table of figures .. 206

DEDICATION

The book is dedicated to my loving wife Raj Pasupuleti.

ACKNOWLEDGEMENTS

The author wishes to express his grateful thanks to the following –

Janab Rashid Ashraf, an engineer, writer and researcher of Karachi, Pakistan for the valuable contribution of film booklets and rare images without which it was impossible to publish the book.

Janab Yasir Abbasi of Gurgoan, India, cinematographer and author of his recent book ' Ye un dinon ki baat hai' who shared some of the reviews from film magazines Shama, Filmindia and others. He was in close association with the book from the beginning as an advisor.

Mohtarma Khadija Zubair of UK who painfully read and analyzed many articles in Urdu, some of the prints had poor legibility due to age and improper storage. She explained the meaning of many Islamic religious terms.

Janab Khalil Ahmed. A former employee of P & T, Karachi, Pakistan.

Janab Sultan Arshad, writer & researcher of Karachi, Pakistan

Begum Bushra Rehman, the award-winning author who had kindly agreed to write a Foreword for my book despite her busy schedule.

Gautam Pasupuleti who had taken great pains in editing my book and giving a presentable look to the old tarnished images. He was also responsible for the cover design.

My loving wife Raj, my son Gautam, my daughter-in-law Munni and my grandkids Roshan and Reema for their love and support during the entire period of my work on this book.

Kamalakar Pasupuleti December 2018.

Millersville PA 17551

ABOUT BUSHRA REHMAN –

Begum Bushra Rehman is a popular novelist, a favorite short story writer, a prominent columnist, a peerless eloquent speaker, a parliamentarian and a social worker. The Punjab Assembly, in recognition of her services, her mastery over expression and unique poetic eloquence, unanimously passed a resolution on June 20, 1990 conferring on her the Title of "Master of Expression", "Sweet Tongued" and "Nightingale of Pakistan".

She has received "Sitara-e-Imtiaz" award from Government of Pakistan.

Her famous books in Urdu are: Lagan, Khoobsurat, Parsa, Chara Gar, Sharmeeli, Bahisht, Afsana Admi Hai, Allah Mian Ji, Dana Rasoi & Payasi.

-

FOREWORD

I am delighted to learn about Kamalakar Pasupuleti's Book; Forgotten movies on Muslim culture 1933 - 1947. An exploratory journey to the origins of native film making in British India, it is indeed a fruit of enthusiastic research and will serve as an important reference on the subject in the future.

Such literary endeavor allows the reader a glimpse into a period of history, which is often distorted and sometimes willfully forgotten. So many of the films were based on the Mughal-era and Muslim culture, that one can see how history of the sub-continent took shape as layers upon layers of culture, faith and tradition.

I commend the author on taking upon such a subject, especially in times when divisions are growing deeper and cultures drifting apart.

Bushra Rahman

Lahore, Pakistan.

PREFACE

When I first thought of writing this book: Forgotten movies on Muslim culture, I expressed my desire with my good friends Yasir Abbasi and Rashid Ashraf who were very helpful in sharing plenty of material for my earlier book: The lost treasure: Early Hindustani talkie. I sent them a big list of movies between 1933-47 asking for their opinion. They were excited and agreed that it is an excellent proposal as there is hardly a book on these forgotten movies. Ongoing through the list, Yasir Abbasi questioned me as to who would be willing to share the film booklets and publicity material of such old movies?

Yes, his doubt was correct. The much-expected sources from which I had accessed the material previously did not come this time. It was a very tough start. I was in a fix as to how it would be possible for me to move ahead with the proposal.

Yasir Abbasi was able to collect useful material for the book from Urdu film magazine Shama published from Delhi. He was also responsible for providing useful material from other magazines. As per his advice I had included K Asif's maiden venture film Phool -1944.

Janab Rashid Ashraf who has a huge collection of film material was optimistic that at least a few of them could be traced to start with. He had spent a lot of time and we did have initial success. Rashid Saheb was responsible in finding out a big chunk of material for the book. Some of them Shamsheer-e-Arab Paak Daman and Qaidi were original film script in Urdu. They were

quite long consisting of 16 pages. The synopses were abridged and translated.

I Initially decided to compile movies on Muslim socials alone but having gone through the material I soon realized that the matter was insufficient to call it a book. What should I do? Do I back off from the project and disappoint my friends who had been searching and helping me for this project or include few movies from Arabian Nights, Arabian folklore and adventure and publish a book? I opted for the later. Hence, the book is not limited to movies on Muslim socials alone but a compilation of many other genres.

The Urdu newspapers came in as a big blessing, some of them furnished the synopses or the story line with sketches. Some of the movies like Bulbul-e-Baghdad, Dil, Muslim ka Lal, Pehli Nazar, Salma and Shalimar are taken entirely from the Urdu newspapers of those time period.

Since films on this subject between 1931-32 were covered in my book the lost treasure; Early Hindustani talkie, I have covered the movies from 1933-47. I have great interest in movies and music of the pre-partition era, hence my book does not cover movies of the later period.

My good friend Mohtarma Khateeja Hashmi Zubair of UK volunteered to help me on this project. She was responsible for reading and analyzing many of the Urdu synopses which were hardly legible. The prints were awfully bad, but she finally succeeded in her effort. She was also an advisor on many of the Muslim topics which the book needed.

Every effort was made to present the images and sketches to the best of its kind. Many images were corrected and made presentable to the book standards but owing to the very poor quality of the original some images and sketches may appear a

little dull and hazy. I hope the readers will understand the difficulty of restoration and appreciate their value.

I sincerely hope the readers will appreciate the efforts made by the author in bringing out a book on the topic.

Author

INTRODUCTION

While working for my book - The lost treasure – Early Hindustani talkies, it was noticed that many movies made in the early years of talkie were based on Muslim culture. The very beginning of the Indian talkie in the year 1931 was with a pseudo-historical movie Alam Ara was a film depicting Muslim culture. It was followed with Abul Hasan, Shirin Farhad, Laila Majnu and Noorjehan which was a historical romance from the Mughal era. Of the 24 Hindi-Urdu films released 7 films were on Muslim culture.

Prabhat film company of Kolhapur was inspired by producing Jalti Nishani, a Muslim pseudo historical movie in 1932. It is surprising to note that the first three movies produced by New Theaters of Calcutta in 1932 were on Muslim culture. While Mohabbat ke Aansoo depicted a Muslim household story, Subah ka Sitara was a folk tale and Zinda Laash was a story from the Arabian Nights. The dialogues and lyrics of these films were in Urdu and not Hindi.

The early talkie depended much on the dramas of the Parsi Urdu and Gujrati theater. There were instances some of the movies depicted both Hindu and Muslim cultures. Paak Daman produced in 1931 was a Hindu household story while the one released in 1940 was a folk tale from the Middle East. There were many story writers for the Parsi Urdu theaters, one notable was Agha Hashar Kashmiri. Syed Yawar Ali a disciple of Daagh Dehlvi also penned many stories and dialogues for the Parsi theaters, some of which were later produced for the screen.

Agha Hashar Kashmiri's famous drama Paak Daman filmed by Stage film company in 1940 Author's collection

Many stories written for the stage were costume dramas and they appeared on the screen as a costume movie. Naqsh-e-Suleimani – 1933 and Bahar-e-Suleimani - 1935 are couple of them. The movie based on the saying that the good always triumphs over the evil were a huge hit. The songs rendered by Miss Dulari an artist of the HMV was very popular in those days.

*Naqsh-e-Sulemani a movie based on good vs evil Neki o Badi
Author's collection*

Image Bahar-e-Suleimani – 1935 prasing HMV artist Miss Dulari. From Urdu magazine Film Author's collection

There were movies of all genres. Naadira – 1934 produced by Ranjit was a hilarious comedy with Dixit and Ghory the comedian duel. The movie ran for many weeks and earned profits for the company. Shamsheer-e-Jung – 1935, a less known stunt movie was another comedy.

Image Film Naadira – 1934 a musical comedy starring Madhuri, E Billimoria Charlie, Ghori, Dikshit, Khatun and Azuri. Author's collection

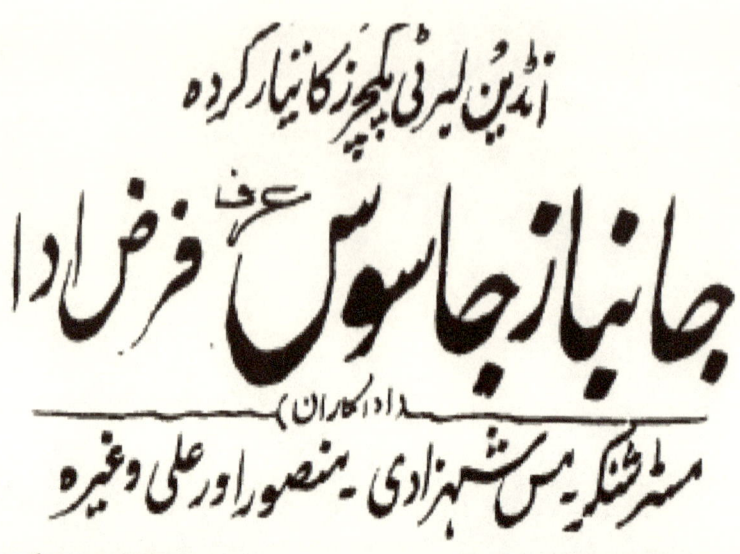

Janbaz jasoos aka Farz-e-Ada – 1935 starring Mr Shankar, Miss Shehzadi, Mansoor and Ali. Author's collection from Urdu magazine Film

Indian Liberty pictures Janbaz Jasoos aka Farz-e-Ada was a great movie on espionage, adventure and Romance. Miss Shehzadi played a prominent role which was the highlight of the movie.

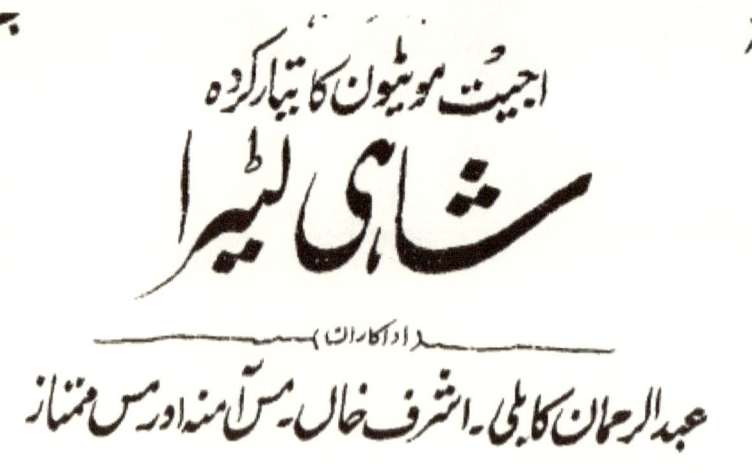

Film Shahi Lutera starring AR Kabuli, Ashraf Khan, Miss Ameena and Miss Mumtaz. Author's collection from Urdu magazine Film.

Ajit movie tones Shahi Lutera was a movie of adventure and deceit. The movie had beautiful dialogues and music.

Many Muslim social movies were made from the early days of

the talkie. Mumtaz Begum - 1934 and Rashida – 1935 are fine examples.

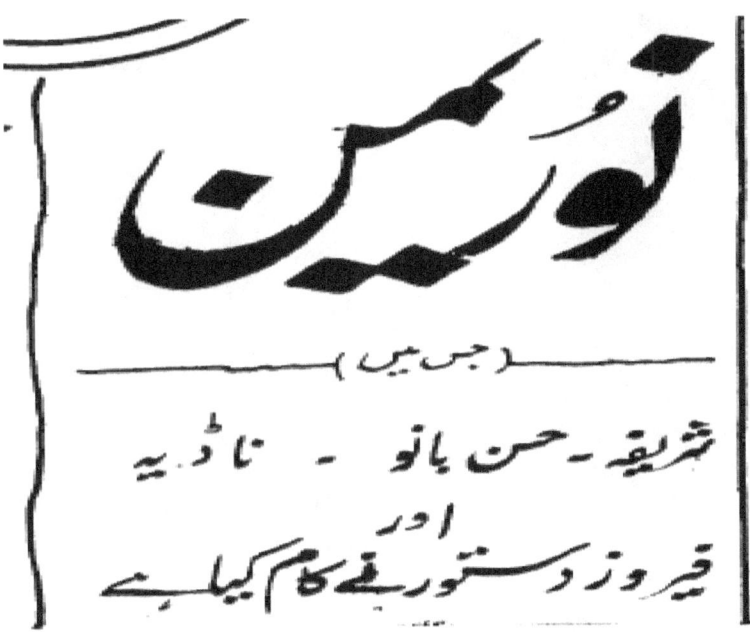

Film Noor-e-Yeman – 1935 starring Sherifa, Husn Banu, Feroze Dastur and Nadia. Image from Urdu magazine Film. Author's collection

Noor-e-Yeman was a stunt movie. All the stunts in the film were played by Miss Nadia. The movie was very successful. It was a big entertainer for all ages. Another great feature of this movie

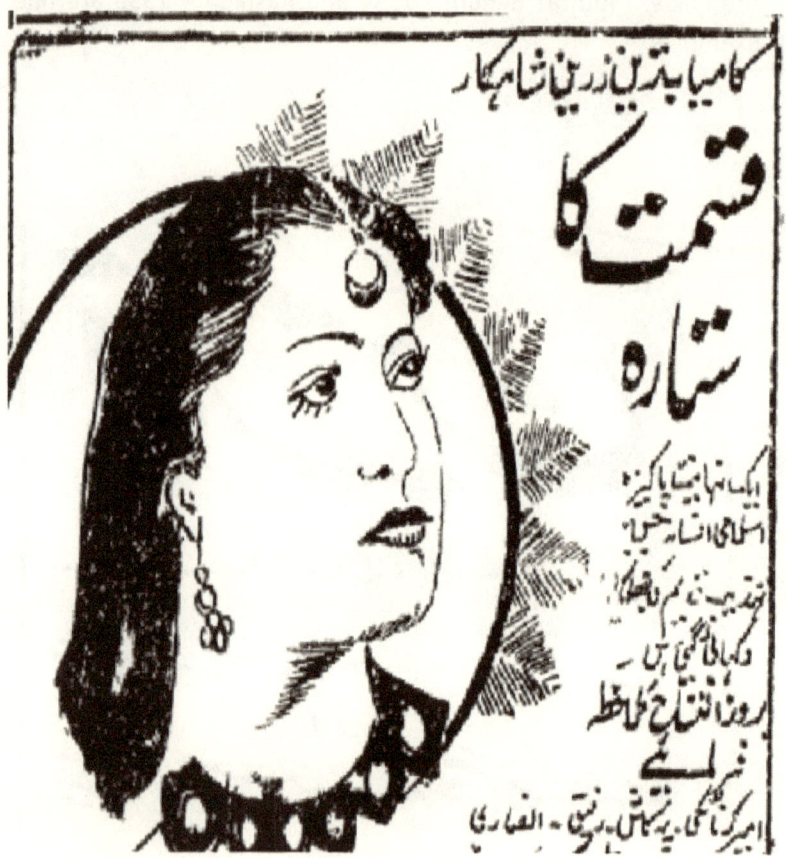

was good music and songs by Master Mohammad.

Qismat ka Sitara was another fine example of a fine movie on Islamic culture Author's collection.

Muslim historical were very popular with the crowds. Noorjehan – 1931, Adl-e-Jehangir – 1934, Anarkali –1935, Jahan Ara – 1935 and Mumtaz Mahal – 1944 are some of them.

Image – Maiden Theaters Historical Jahan Ara – 1935 starring Kajjan, Shehla and Yusuf Effendi. Author's collection

Film Mumtaz Mahal -1944 was a historical movie of the Mughal era

Film Jan Nisar was a movie based on devotion, loyalty, courage and bravery

Some movies Muslim ka Lal – 1941 and Shamsheer-e-Aarab – 1935 were on courage and valor of Muslim men who fought the invaders. Hoor- e – Samandar – 1936 was an underwater adventure by brave Muslim men. The movie was shot using submersible cameras for the first time. Miss Sultana played a pivotal role as the heroine. This was for the first time in the history of Indian cinema an underwater adventure was made.

Hoor-e-Samandar from Urdu magazine Courtesy Rashid Ashraf of Karachi Pakistan

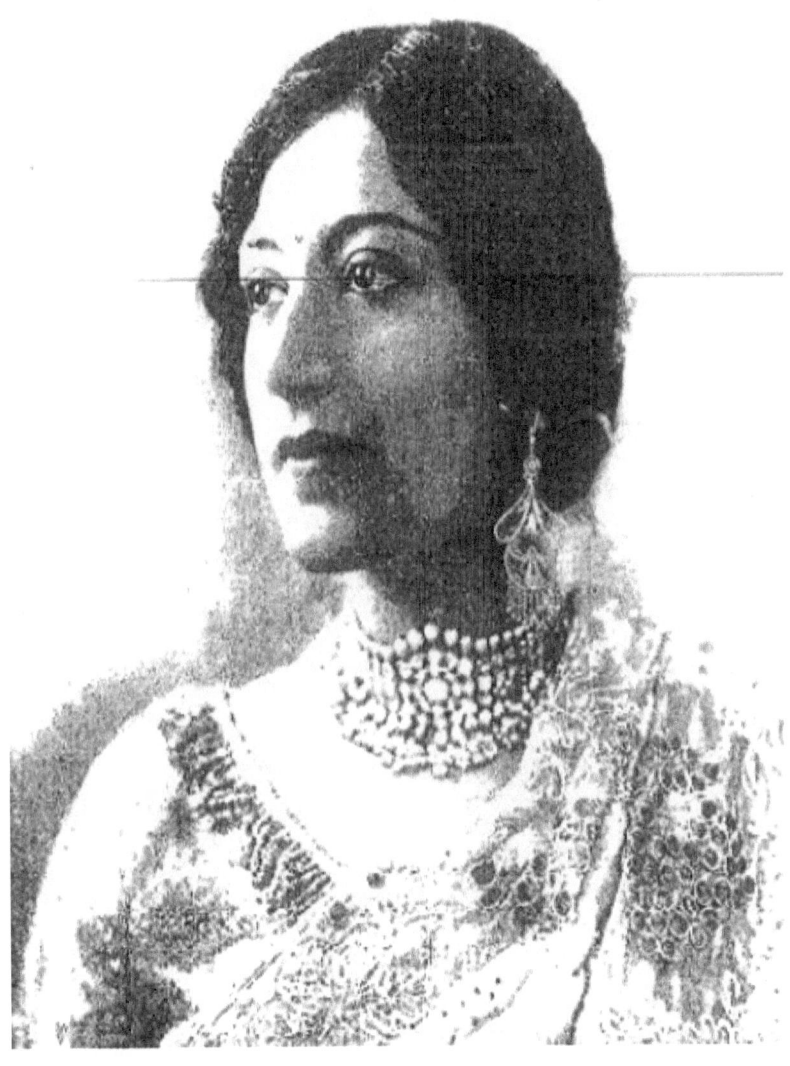

Image – Miss Sultana in Hoor-e-Samadar 1936 Author's collection

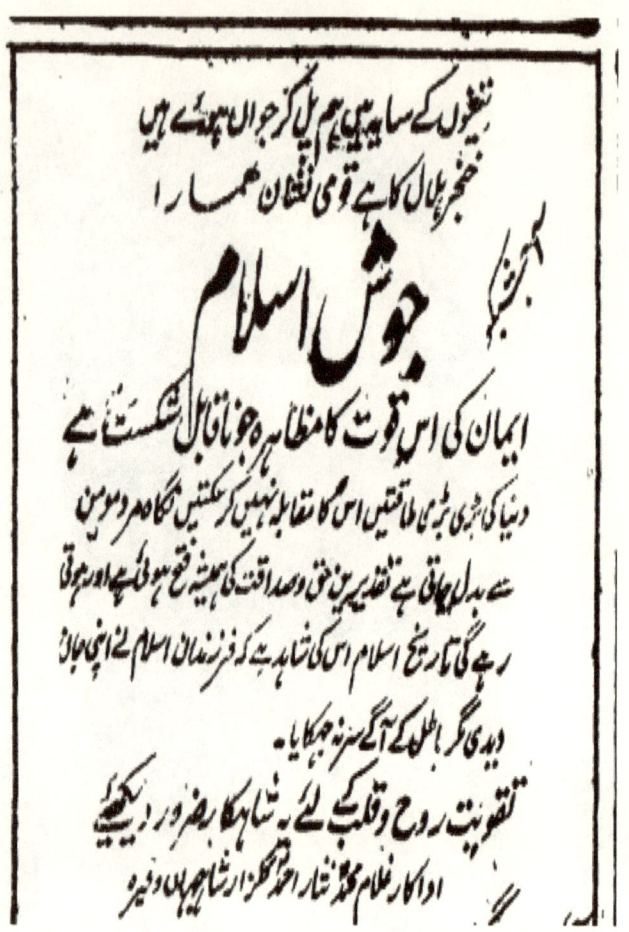

Film Josh-e-Islam -1939. A movie on the greatness of Islam. Author's collection

Josh=e- Islam – 1939 was a movie on the greatness pf Islam. The movie was praised for the songs of Eid, marriage and saalgirah. (birthday) The picturization of these functions was another praiseworthy feature of this movie.

Films on tragic romances, folk-lore were very popular with the movie lovers. Laila Majnu, Shirin Farhad and Sohni Mahiwal are some of them.

Film Laila Majnu – a romantic tragedy Author's collction

Film Shirin Farhad – a romantic tragedy Author's collection

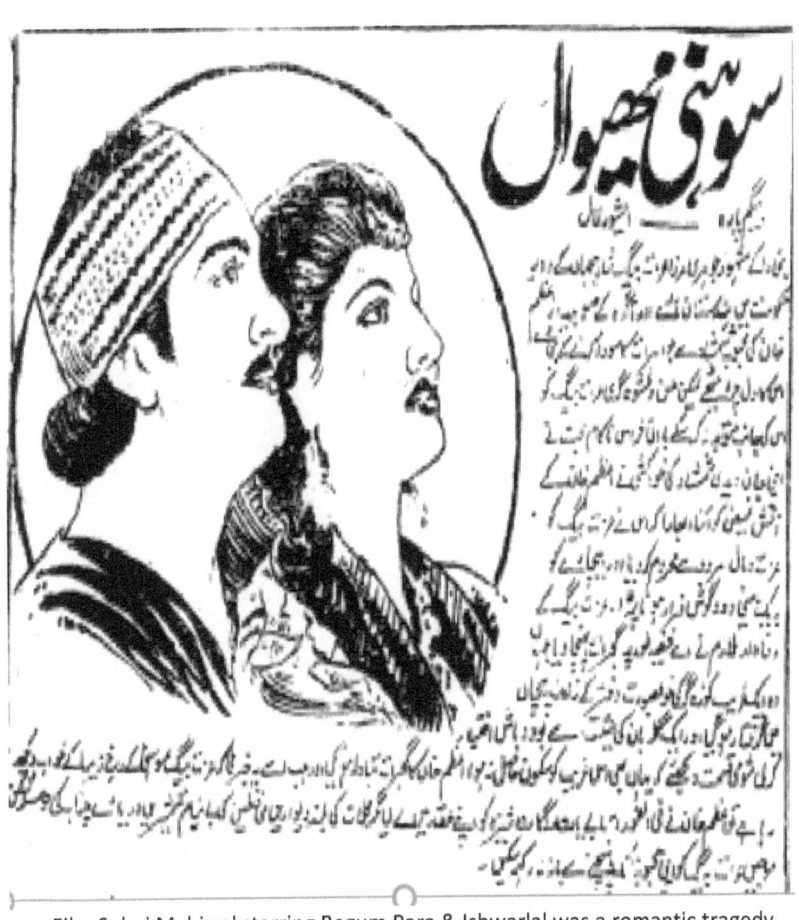

Film Sohni Mahiwal starring Begum Para & Ishwarlal was a romantic tragedy

Fazli brothers will be best remembered for their contribution for the number of Muslim socials they had given. While some of their movies Shama – 1946 and Mehandi – 1947 are available on DVD's, their earlier movies Qaidi, Masoom, Fashion, Ismat and Dil are hard to find. The movies by Fazli brothers always carried a meaningful religious message.

Many movies on Muslim household and society were produced in India before independence. After partition the number of movies on this subject gradually tapered off to the extent in modern times rarely a couple of them are seen on the screen.

AFZAL – HOOR -E – HAREM - 1933

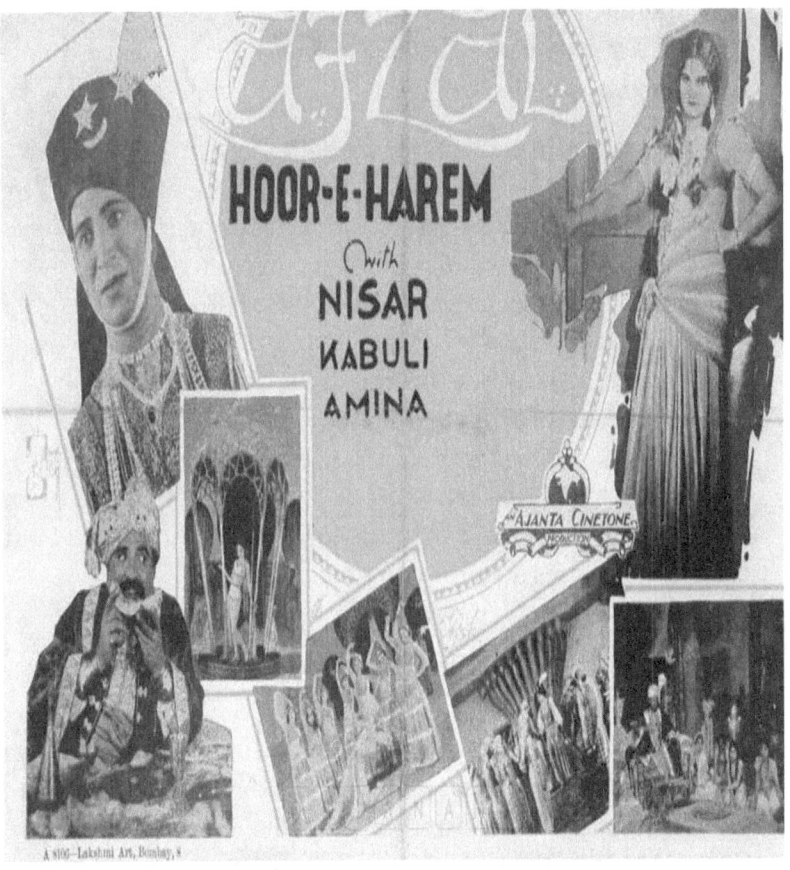

Figure 1Film Afzal aka Hoor-e-Haram booklet cover Courtesy Rashid Ashraf

SYNOPSIS

Afzal, the hero of the movie was a sweetmeat vendor. He was a trickster and an adventurer. He was quite wealthy. He was in love with a girl named Yasmin. Afzal did not know she was a philanderer. Yasmin had a paramour by name Salim. Yasmin and Salim cheat Afzal of his money and disappear. Heartbroken, Afzal leaves in disguise lands in the mysterious hall. The place was filled with beggars and drunkards. Yasmin cheated by her paramour Salim finally lands in the prime minister's palace.

Kaleem was a rich and handsome youth, living in the same town was passionately in love with a young girl by name Parveen. One day the governor's soldiers enter her house, kill her parents and carry away Parveen. Kaleem found her when she was being auctioned in the slave market. He bought her and was heading home when the Sultan's soldiers forcibly take her away into the Royal harem. Kaleem was injured in the struggle that followed. He was carried away by a group of faqir's into the mysterious hall. The faqir's were rebels of Sultan who were unhappy with his rule. Kaleem was trying to find out the whereabouts of Parveen. Sultan on his regular rounds finds Kaleem's suspicious actions and ask his men to keep a watch on him.

Afzal on his way in the mysterious hall by chance steps on the trap door and find himself in front of Sultan. Not knowing what to do he performs clever tricks with the courtiers around him. He won the hearts of the courtiers. The Sultan was very much impressed and appoints him his prime-minister. Afzal find Yasmin in the prime minister's palace. The ex-prime minister as a revenge wants to kill the Sultan by poisoning him on the night of the big feast. Yasmin who was knowing about the plans of ex-prime minister hints Afzal.

Meanwhile, Kaleem was arrested for heading towards the Royal Harem. Sultan orders for his execution the day after the big feast. Afzal comes to know about Kaleem's story. He wanted to help him. On the night of the grand feast when Sultan was ready to drink the wine mixed with poison Afzal stops him and saves his life. Sultan is very much pleased. The ex-prime-minister taken into custody. It was a joyful moment for Sultan. He comes to know about Kaleem from Afzal. Kaleem was pardoned and Parveen released from the royal harem. They both unite and lead a happy life. It was Afzal's bravery that united Kaleem and Parveen. Sultan ruled his kingdom peacefully under the able guidance of Afzal.

REVIEWS –

This was an excellent movie of great adventure with a middle eastern touch. The sultan's palace with lovely corridors, secret passages and tunnels, mysterious halls, trap doors, hidden rooms and many more strange things were very well picturized.

Kabuli played the lead role of Afzal which was very impressive. Apart from that he also wrote the lyrics. Ameena played the pivotal role of Yasmin. Her role was very much admired by the audience. The movie was famous for its attractive dances.

The highlight of the movie was excellent music by BS Hoogan. A musician of the Parsi theater had employed an orchestra consisting of eight musical instruments.

ALIBABA – 1946

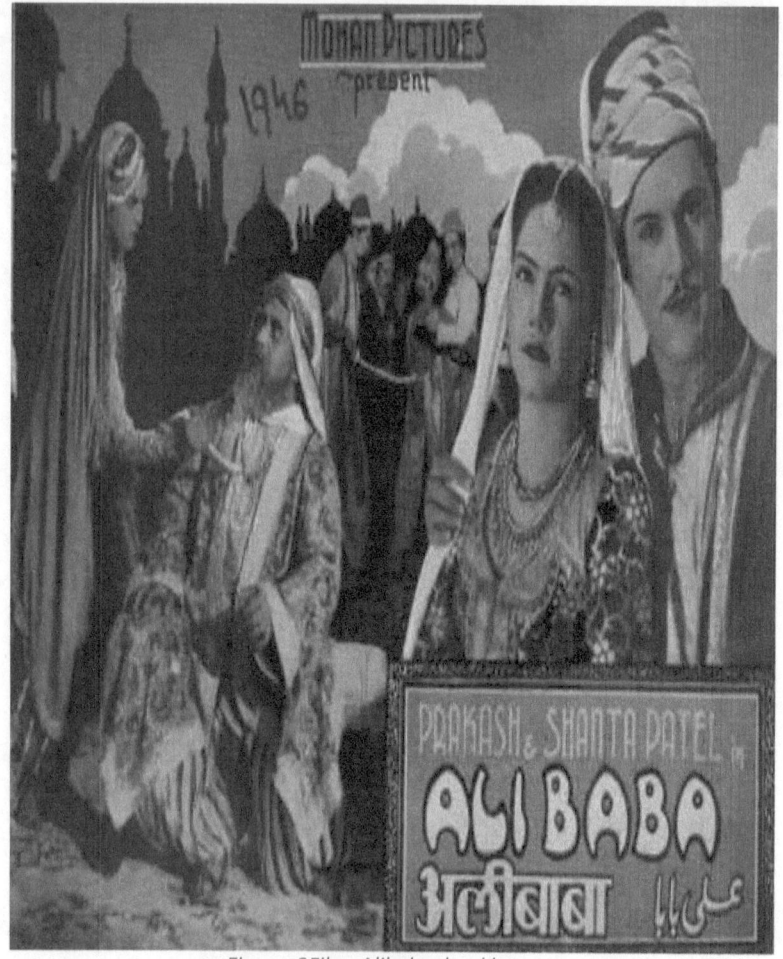

Figure 2Film Alibaba booklet cover courtesy Rashid Ashraf

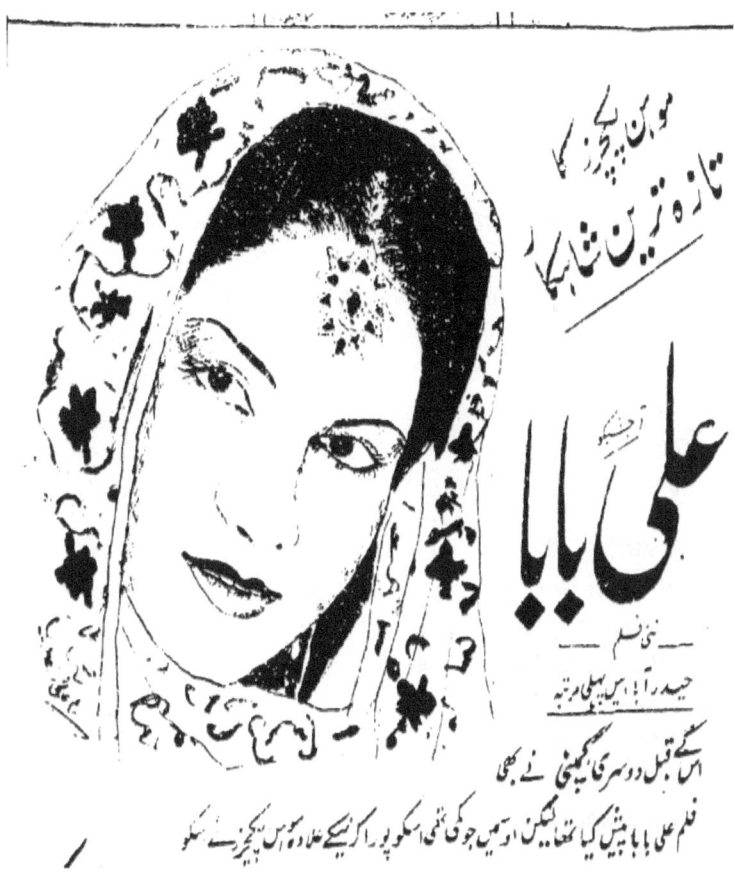

Figure 3 Film Alibaba from Urdu newspaper Author's collection

INTRODUCTION –

Alibaba was one of the most popular stories from the Arabian Nights. It was filmed in 1937 by Madhu Bose and in 1940 by Sagar movie-tone by Mehboob Khan. While both the movies were big budget and big star movies and did well at the box office, Mohan Pictures made this movie on a

small budget with less known artists with a reasonably good profit margin. The movie was quite popular all over the country.

SYNOPSIS –

Alibaba was a carefree cavalier living with his rich elder brother Qasim and his wife Khanum. One day he finds Marjiana, a beautiful young girl dancing in the streets of Baghdad. Her two brothers Noora and Daara were making a living at the earnings of their sister Marjiana. Alibaba was mesmerized at the beauty of the dancer. Their eyes meet with each other and Marjuana too falls for the grace of Alibaba. Noora and Daara soon realize Alibaba was an old schoolmate. They all become good friends.

Alibaba escorts them to Qasim's house where he was living. Unfortunately, Noora and Daara create an uproar and Khanum asks Alibaba to drive away his new friends or leave the house along with them. Alibaba goes out and starts living outside the house. Qasim was very much pained to see his brother living outside the house. He asks Khanum to permit Alibaba to be back in the house. She agrees to that proposal but without Alibaba's friends. Qasim goes to Alibaba and request him to come back and live with him but, Alibaba refuses to join him without Marjiana and her brothers.

Qasim was attracted to the beauty of Marjiana. He approaches her in the absence of his brother Alibaba and lures her with his money and riches but, Marjiana spurns him. Khanum who was watching the proceedings became furious and orders Qasim to ask his brother Alibaba to leave the premises.

Alibaba moves into a nearby hut along with Marjiana and her brothers. He starts living by cutting wood in the forest. He accidentally finds the den of the forty thieves and hears the

magic word 'Open Sesame '. He enters the den after the thieves had left and fill a bag full of gold coins and jewels and return home rich. Alibaba purchase a big house and live like a rich man with Marjiana and her brothers. Khanum wonders how Alibaba became so rich in a short time. She asks Qasim to find out the secret from his brother. Qasim threatens Alibaba and find out the secret.

The next day he enters the den and was surprised at the treasure. He collects many bags full of gold coins and forgets the secret word. Unable to come out of the den, he was locked inside. The robbers come and finding Qasim in the den kill him. Khanum become anxious about Qasim not returning home requests Alibaba to look for his brother's whereabouts.

Alibaba along with Noora and Daara enter the den and carry away the body of Qasim. Marjiana informs Khanum about the tragic death of her husband and together spread the news in the town that Qasim is seriously ill. The next day, they announce his death. Marjiana get a coffin hood made with the help of cobbler Baba Mustafa and get Qasim duly buried.

The robbers find out that there is another person who knows about the secret entry to the den. They try several methods to find Alibaba but, all attempts of them were foiled by smart Marjiana. Once the robber chief comes to Alibaba's house as an oil merchant with his comrades hidden in oil jars but, Marjiana finds out and kills them.

The robber chief escapes and returns. This time as a jewel merchant. Marjiana finds out and kills him with a dagger while dancing before him. Khanum was very impressed with Marjiana and asks Alibaba to marry her. Alibaba and Marjiana get married and Khanum goes on a pilgrimage to Haj.

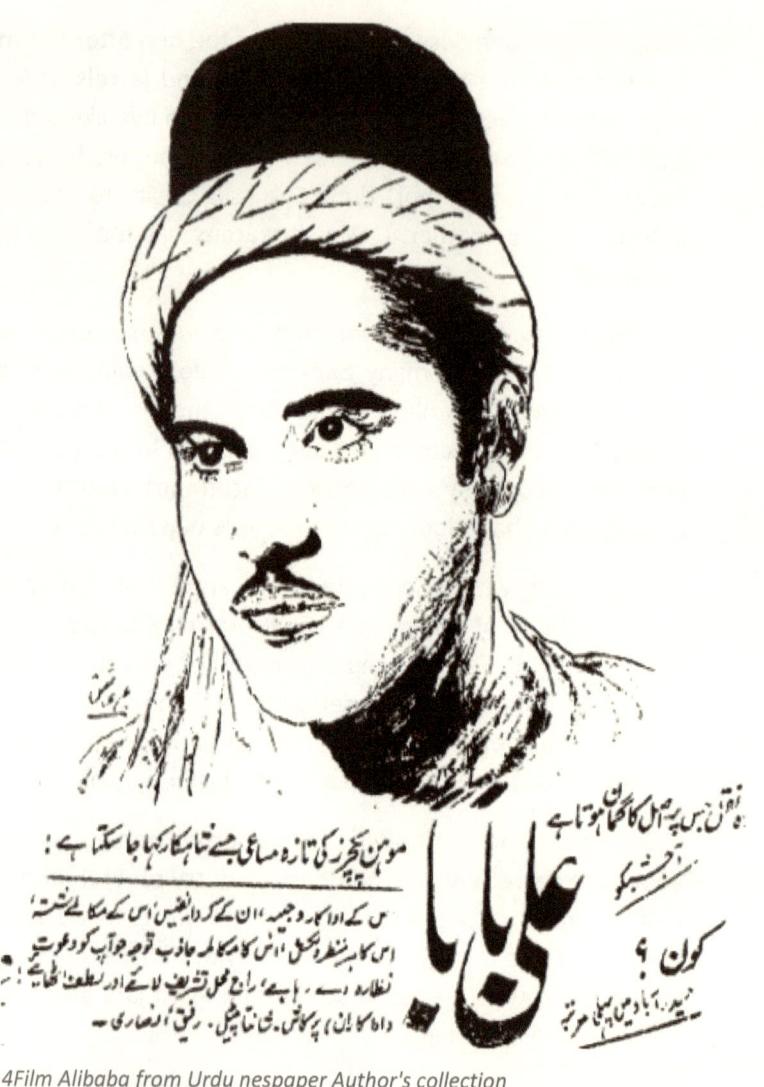

Figure 4 Film Alibaba from Urdu nespaper Author's collection

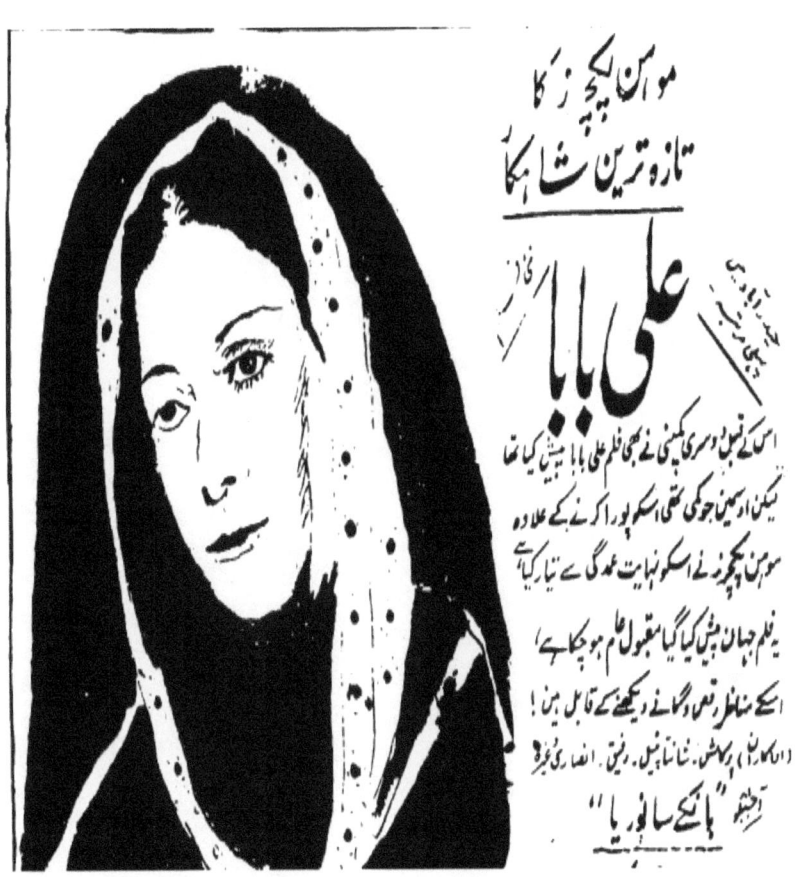
Figure 5 Film Alibaba from Urdu newspaper Author's collection

REVIEWS –

The reviews of Alibaba were great. The movie was a big entertainer for people of all ages. Parents lined up with children at the theaters to show them the story which was so popular with the school kids. The highlight of the movie was the fine dances of Marjuina. Shanta Patel played the role of Marjiana superbly.

ANARKALI – 1935

SYNOPSIS –

This was the famous romantic story of Prince Salim with a commoner court dancer Nadira, later to be called by the name Anarkali. Salim had gone to the extent of revolting against his own father Emperor Akbar for his disapproval to marry Anarkali. The romance ended in a failure

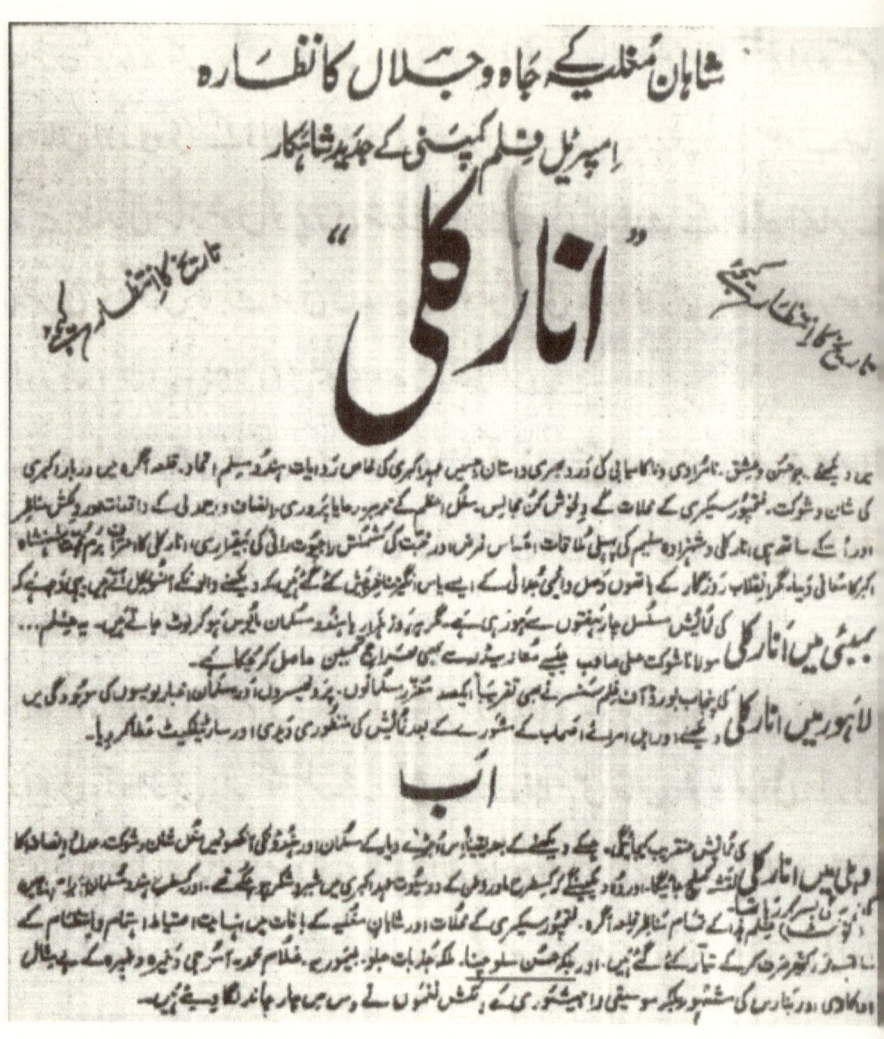

Figure 6 Film Anarkali from Urdu newspaper Lahore courtesy Rashid Ashraf

NEWS –

The Grandeur and Glory of the Royal Mughal.
Imperial film company's latest presentation.

See the unblessed and the unfulfilled love story during the reign of Akbar, the Hindu-Muslim unity, the Royal court at the Agra fort, the palaces of Fatehpur Sikri, the rule and the judgement of the great Mughal, the first meeting of salim with Anarkali at Agra fort, the Rajput queen's turmoil – love vs duty, the pardoning of Anarkali by Emperor Akbar, Prince Salim revolting against Akbar and the scenes which make the viewers eyes filled with tears - - -

Anarkali in Bombay – The movie is running for the last four weeks with unprecedented rush. Every day scores of Hindus and Muslims return back disappointed for not getting admission. The movie received the praise from the prominent leader Moulana Shoukat Ali

Anarkali in Punjab – The Punjab board of censorship had screened the movie for an elite group of hundred Muslim citizens and journalists and on their recommendation had granted the censor certificate.

NOW

Film Anarkali is scheduled to be screened in Delhi very soon, after this the scores of Hindu and Muslim will come to know the grandeur and glory of the Mughal era. They can witness the events of the Mughal period.

NOTE – The film was shot at the actual locations of Agra fort, Palaces of Fatehpur Sikri and the Royal Mughal gardens with utmost care and arrangements. The film was completed after spending substantial amount starring beauty queen Sulochana, queen of emotion Jillo. Billimoria, Ghulam

Muhammad, Asooji etc gave excellent performances and the songs by Malika -e-Mousequi (Queen of melody) Rajeshwari of Benaras had added one more feather in the cap.

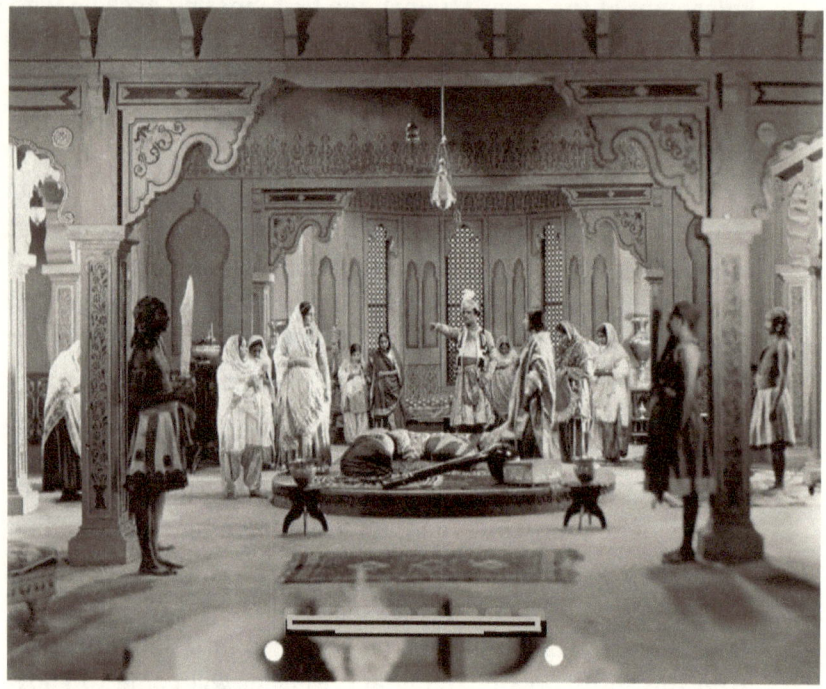

Figure 7 A scene from film Anarkali courtesy Rashid Ashraf

REVIEWS -

Anarkali was one of the landmark movies of 1935. The movie did very well at the box office. **Miss Sulochana** excelled in her role as Anarkali with her fine dances and dialogue rendition. **Jillu** as Maharani Jodha justified her role. The dialogues of the movie were very powerful at many places and were written in chaste Urdu. The highlight of the movie was excellent music by **Anna Saheb Mainkar**. The use of *shehnai, trumpets and naqqarah drums* at some places in the background was appreciated by music lovers. The songs by **Rajeshwari Devi of Benaras** was another highlight.

ARAB KA SITARA - 1946

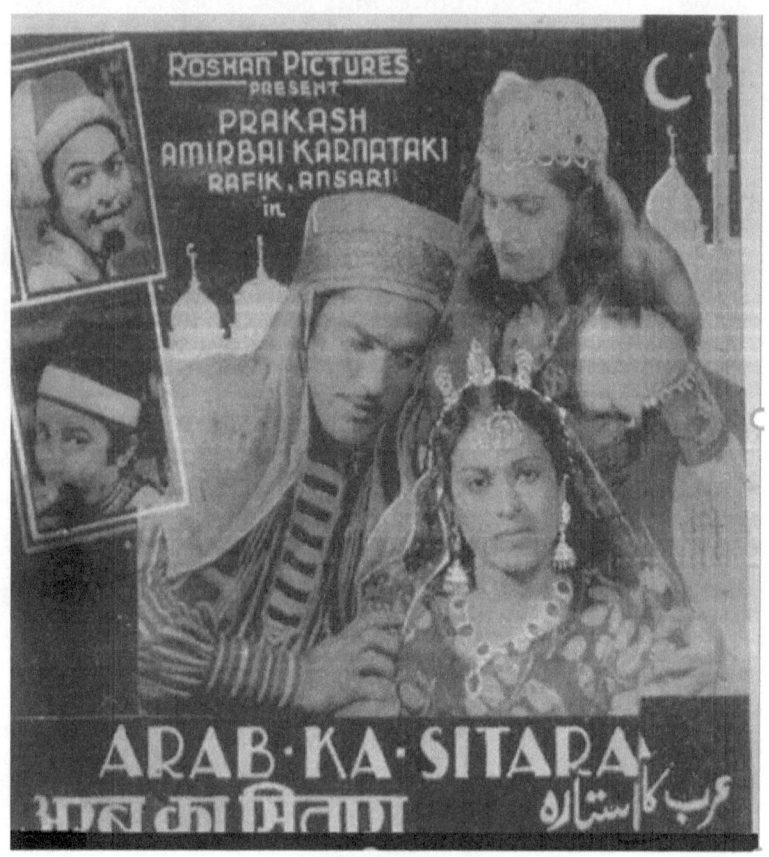

Figure 8 Film Arab ka Sitara booklet cover courtesy Rashid Ashraf

SYNOPSIS –

Anwar was a devout Muslim. He would pray namaaz five times a day religiously. This was the key to his success. From a common soldier he became a commander-in-chief and later he became a king. He was loved by all. He attributed everything to the power of namaaz. His murshid advises him to go to the neighboring kingdom of infedals and spread the religion of Islam.

Anwar travels to the neighboring kingdom and enters the harem. He meets the beautiful princess Arifa. Arifa was very much impressed with his charm and his eloquent speech. She falls in love and converts herself to Islam. The king comes to know about this from the peshwa and he imprison both Arifa and Anwar. Anwar was tortured but, his full faith in namaaz and Allah made him bold and passed through all the difficulties. Finally, the king was convinced with the teachings of Anwar and he accepts Islam as his religion. The king announced Arifa's marriage with Anwar. Anwar was overjoyed and forgot to offer his paryers – namaaz. This proved bad for him.

The peshwa comes to know about this. He leaves the kingdom and gathers a big army of infidels to rebel against the king. Anwar and the king were arrested. Anwar was freed by a good Namazi (one who prays regularly). Anwar heard the azaan (call of Islamic prayer). Anwar bows down and offer his namaaz. The king also followed him offering namaaz. Allah removed all the obstacles from there way. Anwar got hold of a magic pitcher through which he got plenty of strength. The rebels flee. Anwar was married to Arifa. The whole kingdom got converted to Islam.

REVIEWS –

The movie was an excellent example of the power of prayer – namaaz and the utmost belief in the supreme – Allah. The movie was quite popular in most parts of the country. There were all praises for Amir Bai Karnataki.

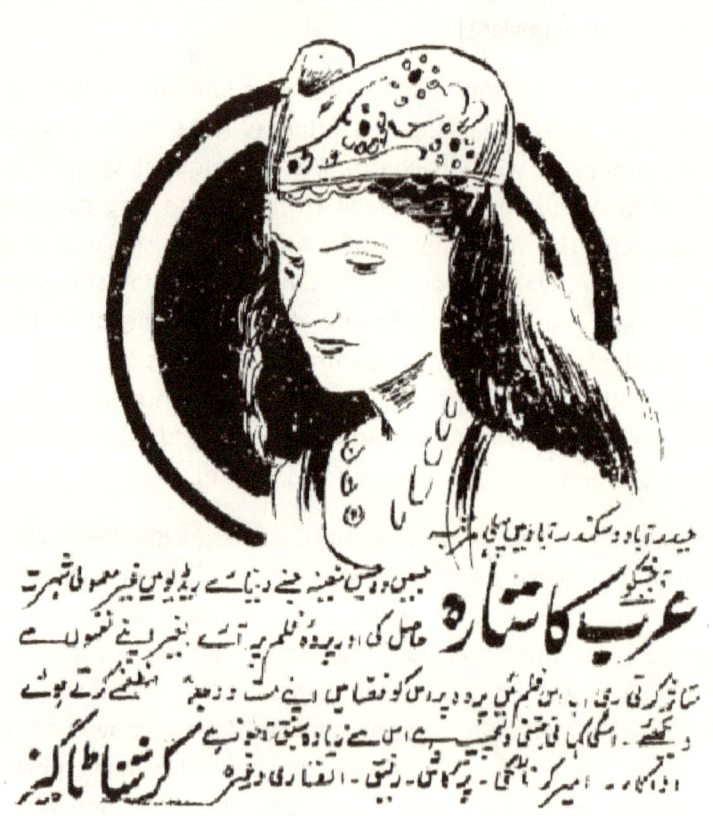

Figure 9 Film Arab ka Sitara Amirbai Karnataki the famous singer as heroine from an Urdu newspaper. Author's collection

BARE NAWAB SAHEB - 1944

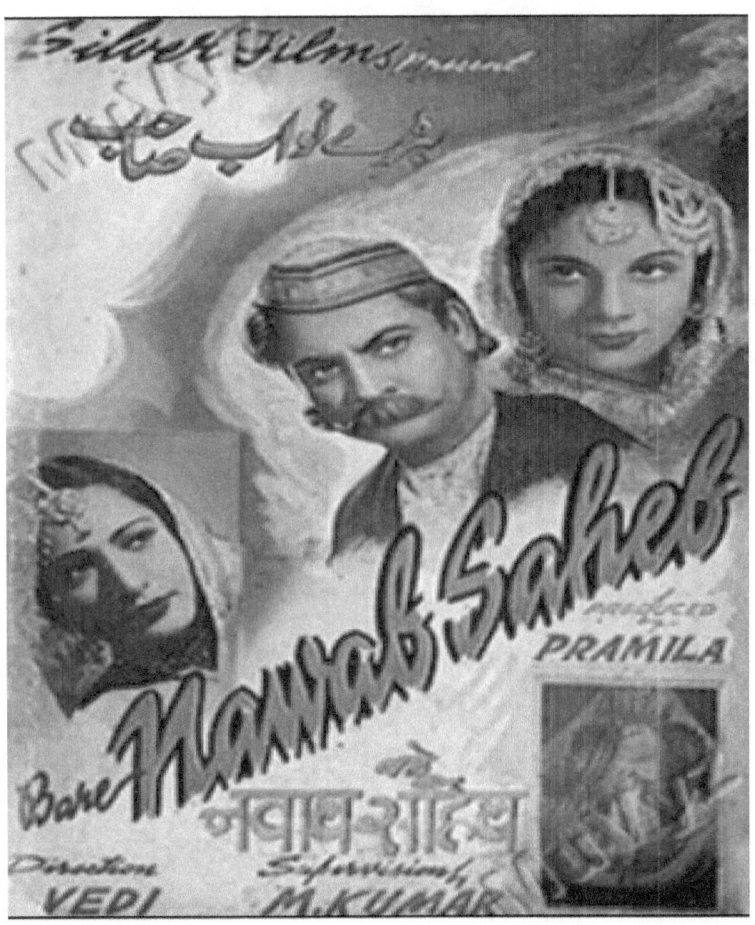

Figure 10 Film Bade Nawab Saheb booklet cover courtesy Rashid Ashraf

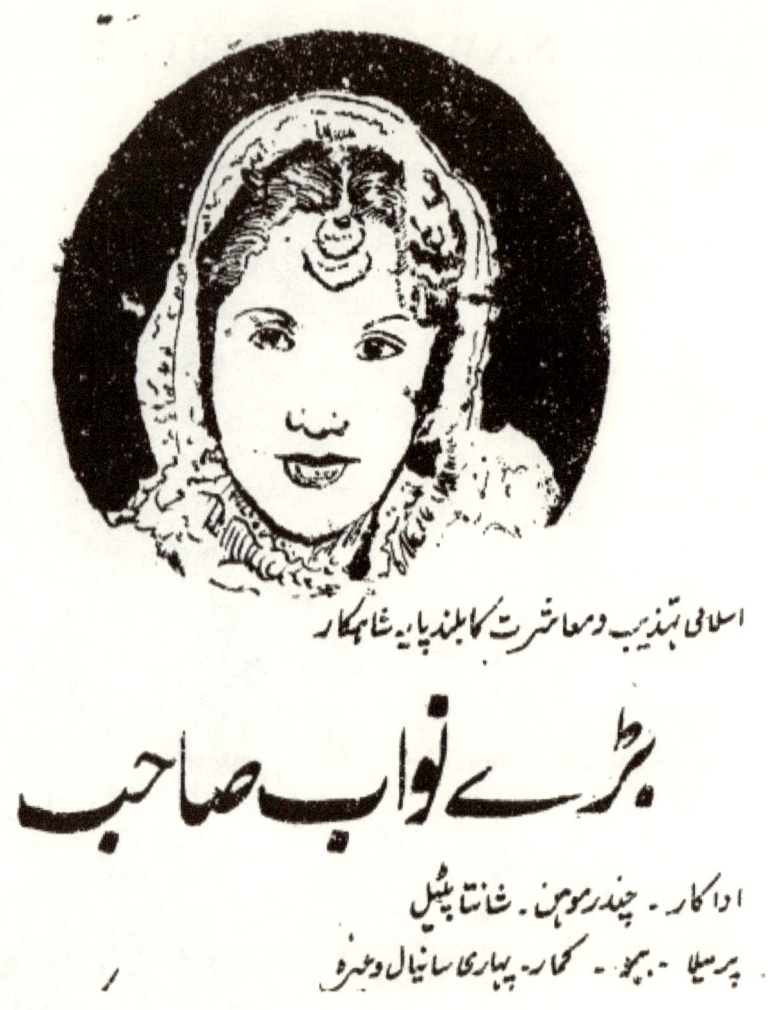

Figure 11 Film Bade Nawab Saheb describing a movie based on Islamic culture and etiquette from Urdu newspaper Author's collection

SYNOPSIS –

Film Bade Nawab Saheb is based on a true story, only the names of the characters are fictitious. Like all movies it is possible some extra spice could have been added to make it little more attractive. The events are from the glorious days of Lucknow which was renowned for its rich and traditional Muslim culture. Nawab Kokub Mirza was a god fearing and temperate person. He had a good reputation in the city of Lucknow. He had two wives. Nawab Saheb loved his second wife Choti Begum so dearly that he became a puppet in her hands. Nawab Kokub Mirza had a younger brother Sikandar, for whom the elder brother was everything. He respected and treated him as his father.

Nawab Saheb's beloved Choti Begum also has a brother, Nawab Mushir Jung, a person of questionable character. He is aware of inside and outside dealings of Nawab Saheb. His interference is a cause of concern for the Nawab Saheb but, unable to do anything, he tolerates him.

There is one more important person in the household worth mentioning, Bakhsho, a faithful and honest servant of the Nawab Saheb. Everyone knows and respect him in the big mansion except his Choti Begum and her brother Mushir Jung. They also disliked Sikandar and at every small incidence try to tarnish his image. They both conspire to expel him out of the mansion but, Bakhsho always comes to his rescue and shields him. Choti Begum and her brother were impatiently waiting for an opportunity to see that Sikandar is removed from the mansion.

The right moment has arrived. Sikandar marries Anwar, an orphan girl from an unknown family against the customs and traditions of the Nawab's family. This was the perfect reason.

Choti Begum and Mushir Jung enrage the Nawab Saheb against his brother Sikandar. Despite all the pleas from his Badi Begum (elder wife) the enraged Nawab Saheb asks Sikandar to leave his mansion.

Sikandar was a pampered boy, brought up with all the riches and glory of the Lakhnawi Nawab style goes in search of a job to make a living. His job hunt does not yield any result. He along with his wife Anwar approach Bakhsho, who offers them shelter in his house. Bakhsho tries to unite both the brothers but, through the influence of Choti Begum and Mushir Jung Nawab Saheb removes Bakhsho from the service. He also prohibits him from entering his mansion.

Sikandar goes in search of a job leaving his wife Anwar with Bakhsho. The pain of losing the job and unable to unite the brothers was something unbearable for Bakhsho. Heartbroken, he dies in sleep. The young and helpless Anwar takes up a job as a servant in Nawab Saheb's mansion. She was unaware of the fact that Nawab Saheb is the elder brother of Sikandar. With her sincerity and hard work, she wins the heart of Nawab Saheb and Badi Begum Sahiba in a very short time. The evil eyes of Mushir Jung falls on the young and beautiful Anwar. One night he enters her room and tries to molest her. On hearing the cries of Anwar Nawab Saheb comes to her rescue. The sinister plans of Mushir Jung was exposed. He drives him out of his mansion. This event had tarnished the image of Choti Begum. Nawab Saheb finds solace and spends more time with Badi Begum Sahiba. Taking this opportunity, she asks Nawab Saheb to forgive Sikandar and call him back to the mansion.

Sikandar was found and brought back to the mansion. Sikandar finds Anwar and to his astonishment, he learns about the events leading to her presence in the mansion. On Choti Begum's request Mushir Jung was also pardoned. The pardoning of Mushir Jung was a big mistake by Nawab Saheb. Mushir Jung

was revengeful and wanted to kill Nawab Saheb. One day he manages to mix poison in Nawab Saheb's *hareera – an Indian porridge made of cream of wheat, clarified butter and milk.*

The booklet synopsis ends here. What happened next – Did Nawab Saheb consume the porridge and die or someone else consumed and the poison identified? How the criminal plans of Mushir Jung were exposed and how the story finally ended. For answers, readers were asked to witness the movie on the big screen and find out the answers for themselves.

Figure 12 Urdu newspaper announcement dated August 11 1944 Author's collection

Translation.

After film Najma, this is the second movie based on culture and etiquette of Lucknow. The story of Film Bade Nawab Saheb belongs to an upper class Nawab family of Lucknow presenting the house hold problems in a fine way. Chandramohan, Pahari Sanyal, Kumar, Bibbo and Pramila had played their roles very well. The movie will be released in all big cities of India

BHAIJAN – 1944

THE UNITED FILMS.

PRESENTS

NOORJAHAN

in

🖝 BHAIJAN 🖜

STARRING

MEENA ★ ANISKHATOON
(COURTESY MINERVA MOVIETONE)

KARAN DEWAN, QAIMALI, ANSARI, NAZIR KASHMIRI, QAMAR
LADDAN, AZBELLA BEGAM, SUMAN ETC.

and

SHAHANWAZ ★ as ★ BHAIJAN

=== BHAIJAN ===

Photography by:- B. JAGIRDAR — Art:- B. N. TAGORE
Asst:- G. Vasant — Make up:- TAREEF
EDITED by:- S. PRABHAKAR — Music:- SHYAMSUNDER
Asst:- SABU — Asst:- ABDUL KARIM
Costumes:- QAIMALI — Dance:- BOLEN DUTTA

Assistant Directors:-

CHANDRAKANT M. H. MOHIB MURTAZA CHANGEZEE

Directed by:- S. KHALIL

Story by:- AFZAL MIRZA CHUGTAI and S. KHALIL

Dialogues & Songs:- PARTAO LUCKNAVI

Produced by KHALIL & MURAD

Production Manager:- M. S. BURMAN

Figure 13 Film Bhaijan cast from booklet courtesy Rashid Ashraf

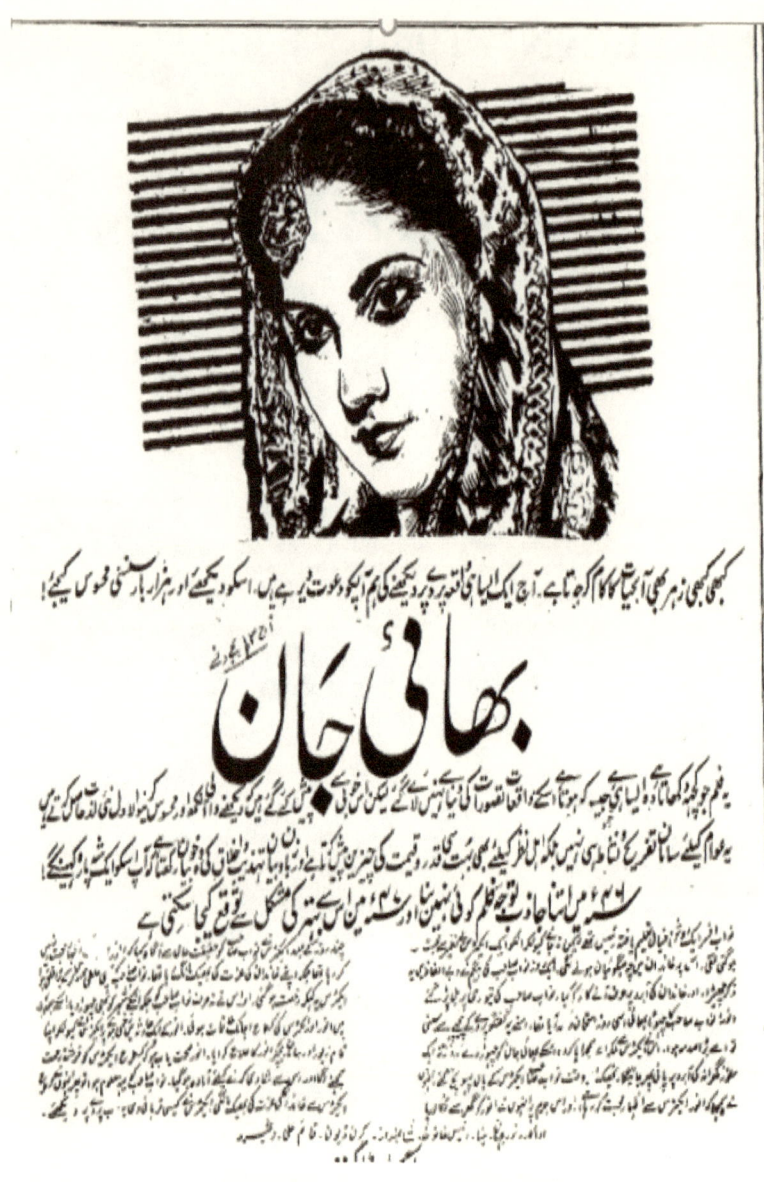

Figure 14 Film Bhaijan synopsis from Urdu magazine Author's collection

SYNOPSIS –

This is the story of two rich, well-educated and cultured brothers. Nawab Afsar and Nawab Anwar. Afsar, the elder one was newly married but falls in love for a dancing girl Benazeer. He makes her famous by building a theater for her but, she merely looks at him as a patron. The indifferent behavior of Afsar makes his wife Begum Sarwari spend her time in tears and sighs. A child is born and is welcome in the house. Begum Sarwari's sister, Shahida joins her to spend some time with her sister.

Nawab Anwar, the younger brother of Afsar who was studying in college returns home. Anwar and Shahida fall in love with each other. Noticing this Begum Sarwari informs her parents who readily agree for the marriage of Shahida with Anwar.

Anwar comes to know about the discontent between his brother Afsar and his wife Sarwari due to Benazeer. He wanted to set things right, approaches Benazeer, ask her to stay away from his brother's life. Benazeer. In the process she falls in love with Anwar.

A relative of the Nawab Saheb Shaukat was living in the house as a guest. He was a very mischievous person. On seeing Shahida he was dreaming of marrying her. In order to remove Anwar from his way, he made false allegations on Anwar that he was in love with Benazeer. One day, Afsar finds Anwar at Benazeer's place and immediately concludes that he is in love with her. He believes the words of Shaukat and asks his brother to move out of his house. Anwar leaves the house for good.

Unable to bear the separation of his brother Afsar falls sick. Begum Sarwari approaches Benazeer to nurse him back to recovery. She obliges and Afsar makes a fast recovery. Benazeer

learns that Anwar was thrown out of the house by Afsar. She decides to leave the theater and moves over to Bombay. On his recovery Afsar learns about the cunning tricks of Shaukat. He asks Shaukat to leave the house. Afsar asks Ladle Mirza, the theater manager to trace the whereabouts of Benazeer.

Anwar goes to Bombay in search of a job. Luckily, one day he finds Benazeer. One day while on a job hunt he falls from the staircase and was badly injured. Benazeer comes to his rescue by selling some of her jewelry to pay the medical expenses. Ladle Mirza finds Anwar in Bombay and informs Afsar through a telegram. Afsar immediately rushes to Bombay. Both brothers get united.

Shaukat after leaving Afsar's house goes to Shahida's parents, and spread rumors that Anwar is in love with Benazeer. They agree to get him married to Shahida instead of Anwar. Sarwari Begum informs her parents about the cunning tricks of Shaukat. They cancel the marriage with Shaukat and decide to marry Shahida to Anwar as proposed previously. On knowing about the love of Anwar for Shahida and the proposed marriage with her Benazeer decides to move out of their way. She commits suicide by consuming poison.

REVIEWS –

Bhaijan was a maiden venture from the United Films, Lahore. It was a small budget movie which had big success at the box office. The dialogues in simple Urdu were very well written. The songs were mostly ghazals and poorly recorded, Nurjehan rendered the songs for the screen but. The songs on 78 RPM discs were recorded in the voice of Zeenat Begum, a big disappointment for the Nurjehan fans.

Nurjehan as the dancing girl played her role very well. Shah Nawaz as elder brother and Karan Dewan as the younger one Anwar justified their roles. Meena as Shahida looks pretty. Anis Khatoon as Begum Sarwari deserves a big praise. overall Bhaijan is a very good movie depicting Muslim social life worth watching for all ages young and old.

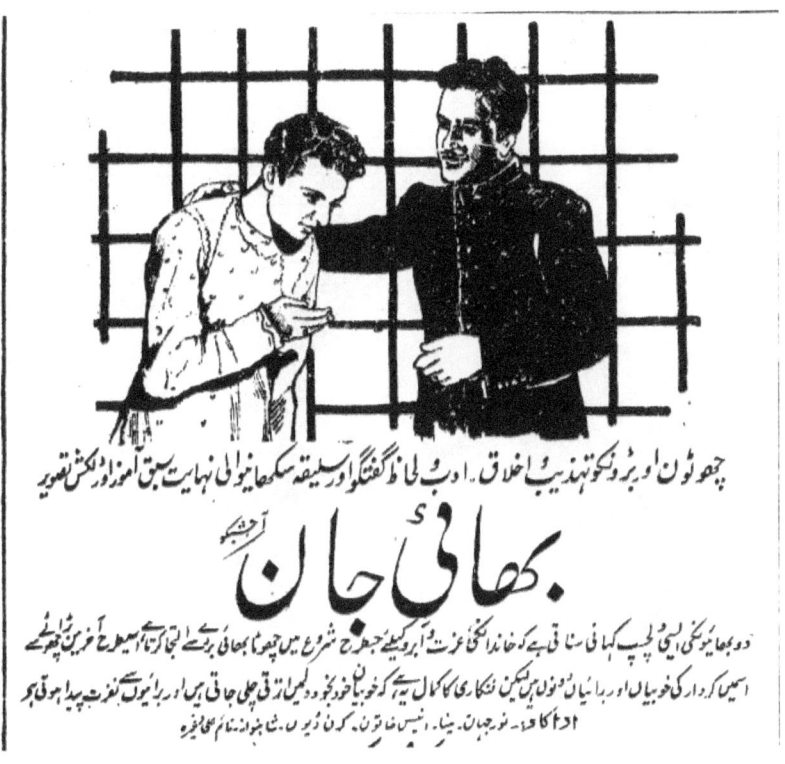

Figure 15 Film Bhaijan a movie filled with Muslim culture, society, manners and etiquette. Author's collection

BULBUL-E-BAGHDAD – 1941

INTRODUCTION –

A movie with a similar name was released in 1932 starring Bachu, Khatun, Yaqub, Sushila and Mehboob. No further details are available. No songs were listed. It was produced by Sagar movie-tone, Bombay. The film released in 1941 was very popular.

Figure 16 Indurani in film Bulbul-e-Baghada from Urdu film magazine. Author's collection

SYNOPSIS –

Bulbul was the daughter of a well to do family of Baghdad. Her parents, under unavoidable circumstances left her in their friend's house. She grew up to a young girl of great beauty. She was attracted to a young and handsome man Rasheed. They were having a good time, playing games and singing songs. Suddenly, one day, she disappeared.

Rasheed, patiently waited few days but, finding no trace of Bulbul went on a mad search. He was almost mad not finding her. He finally gave up hope and concentrated on his higher studies. Basra was a notorious city for bandits.

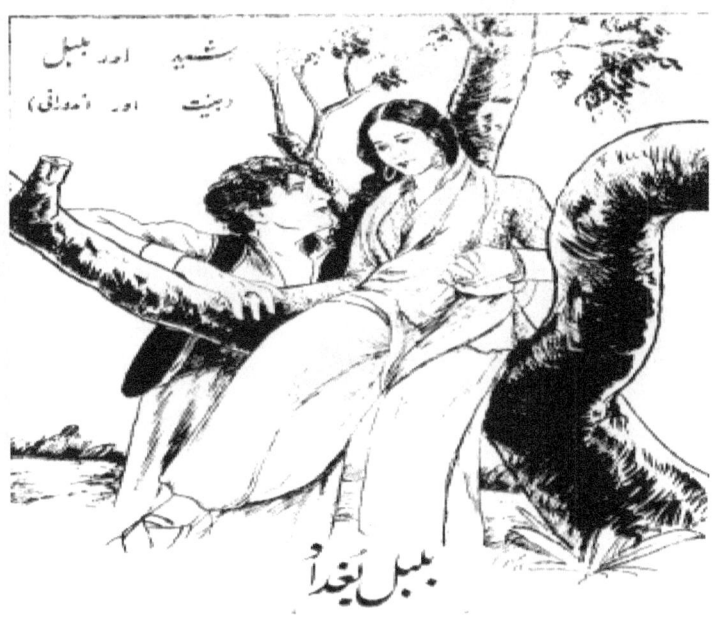

Figure 17 Happy days - Bulbul and Rasheed in film Bulbul-e-Baghdad. Author's collection

Bulbul took dancing lessons and soon, she was dancing on the streets of Basra. Her earnings became a livelihood for the bandits. Bulbul tried to escape from the bandit's camp but, every time she was caught by the bandits and placed on strict guard. She had no other alternative but to remain a captive.

Figure 18 Yaqub as daku Rasheed in Bulbul-e-Bghadad from Urdu magazine. Author's collection

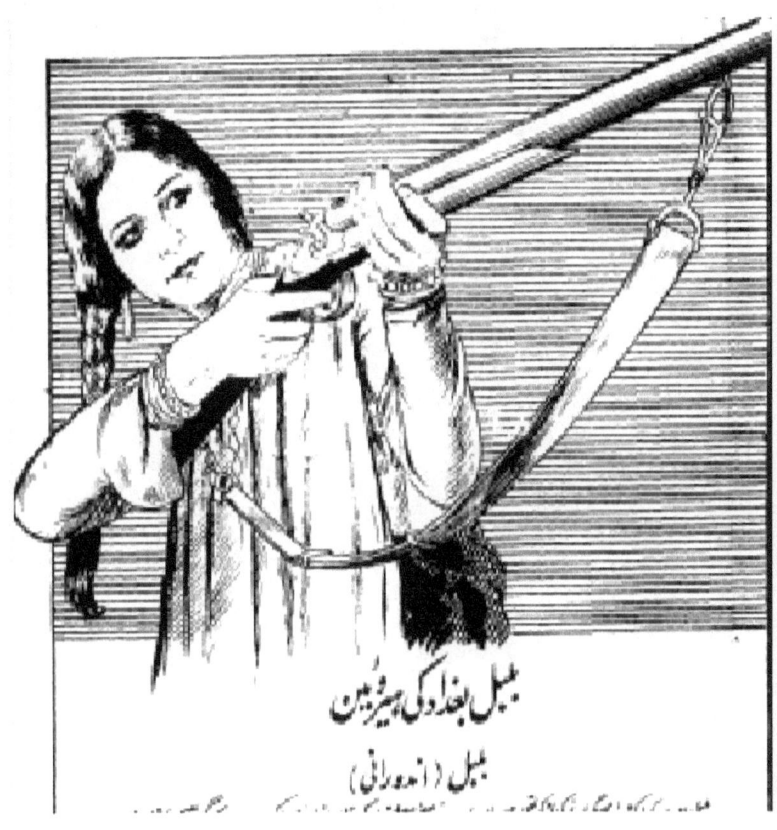

Figure 19 Film Bulbul-e-Bghadad Bulbul trying to escape from Urdu magazine, Author's collection

Figure 20 Film Bulbul-e-Baghdad Rasheed arresting Daku Rasheed from Urdu magazine. Author's collection

Rasheed got tired searching for Bulbul. He concentrated on his studies and passed his exams with distinction. His higher education earned him a high-ranking government job.

The city of Basra was fear stricken with Rasheed Daku. There were many complaints and the government wanted to get the

bandit chief arrested. Rasheed was entrusted the job of finding Rasheed Daku and put him behind bars. It was not an easy task for Rasheed to arrest a tough and merciless bandit. In a strange development Rasheed Daku came to know about his son who had become a responsible official. When Rasheed came to arrest him, he was happy to see him, instead of firing a bullet, he calmly surrendered. His heart melted like a candle. Bulbul recognized Rasheed and they both got united.

How Rasheed Daku and his son Rasheed got separated and how Rasheed Daku came to know about his son is something to be seen on the silver screen

Figure 21 Film Bulbul-e-Baghdad Bulbul and Rasheed get united from Urdu magazine. Author's collection

REVIEWS –

The movie was a huge success at the box office. It was a well- directed movie with good photography and music. The leading pair Jayant and Indurani acted very well but, Yaqub as Rasheed Daku stole the show.

DIL – 1946

BOOKLET SYNOPSIS

Figure 22 Film Dil booklet synopsis in English & Urdu courtesy Rashid Ashraf

Fazli Bros were the famous movie makers who were renowned for producing movies on Muslim culture like Qaidi, Masoom, Fashion, Ismat and Shama, unfortunately, in most cases they did not furnish any clue to the story. The reviews of their movies are hard to find. The synopsis of film Dil does not furnish any details of the movie. Certainly, Dil or Heart is difficult to define. The author was able to find out a little outline of the story from the film publicity advertisement which are given below.

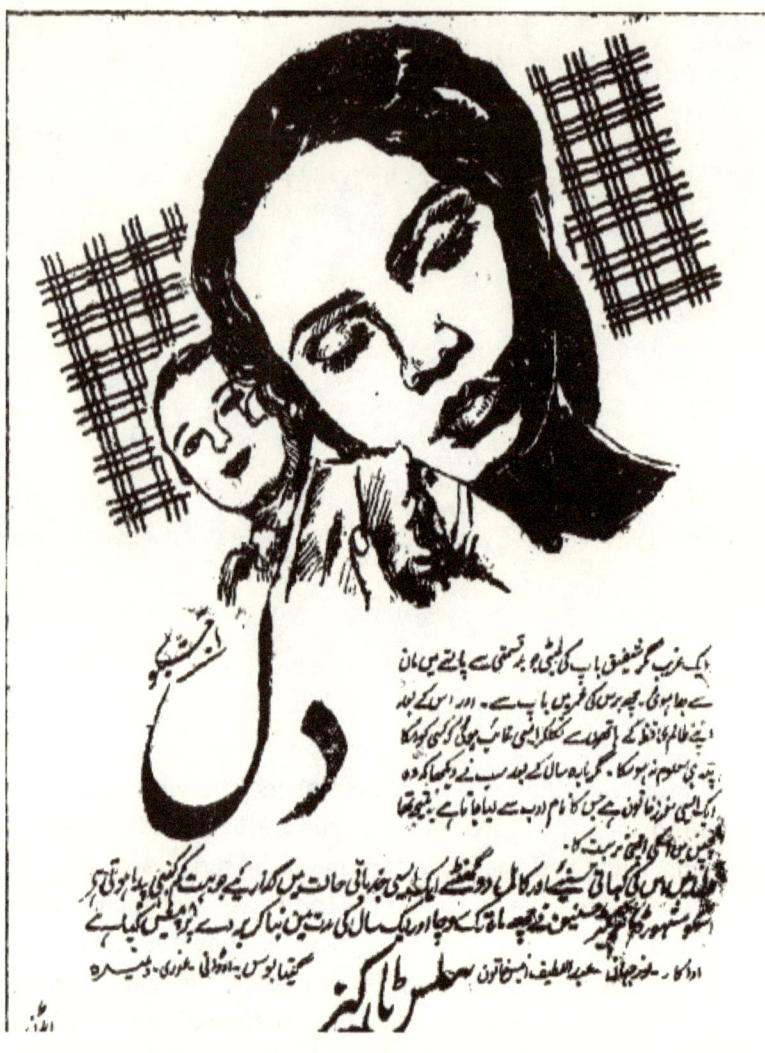

Figure 23 Film Dil synopsis from Urdu newspaper. Author's collection

STORY OUTLINE –

This is the story of a poor girl whose father was a kind and compassionate person. She was separated from

her family under unfortunate circumstances. Later, she had to leave them as they were unkind and rude towards her. After a lapse of twelve years the young girl had transformed herself into a respectable lady of nobility who was adored and admired by everyone.

The secret behind her success was the training as per Islamic studies given to her by her father. Faith in God, discipline, truthfulness, prudence, patience and perseverance devoid of jealousy, envy, hatred are qualities which will lead a person to success with respectability and honor.

Figure 24 Film Dil a movie filled with Islamic values. Author's collection

REVIEWS –

One of the last movies of Noorjehan in India was a huge success. The movie was based on the importance and success of an individual based on Islamic values. One of the high-light of the movie was the music by Zafar Khursheed, who

was with the Megaphone records. It had many melodious songs by Noorjehan. The film was considered one of the best movies of the year.

Figure 25 Film Dil announcement 24th May 1947 the movie is being shown in color

The success of the movie was so great that the Fazli brothers made color prints of the movie and the movie was shown in color only.

FASHION – 1943

INTRODUCTION –

Fazli brothers were renowned movie producers initially based in Calcutta. Their films were based on Muslim culture and society. Fashion was the third movie produced by them. Qaidi and Masoom were their earlier movies.

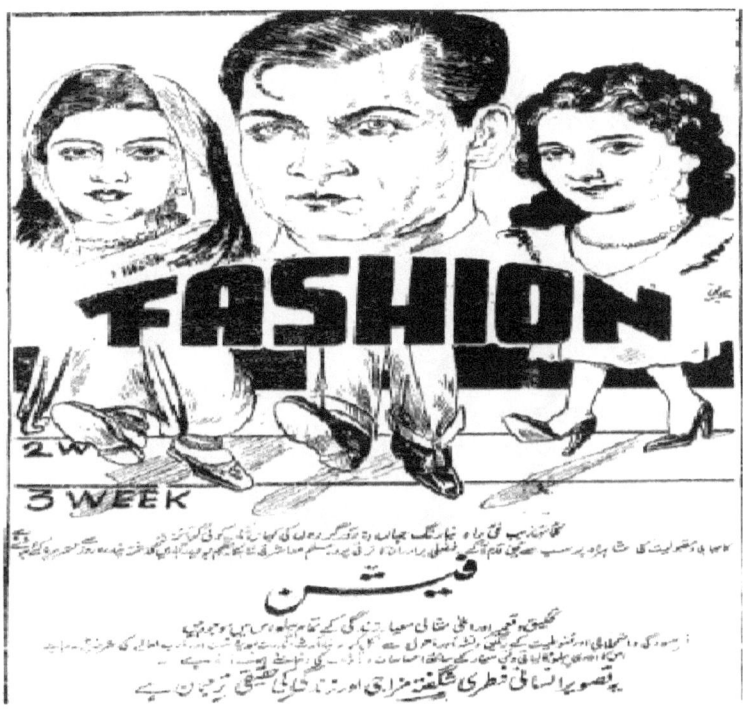

Figure 26 Film Fashion from Urdu newspaper. Author's collection

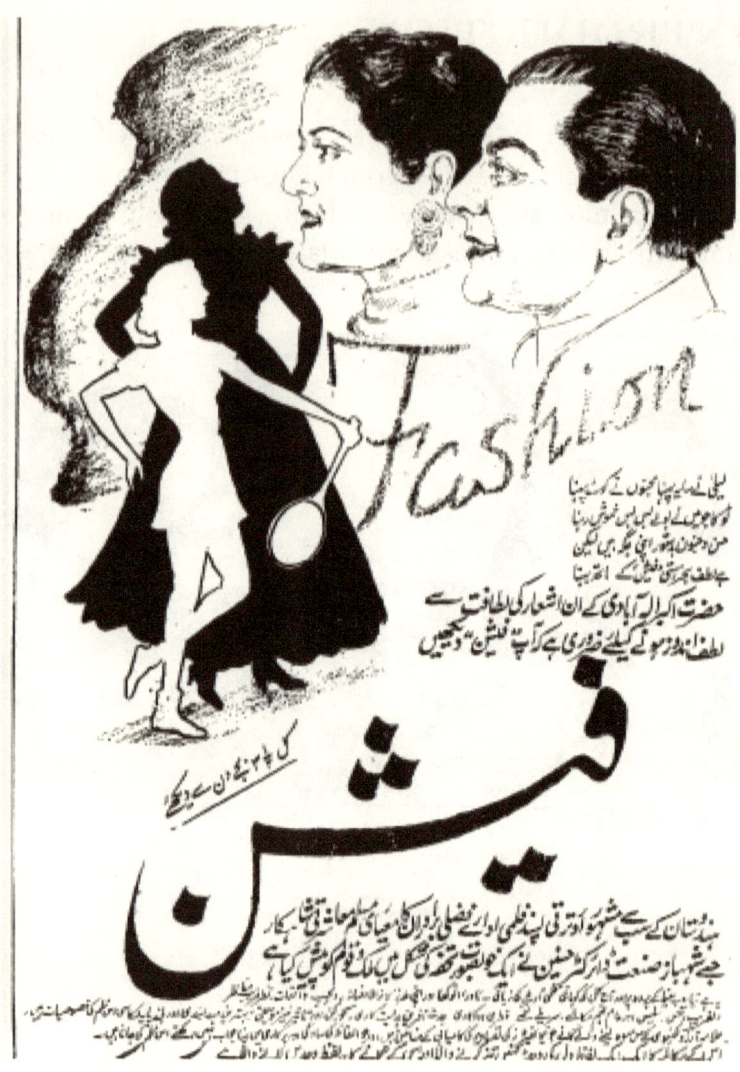

Figure 27 Film Fashion description of the movie from Urdu magazine. Author's coolection

SYNOPSIS –

Yusuf is an enterprising young man married to Razia. Forced by circumstances he had to live in his in laws house. His father-in-law was a rich man. He had everything to give Yusuf and his daughter who was so dear to him, but Yusuf was revolting within about his situation. He wants to live honorably by earning his own bread. He applied for various jobs and finally succeeded in getting one, a petty one on a salary of Rs 50 per month in Bombay.

Yusuf decided to move over to Bombay along with his wife Razia, but his father-in-law was worried as to what sort of comfort Yusuf could give his daughter in a petty salary in an expensive city of Bombay. Razia was a dedicated and duty-bound wife who would respect her husband's decision. She agrees to move with him and her father had no means to stop but leave her to face the situation.

Yusuf lands in Bombay, a day late for reporting for duty. His job offer was cancelled. He was standing with his wife in a big city thinking how he and his wife could survive. Accidentally he finds a purse consisting of Rs 200, a big amount which can make him survive till he finds another suitable job. He opened the purse and found the address to whom it belongs. Yusuf was an honest man and thought it is wise for him to return the purse to its owner.

The owner of the purse, a rich businessman was close by. He was deeply moved at the honesty of Yusuf. He heard him patiently and offered him Rs 500 as a loan to start a small business. He also helped in establishing his business. Yusuf was lucky, very soon he became a successful businessman. He earned plenty of money. As he grew rich he got in touch with many rich businessmen. He was visiting clubs and become

friendly with Farida, a girl with a highly western outlook and habits. This had affected his domestic life, he neglected his wife and new born son. Razia handled the situation calmly. Yusuf's love for Farida was so intense that he married her and made her live in the same house.

Razia was very accommodative. She behaved well with Farida and helped her to make her feel comfortable, but Farida did not like the very presence of Razia. Razia was the biggest obstacle for Farida. She started ill-treating her. Finally, Farida succeeded in separating Razia from the house.

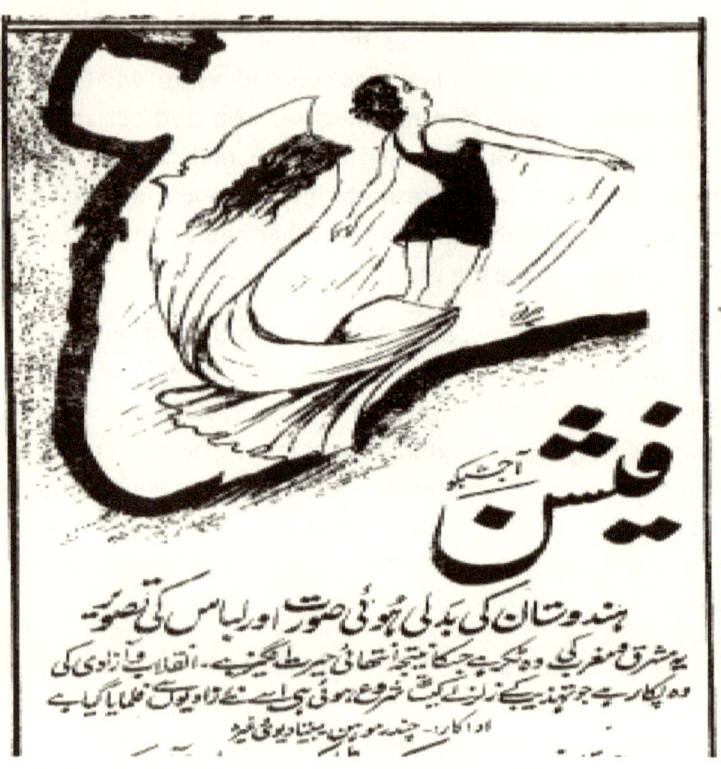

Figure 28 Farida in film Fashion from urdu magazine Author's collection

The images from Urdu film magazines describes about the changing trends and the influence of the Western culture in India. The clash of two cultures.

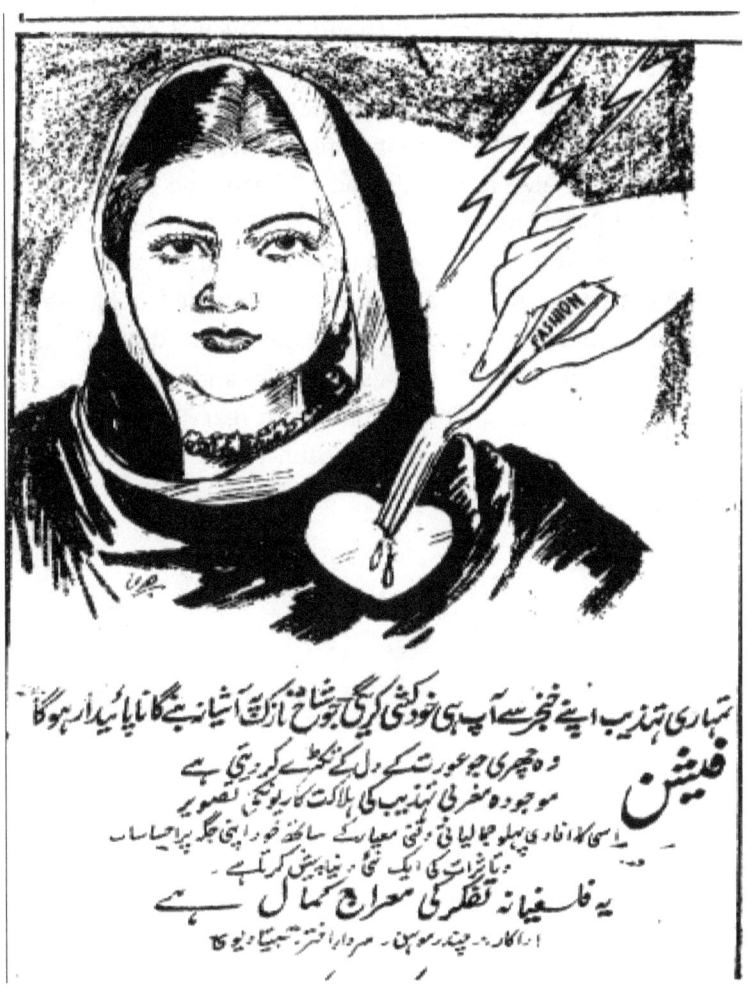

Figure 29 Razia in film Fashion from Urdu magazine. Author's collection

Life was becoming difficult for Razia and her son. They were managing the house on a meagre funds provided by Yusuf. Farida was enjoying all sorts of comforts. She was a spend-thrift and Yusuf had to pay all her bills. Yusuf could not control her extravaganza and her expensive habits. He felt his earnings were draining out. The domestic life too was not peaceful for Yusuf as Farida always complained of Razia and her son. The presence of Razia and her son living in the same house became a big obstacle for Farida. In a bid to drive her away she planned to kill Razia's son. The bid fails, and Farida fearing trouble leaves Yusuf for good. One by one, Yusuf comes to know Farida's misdeeds. Yusuf repents at his mistake and asks Razia for pardon. Razia, a true Indian woman, with tears in her eyes she falls into her husband's arms. Yusuf holds her in a tight embrace.

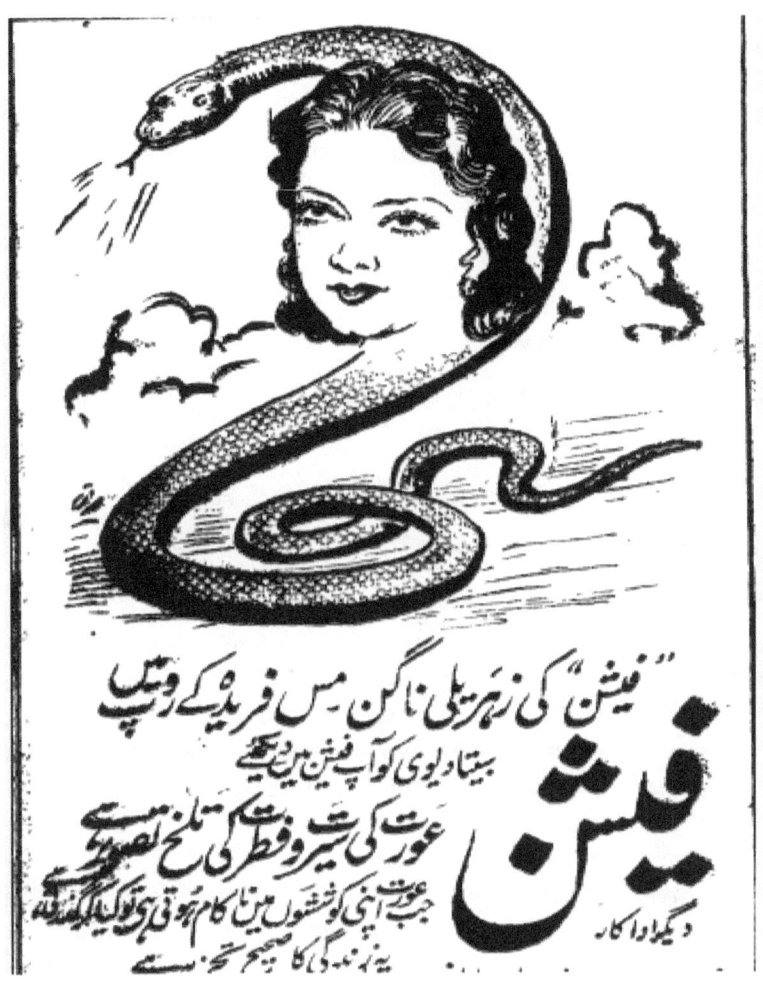

Figure 30 Film Fashion, Farida the villainous character played by Sabita Devi from Urdu magazine. Author's collection

REVIEWS –

There were many good reviews about the movie. A couple of them are given below.

Prof Muhashar Abidi wrote the following in Urdu magazine 'Film'. The translation is given below

Fazli brothers have presented the correct situation of the Muslim society in India in a precise way in film Fashion. There are many merits in the Eastern culture not from today but from many centuries and we have been neglecting them and adapting the Western culture blindly without proper understanding.

The theme of the movie is not new. The basic feature in the Indian society and the Muslim culture is the submissiveness of a wife to her husband. Although a woman has every freedom to take a decision, it is always the husband's decision which she abides by. Our mothers and daughters should take a lesson from this movie.

The story, dialogues, acting and the music all of them have made it a very interesting movie. I think we do need more movies like this in India.

Below is another review from leading Urdu film Magazine Shama

Those who have witnessed director Hasnain's film Masoom are aware that the movie Masoom can be called the first Muslim social movie that contained all the essential features of the Muslim culture. We are happy that they have succeeded in presenting movies on Muslim society. The proof is their latest film Fashion which has an edge over film Masoom. Fashion is a movie which portray certain shortcomings in the Western culture and is a lesson for those who are adapting the new trend without proper understanding,

The story of Fashion filled with great emotion. Each character in the movie was picturized and presented with utmost accuracy. It is the wish of every wife to be a part of her husband, Razia who was grown up in a well to do family with all comforts decides to move with her husband to a strange place with a meagre income to survive, later as a devoted wife endures all humiliations and discomforts created by her sister-wife was shown to the audience in a fitting manner. There is a lot for the audience to learn from this movie. It is the

greatness of director Hasnain who turned this solemn story into an entertainer.

All four major stars in the movie are very versatile actors. Sardar Akhtar, who played a memorable role in Mehboob Khan's Aurat. Chandramohan, with his big expressive eyes. Who can think Sabita Devi with innocent face and beautiful eyes could play a villainous role trying to kill the child? Budho Advani with his skillful comedy, all of them justified their roles. Apart from this the dialogues, photography and music all of them have made Fashion a very successful movie.

HOOR-E BAGHDAD – 1934

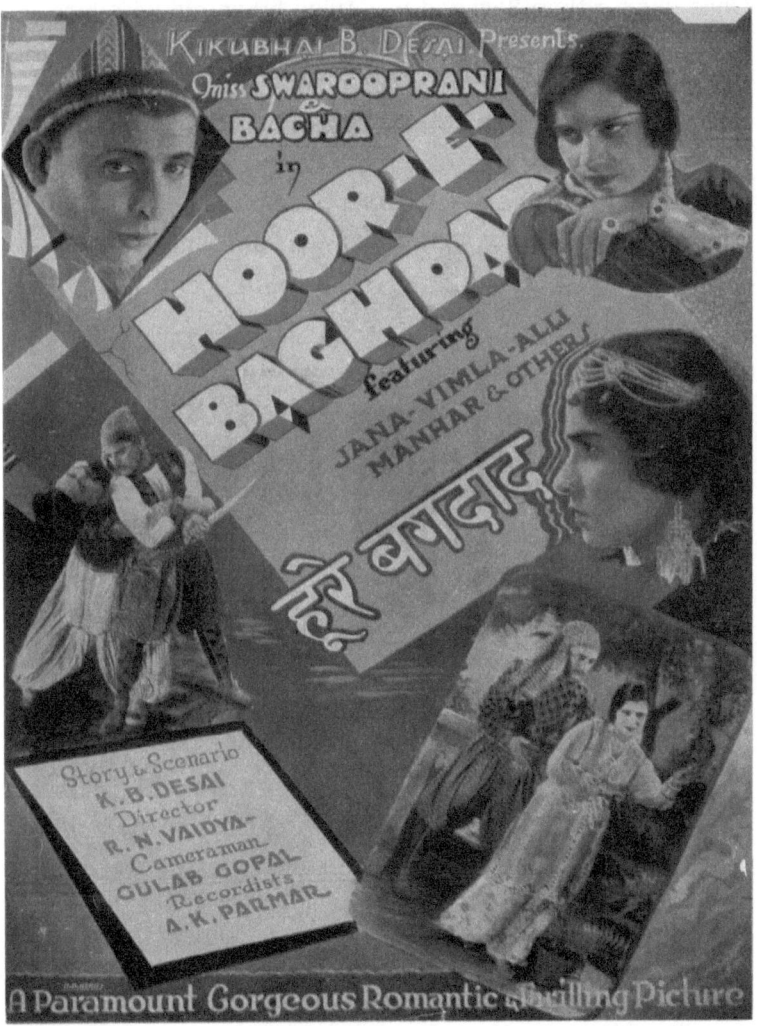

Figure 31Film Hoor-e-Baghdad booklet cover courtesy Rashid Ashraf

SYNOPSIS –

Once upon a time Baghdad was ruled by an old wise king. He was loved by all for his honesty and wisdom. He had two queens and four sons. As he grew old, he thought of giving up his responsibilities by crowning one of his sons as a successor. He wanted his predecessor to be the most efficient and ablest. He tested all of his four sons and selected the eldest one to be his successor. The younger queen was not satisfied with the king's decision. She wanted her son to be the successor.

The king called in for a special royal court of all the ministers and eminent and learned men of Baghdad to examine and select the ablest one to be his successor. There were all sorts of competitions, sword fighting, spear fighting, horse riding, wrestling and many other skills. The special court too found the eldest one to be the most efficient one to rule the kingdom, but, the younger queen does not agree to the court's decision. She insisted her son alone is the ablest and should be crowned the successor.

The king was in a dilemma. The younger queen put up a proposal. She had enormous faith in the Vazir, the chief minister, who was a very learned and wise man. He had a very beautiful daughter who was famous for her beauty and was called Hoor-e-Baghdad. The Vazir summoned all the four of them and said whosoever bring the most precious thing would be crowned as the successor and will also win the hand of Hoor-e-Baghdad in marriage. The offer was really tempting.

The four of them left in different directions, each met with different experiences and difficulties. The younger queen's son was very selfish. He kept on following the elder one as he too was confident that he was very capable. After overcoming many hurdles, the elder one enters a cave where he meets a hermit.

The hermit comes to know about what the prince was looking for. The hermit felt he was the wise and able prince to succeed the throne. He gave him a small box and told him to take it to the royal court. It contains the most precious thing.

The elder prince was tired and was taking rest under a tree for a brief time before returning to the palace. The lazy younger prince who was following the elder one found the right time to steal the box. He managed to steal and started heading to the palace. The elder prince chased him but the younger one reached the palace first and presented himself before the king and the assembly of ministers. The elder one too reached and was standing in the assembly hall.

The vazir asked the younger prince to open the box and show the king the precious thing he brought. He tried to open the box, but the box would not open. He tried hard many times but could not succeed. The wise vizir understood that the box was stolen. The box can be opened by the rightful owner of the box. The elder prince who was in the audience stepped forward and narrated the entire story. He was able to open the box and show the king what was there in the box.

The king was happy and announced him as his successor and his marriage with the vazir's daughter Hoor-e-Baghdad. He ordered the younger prince be imprisoned for his fraudulent and deceitful action. The younger prince asked for pardon. The younger queen who was witnessing the proceedings came forward and told his son – I am ashamed of such an undeserving, fraudulent and dishonest son. You do not deserve any pardon and prison is the right place for you.

Well, what was the precious thing in the box. See on the silver screen.

REVIEWS –

This movie was admired by one and all. It was a big entertainer. The movie was meant for all ages both young and old. It was this movie that established Swaroop Rani as a heroine. The role of the younger queen was appreciated by the audience when she came out against her own dishonest son. There was no mention about the music.

ISMAT - 1944

Figure 32 Film Ismat synopsis from Urdu magazine. Author's collection

Figure 33 Film Ismat cast in Urdu Author's collection

Translation

Actors – Mehtab, Nandrekar, Nargis, Ghori & Budho Advani
Story & Dialogues - - Shams Lukhnavi – Lyrics – Mr Sharma etc.
Director – S Fazli. Presented by Messrs Fazli Brothers Ltd-Bombay.

SYNOPSIS –

This is the story of two young Muslim couples. Aslam is an artist, marries Ismat from a good and traditional Muslim family. They both follow Muslim culture and tradition.

The same day another young Muslim Shafi Anwar who is accustomed to western culture and habits marries Ishrat who too like him had a taste for western culture. The story moves further with few instances of adopting different cultures. The eastern culture has been shown with great dignity and pride.

Divorce and separation one of the common evils of western culture. The bad habits, deviating from their own culture had their effects on their married life. They could not get along well and get separated. After getting separated from Shafi Anwar, Ishrat joins a theater company as a dancer. The theater company pays her a good salary due to her dancing skills. She becomes rich and famous in a short time.

Figure 34 Film Ismat Mehtab on left Nargis on right. Author's collection

Aslam goes in search of job to Bombay and was run over by Ishrat's car. He receives a head injury which makes him loose his memory to the extent he forgets his own wife Ismat. Ishrat takes care of the injured Aslam in her house. Eid (festival) had come and gone but there is no trace of Aslam. Ismat's brother finds a photo of Aslam with Ishrat in a newspaper and get separated from his sister. Ismat tries to clarify her brother's misunderstanding. He goes to Aslam, who show him the injury on his head. Ismat's brother now clear from his own mistake joins his sister.

Figure 35 Film Ismat the power of prayer from Urdu magazine. Author's collection.

Meanwhile, the doctors tell Ishrat that Aslam's memory can be restored by slowly reminding of his past. Ismat, having come to know about the whereabouts of her husband goes to Ishrat wearing a burqa (veil) and takes up a job of a servant in her house. Ismat was reminding slowly of Aslam's past which was effective, but, Ismat's closeness was unbearable to Ishrat. Ishrat removes her from service and Ismat return home.

A deeply disappointed Ismat was in total despair. She did not know what to do. An inner voice, deep inside made her sit in prayer. Her prayer had magical effect. Suddenly, there was severe thunder and lightning so intense that could make one deaf and blind. Aslam felt powerful vibrations in his entire body. Suddenly, having regained his memory, he feels himself living in a strange place. He on his own joins his wife Ismat. Ismat was overjoyed to see her husband. The story ends in a happy reunion.

REVIEWS –

Fazli Bros were one of the pioneers in producing movies on Muslim culture. They have earned a reputation in producing films on the importance of the duties of a woman in the household. The love, devotion, and care of a husband has been picturized very nicely, but, accidents, head injuries causing one to forget memory has been picturized in many movies and more and more movies have come out adapting this feature in movies. It was better if some other means could have been explored. Anwar and Ishrat as the pair who fall for the western culture, their marriage and separation have been portrayed

nicely but, it is not understood why our films always present a dark side of the western culture. In this respect Fazli Bros too, who are progressive minded too have fallen a victim. Some of the blemishes in the story have been nicely covered up by the good direction of Sibtain Fazli. Mehtab and Ghori as the couple hooked up to western culture have acted very well. Nargis as the loving and devoted wife justified her role elegantly.

JUDGEMENT OF ALLAH – 1935 (AL HILAL)

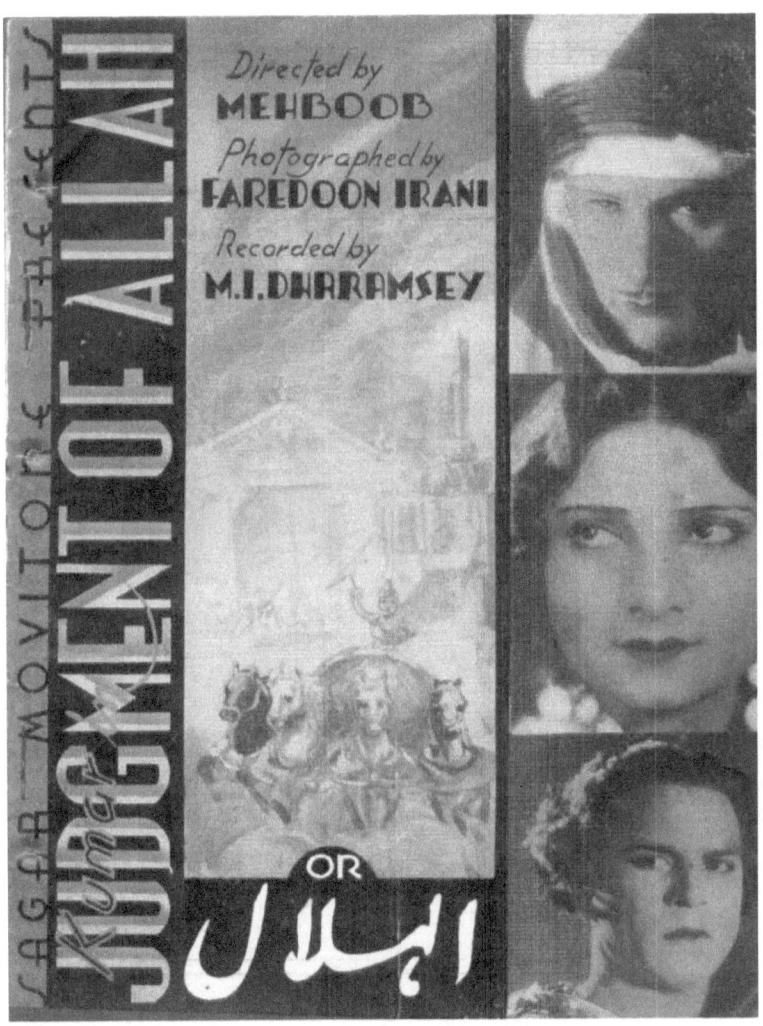

Figure 36 Judgement of Allah aka Al-Hilal booklet cover courtesy Rashid Ashraf

"Judgment of Allah."

CAST.

ZIYAD	Kumar.
RAHIL	Indira.
JULIUS	Yakub.
LEILA	Sitara.
CÆSAR	Pande.
PLUTO	Wallace.
SULTAN	Asooji.
PRINCE	Razak.
OBEID	Kayamali.
DANCER	Azurie.

Story, Scenario and Direction	**MEHBOOB.**
Chief Cameraman	**FAREDOON A. IRANI.**
Sound Engineer	**M. I. DHARAMSY.**
Settings	**RURAH MISTRY.**
Assistant Director	**LALITCHANDRA MEHTA.**
Hindi Dialogues and Songs	**MUNSHI EHSAN LUCKNOWI.**

Figure 37 Judgement of Allah aka Al-Hilal cast courtesy Rashid Ashraf

SYNOPSIS –

The history of Islam is a book of golden deeds. To keep the Islam flag flying Muhammadans have bravely faced all the sacrifices demanded by the struggle for freedom. They have faced death with smiles on their faces, protecting their sacred banner. The story of their struggle is the story of the brave people, who always keep an eye on the lofty ideals of Islam and our story is the tale of struggle between the Muhammadans and the Romans.

At the dead of night when the Muhammadans were fast asleep, the Romans pounced upon them and much blood sprinkled on the ground as a result of this defeating fight. Muslim Prince Ziyad got wounded and taking the advantage of his helpless condition, they arrest him and take him to the Roman capital. Ziyad was not only brave, but he was also handsome which drew attention of the Roman Princess Rahil. Romans celebrated their victory with plenty of wine and other pleasures, while the mighty Sultan grew anxious over his son Ziyad's disappearance. He sent his men in search of his son.

Princess Rahil was madly in love with Ziyad. She fondled this memory of love and she put her favorite maid Laila as Ziyad's guard. Laila was a Muhammadan and she all the time helped the Muslim Prince Ziyad. No one ever doubted her as she was in confidence with the Princess. Prince Ziyad wanted to send a message to his people but, he was helpless. There was no ink to write a message. Realizing this, Laila without hesitation put a sharp knife into her body and up rushed the scarlet blood, with which Ziyad wrote a message that made its way into the hands of the Muhammadans. Rahil helped Ziyad in obtaining permission to see his father under the condition that he will

return after meeting his father. The Roman spies followed him and arrested him. This time the Roman King ordered his men to throw him to the hungry lions. This brutal practice was prevalent in those days. This was something unbearable to Princess Rahil. Risking her own life Rahil saved the life of Ziyad and both eloped.

The Roman soldiers chased them. They were caught while crossing the river. Ziyad escaped but soon was wounded by the wild tribesmen. Princess Rahil was taken into custody.

The story has reached the climax. Laila, the faithful maid of Princess played a pivotal role of finding an escape route for Princess Rahil. It was Laila who with all her bravery unite both Ziyad and Rahil. They both go back to Ziyad's palace, but how all these things have picturized has to be witnessed on the silver screen.

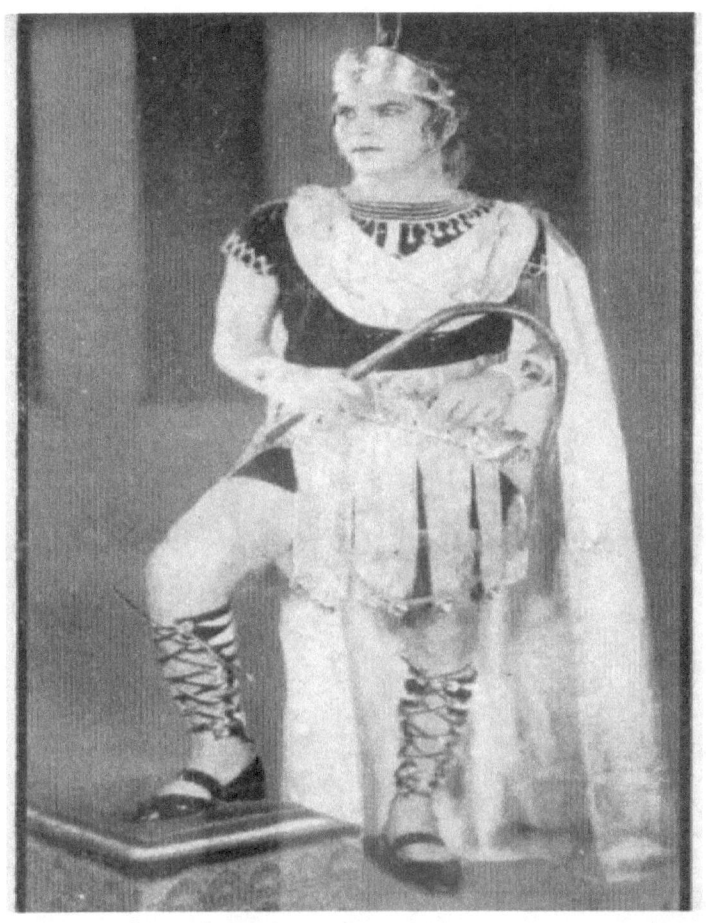
Figure 38 Yaqub in Judgement of Allah aka Al-Hilal courtesy Rashid Ashraf

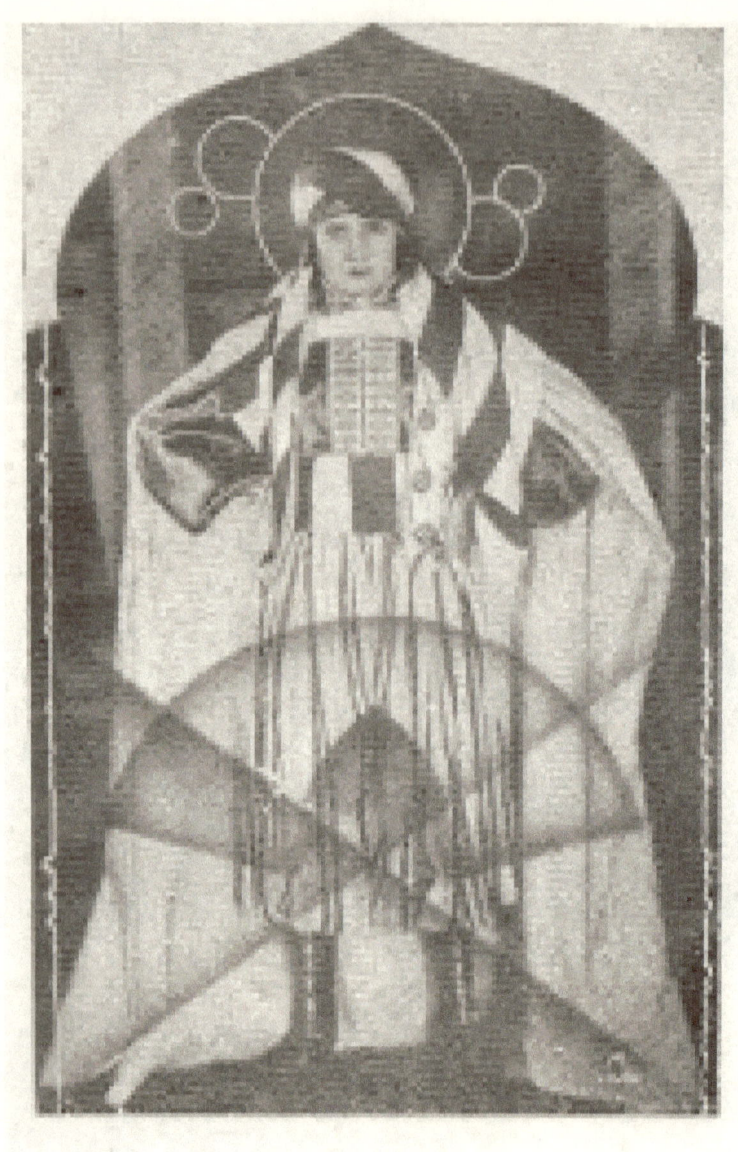

Figure 39 Kumar in film Judgement of Allah aka Al-Hilal courtesy Rashid Ashraf

Figure 40 Images from Film Judgement of Allah aka Al-Hilal courtesy Rashid Ashraf

REVIEWS –

This was the first movie by Mehboob Khan as director. This was a highly successful movie with excellent photography by Faridoon Irani. Actors Kumar, Yaqub came to limelight with this movie. The two dancing stars Sitara and Azurie also earned a big name. Nothing much was mentioned about the music.

MASOOM – 1941

INTRODUCTION –

This is the first time that the producer has given to the Indian screen an excellent portrayal of the social life of a Muslim family.

SYNOPSIS –

Noor Ali, a rich merchant becomes a widower. His loving wife pass away leaving a child Masoom to take care of. He remarries. He was fortunate as his new wife takes care of Masoom dearly. Masoom too was happy with his step mother. The step-mother had a son Jameel from her previous marriage. His arrival into their house-hold created problems to Masoom. Like any stepmother, her love and care towards Jameel became a priority while Masoom was slowly being neglected.

As time pass on Masoom and his step-brother Jameel grow up. Masoom had a childhood friend Rehana. Their friendship turns into love. Jameel on the other hand falls in love with a modern day educated girl Shahida. Their romances go through many ups and downs as usual with time and finally ends up well.

REVIEWS –

Many film magazines wrote that Fazli brothers for the first time have portrayed the Muslim household life excellently. The movie was a big hit. Mazhar Khan as Noor Ali and Ramola as Rehana stole the show. Mehtab as Begum Noor Ali and Amjad as Masoom justified their roles. Hasnain's

direction received praise. However, the reviewers felt that the photography and music failed to inspire. It could have been improved.

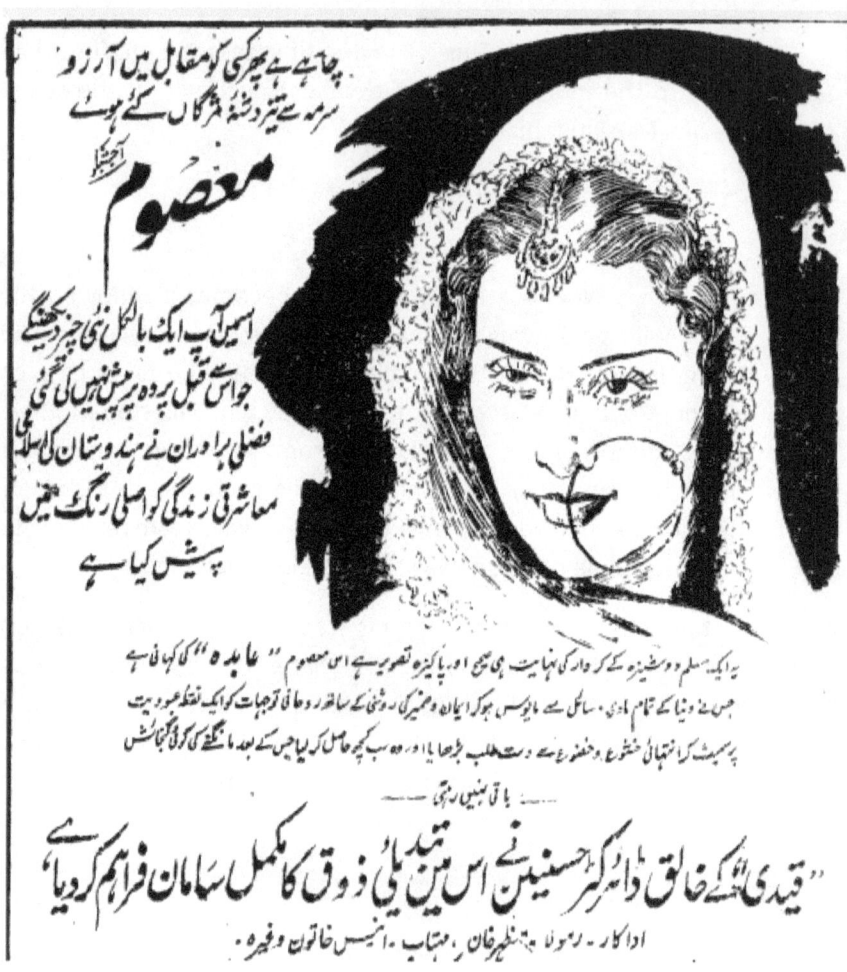

Figure 41 Film Masoom the story of Abidah from Urdu magazine. Author's collection

Translation

This is an authentic and pure picture of a Muslim maiden's character.
It is the story of the innocent Aabida who, after being disappointed
with the material lures of the world, carried the light of faith and
conscience to bring her spiritual enlightenment to a point of devotion to seek it with extreme humility and self-mortification. And she ended up gaining so much that there was nothing left to ask for.

any further.

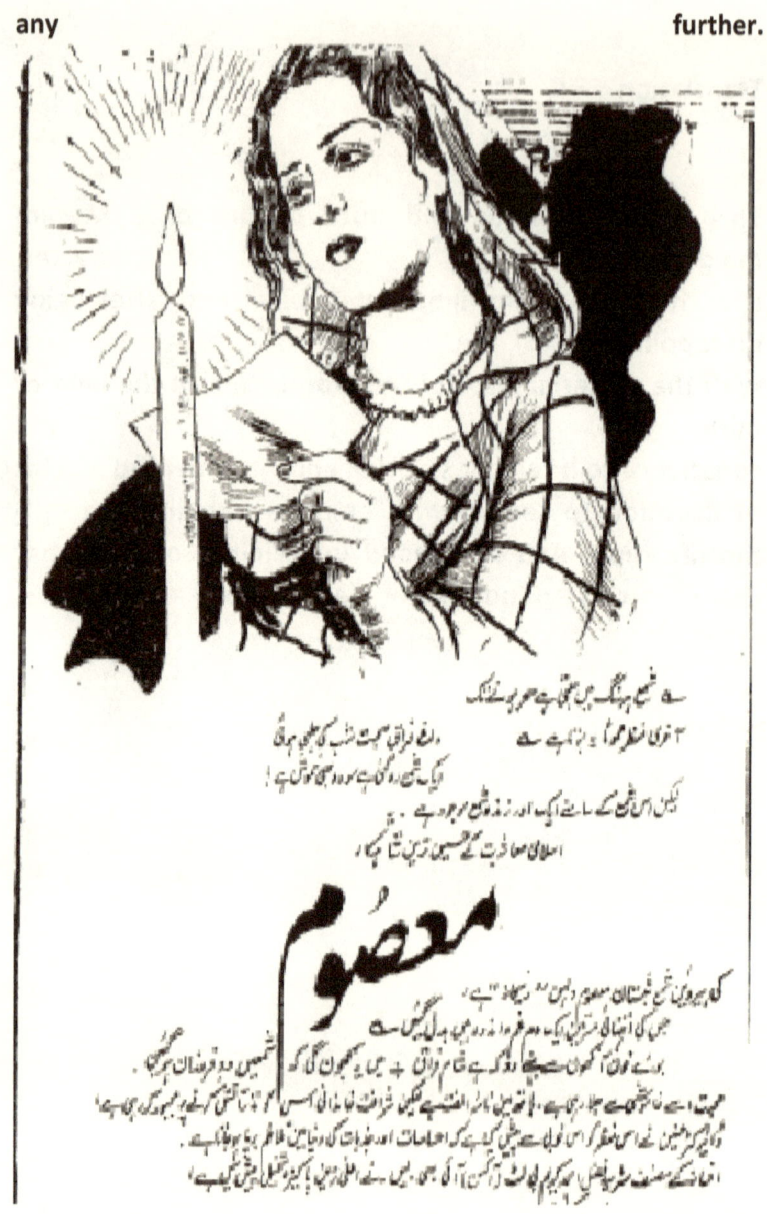

Figure 42 Film Masoom dramatization of Rehana's part played by Miss Ramola from Urdu magazine. Author's collection

MULAQAT – 1947

INTRODUCTION –

This was one of the popular Muslim social movies of the 1940's starring Naseem Banu. Efforts were made by the Tajmahal pictures to bring in Nitin Bose and Punkaj Mullik for the direction and music for this film but, unfortunately, they failed.

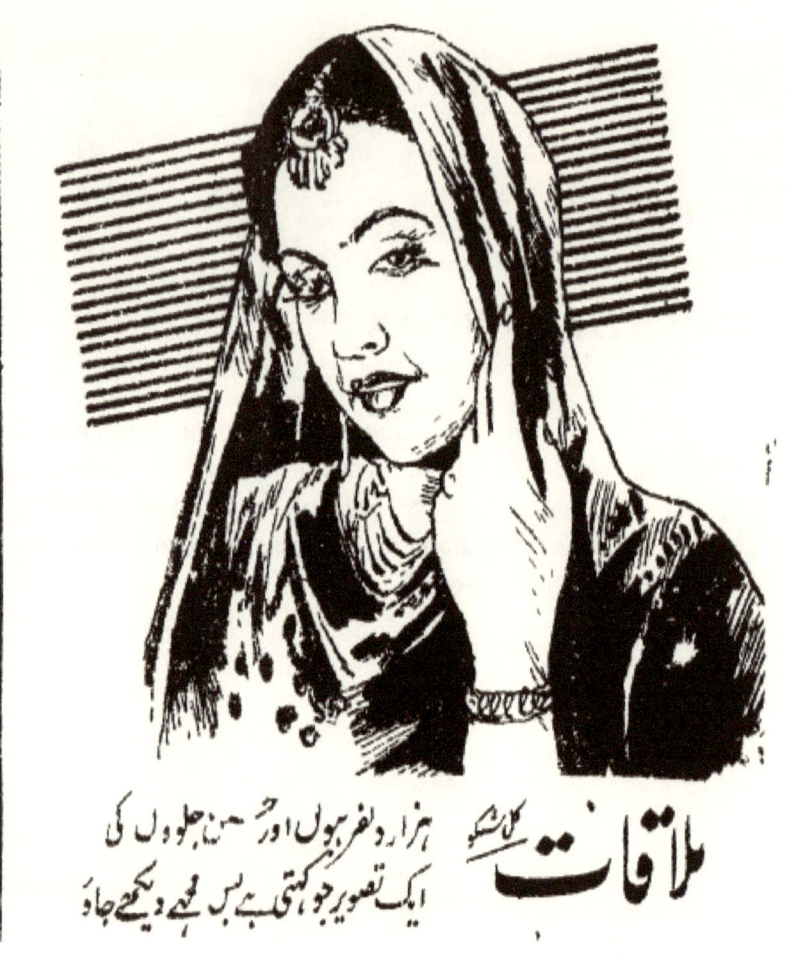

Figure 43 Naseem Banu in film Mulaqat from Urdu magazine. Author's collection

SYNOPSIS –

Nasir is a young school master. One night on his way back home he meets a young girl Saeeda. It was a love at a first sight for both Nasir and Saeeda. The inquisitive Nasir tries to find more details about her but, his efforts did not bear fruit.

Meanwhile, Saeeda loses her father. It was a very painful thing for her. She, now an orphan had to move over to her uncle and aunt's house. Things were not happy at her uncle's house. She was constantly being ill-treated by her aunt. Her uncle had not much of a say. The depressed and dejected Saeeda plans to end her life by committing suicide. She was heading on the railway track and about to jump under the train. A Nawab sahib of the town was heading that way and rescue her. On finding about her domestic circumstances he takes her home. She was accommodated in his palatial mansion. He assured her of full security and safety. Nawab Saheb had a school going daughter Shaukat, who was a student of Nasir in the same school. Through Shaukat, Nasir gets in touch with Saeeda. Nawab sahib had a son Mukarram, a vagabond and a drunkard. He returns asking his father to pardon him. He promises Nawab sahib of his repentance from his bad habits and becoming a good man. Mukarram joins the household. The renewed contacts between Nasir and Saeeda develops into an inseparable love. They thought of getting married.

Mukarram was trying to get closer to Saeeda. He was mad of her. He expresses his desire to marry Saeeda for which Nawab Sahib asks for the consent of Saeeda. Saeeda, under the obligation of Nawab sahib was unable to refuse. Nawab sahib arranges Saeeda's marriage with Mukarram. The day before marriage the police arrest Mukarram in connection with a murder committed by him. Nawab sahib substitutes Nasir as bridegroom. Saeeda is married to Nasir.

REVIEWS –

This was a good Muslim social which was appreciated the way it was presented on the screen. The portrayal of the Muslim household, the greetings, manners, the decor and other customs were shown in detail. Naseem Banu in the role of Saeeda was the main attraction of the movie. The versatile actress with her vast experience acted the role with grace and charm. Prem Adeeb as Nasir played his role well. He was quite elegant, and his dialogue rendition in Urdu was perfect. Rama Shukla as Makarram, the villain was perfect as an alcoholic vagabond. Shah Nawaz the seasoned actor of character roles played the role of Nawab Sahib with dignity. Mumtaz Ali gave a couple of good dances. The dialogues were in refined Urdu. The music by Khemchand Prakash was moderate. Overall, it was a good Muslim social.

Figure 44 Film Mulaqat House Full, from Urdu magazine. Author's collection

The movie drew huge crowds for few weeks. Movie lovers were disappointed as they had to make couple of trips to watch the movie.

MUMTAZ BEGUM – 1934

Figure 45 Film Mumtaz Begum booklet cover courtesy Rashid Ashraf

MORAL –
Truth prevails. Evil doers are destroyed by God.

SYNOPSIS –

Col Mustafa, a commandant of a regiment had a beautiful and intelligent daughter by name Mumtaz. She travelled to England to pursue higher studies. Capt Baig and Lt Rashid were two junior officers under Col Mustafa who were sent to England for training in armaments.

After completing her studies Mumtaz was returning to India by ship. Capt. Baig and Lt Rashid too were returning in the same ship on completing their training. Mumtaz was happy to be in the company of the two officers who were well known to her father.

Mumtaz had a keen eye. She noticed Capt. Baig was a well-mannered young man. He was very polite and courteous at the dining table. On the other hand, Lt Rashid was a bit rough in his ways and always boasted of his achievements. Capt. Baig's, handsome looks, robust physique coupled with humble nature made Mumtaz to have special feelings for him. Lt Rashid noticed this in Mumtaz's behavior. This made him jealous of Capt. Baig.

The ship which was sailing comfortably was suddenly caught in a very bad cyclone. There was panic everywhere, hue and cry. The ship wreck brought many of them ashore. Mumtaz was safe but unconscious due to an injury to her forehead. Capt. Baig pulled her to safety, bandaged her forehead and nursed her. Lt. Rashid took advantage of the situation. He asked Capt. Baig to have rest for a while and will look after Mumtaz.

When Mumtaz regained conscious Lt Rashid told her that he saved and took care of her. Mumtaz did believe it for a while but, deep inside her conscience she felt Lt Rashid was deceitful.

Lt Rashid understands that his cunning plan had failed to win the heart of Mumtaz. Capt. Baig continued to be in the good books of Mumtaz

Lt Rashid approaches Col Mustafa and narrates a heroic story of saving his daughter. Col Mustafa was greatly pleased and arranges a big party in honor of Lt Rashid. The party was in full swing when Lt Rashid observed that Mumtaz was talking and smiling at Capt. Baig and did not even care to look at him. Lt Rashid was enraged at this and asked Capt. Baig to come out of the party and challenged him in a duel. Capt Baig punched him so hard that he fell to the ground with a big mark on his forehead. The insult was much more severe when he noticed Mumtaz was keeping a watch at the duel behind the window curtain.

The embarrassed Lt Rashid excited the Col Mustafa family with a story against Capt. Baig. He later kills Asghar, son of Col Mustafa. Lt Rashid was arrested and imprisoned. He managed to escape from the prison, lives a miserable life for some time and dies. The Almighty decides the right time of punishing an individual according to his deeds.

There was an intrusion on the countries border, causing large scale arson and loot. Thousands of innocent villagers were affected. Col Mastafa's regiment was pressed into service. Capt. Baig along with his team takes a lead role and drive away the enemy. Mumtaz accompany the army and helps the villagers in rehabilitation work. A friend of Col Mustafa reveals the murder mystery of Asghar. Mumtaz marries Capt. Baig and become Mumtaz Begum. They lead a happy life.

MUSLIM KA LAL – 1941

INTRODUCTION –

This was a historical movie. The story dates to 13th century. The Tatars invaded and occupied a vast area of the middle-east.

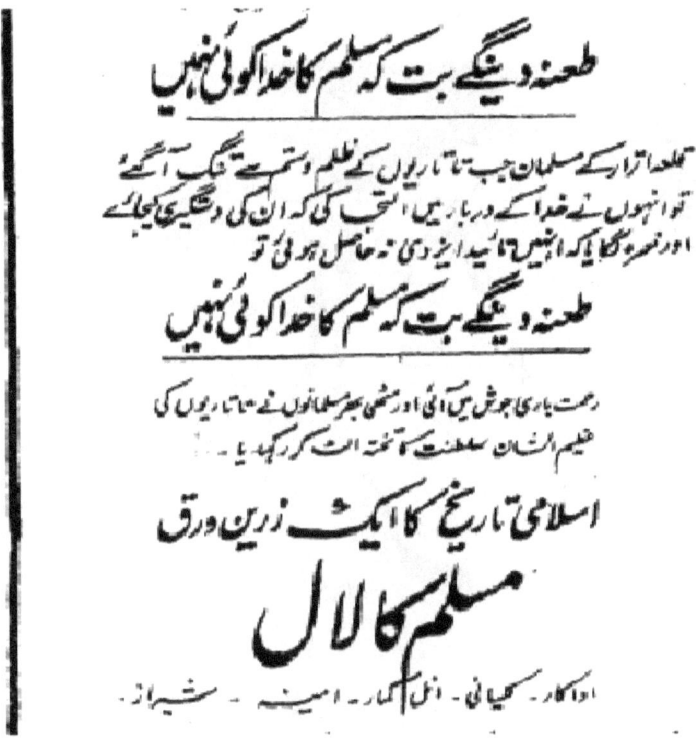

Figure 46 Film Muslim ka Lal from Urdu magazine. Author's collection

TRANSLATION

When Muslims of Fort Atraar were vexed with the tyranny and oppression of the Tatars, they all prayed at the house of God for help and vowed to drive away the Tatarians with all their courage, spirit and fighting ability with the slogan –

Taana denge but ke Muslim ka Khauda koi nahin

The idols would taunt that a Muslim has no God.

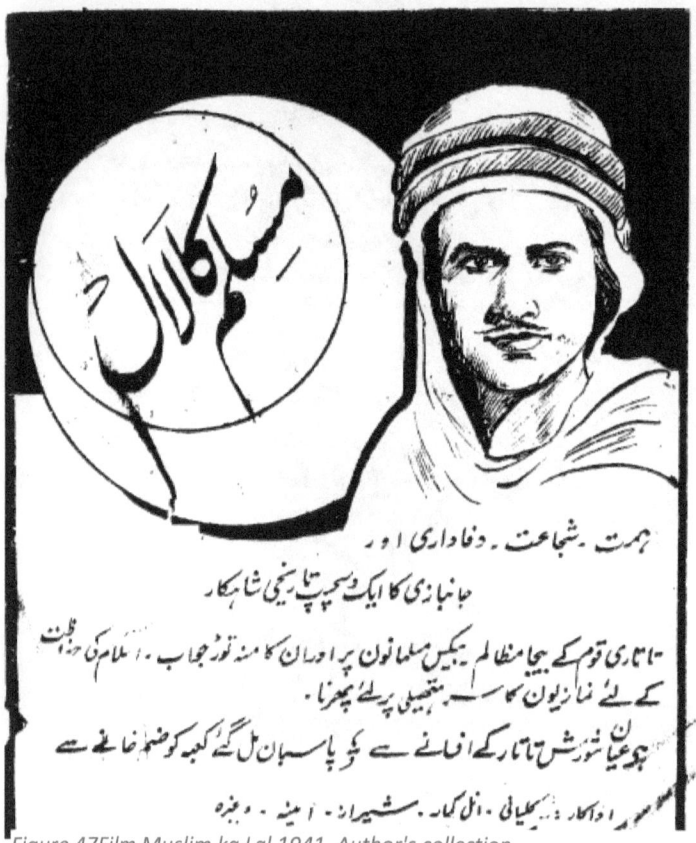

Figure 47 Film Muslim ka Lal 1941. Author's collection

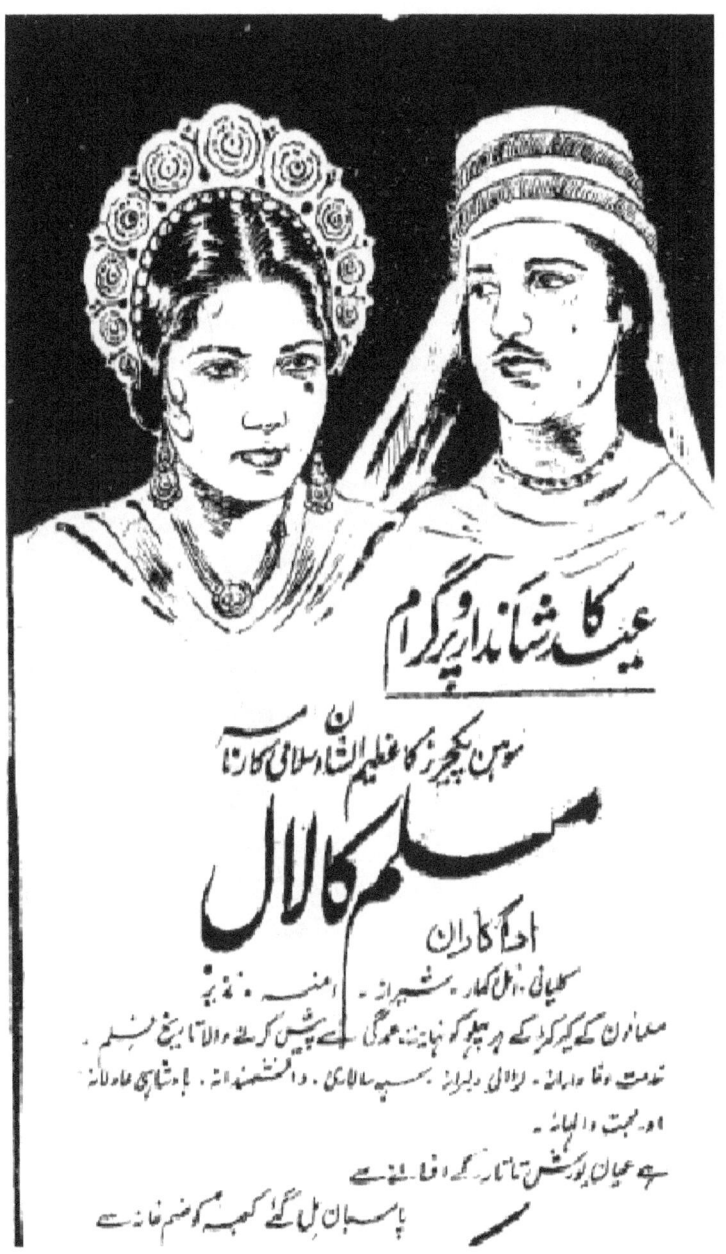

Figure 48 Film Muslim ka Lal from Urdu magazine. Author's collection

Hay ayaan shorish-e-tatar kay afsaanay say, pasban mill gaye Kaabay ko sanam-khanay say

TRANSLATION

As the Tatars had invaded and created one of the largest assaults of history on the Muslim country, later they themselves turned into Islam and became representative of Muslims.

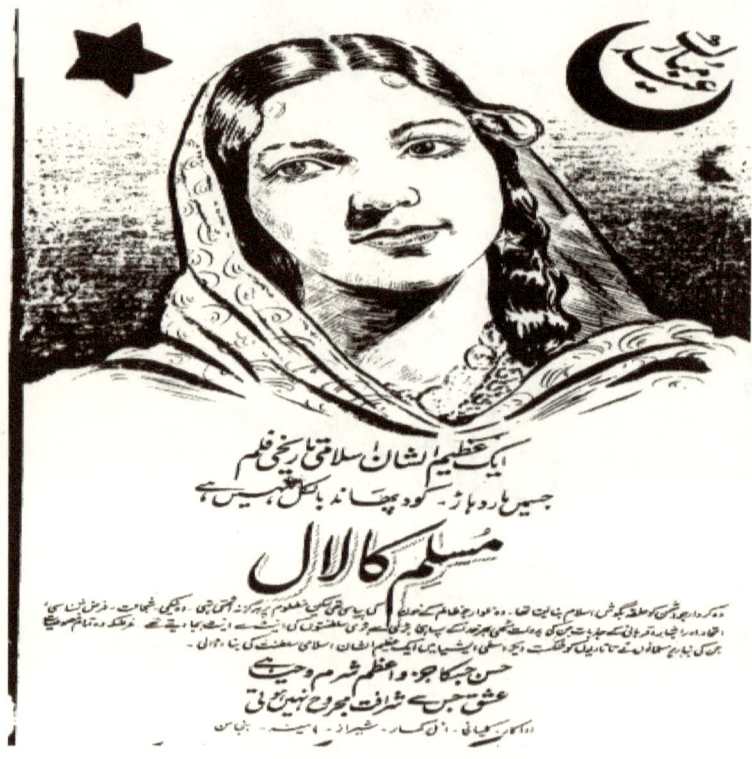

Figure 49 Film Muslim ka Lal from Urdu magazine. Author's collection

THEME –

The story of Muslim ka Lal is based on the siege of Baghdad by the Tatar- Mongol rulers under the leadership of Hulagu Khan. They destroyed the palaces, mosques, libraries, looted gold, silver, precious things and brutally massacred over 90,000 residents. The atrocities were inhuman. The residents endured bravely for some time. They later collectively planned to fight the brutal Tatars. A handful of brave Muslims decided to wage a mighty war against the Tatars who were 10 times larger in number. They all gathered at a holy shrine and prayed for help. Their prayers were earnest, sincere and full of humility. Their prayers were answered. They fought the Tatars with full might and determination and finally drove them out. Later, in a strange development the Tatars accepted Islam and became the guardians of Ka'ba.

REVIEWS –

Muslim ka Lal was one of the most popular movies produced by Mohan pictures. The historical movie about the Tatars taking control of Baghdad was released on the day of Eid Ul Fitar (Ramadan) 22 October 1941. The theaters were fully packed for the first two weeks at major metropolitan cities. This was a small budget movie that turned out to be a big success. Miss Kalyani the singing star played the lead role singing couple of delightful ghazals.

PAAK DAAMAN – 1940 AKA SHAHEED NAAZ

INTRODUCTION –

This was a popular stage drama of the early 1900's. There were many versions of the story with small variations. The Parsi Urdu theater was penned by Late **Agha Hashar Kashmiri**, famously known as the Shakespeare of India. The Parsi Gujrati plays were written by various authors. **Syed Yawar Ali**, a student of **Dagh Dehilv**i penned the script for the Moon Parsi theater. The Alfred drama company had their own version of the story.

Paak Daaman produced in 1931 starring **Miss Rampyari** and **Hyder Shah** was based on a Gujrati play. **Paak Daaman** of 1940 was penned by Late **Agha Hashar Kashmiri** for the Parsi Urdu theater. This was a small budget movie with not so popular star cast.

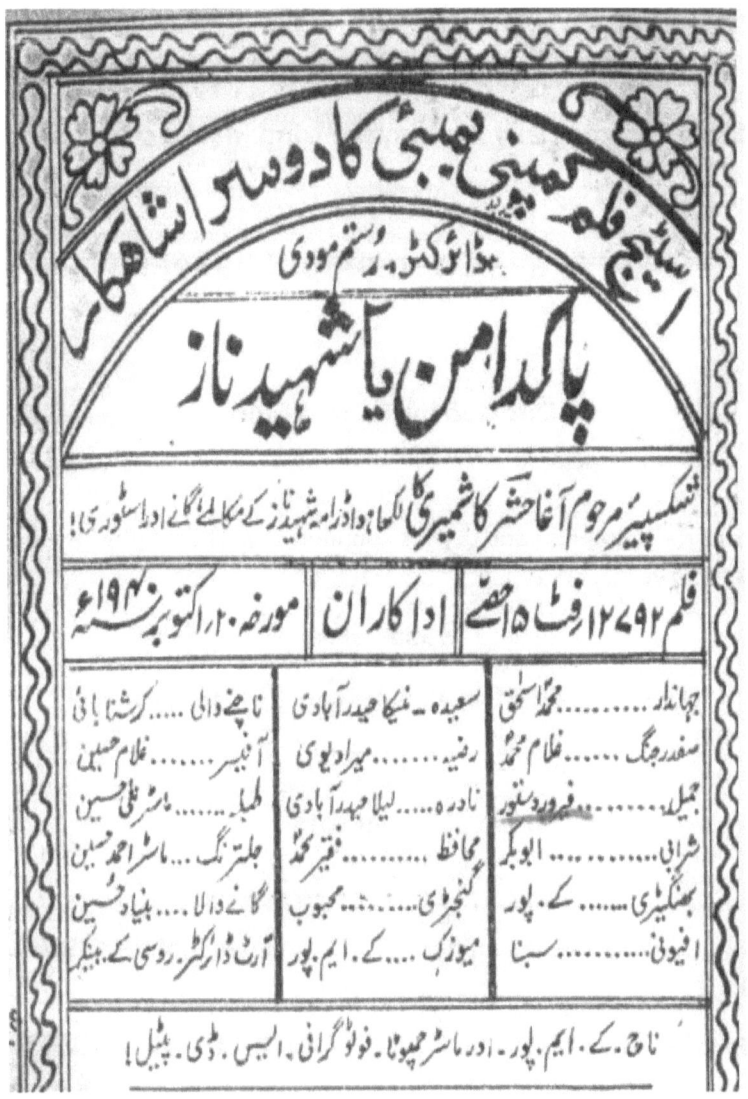

Figure 50 Paak Daaman Urdu script courtesy Rashid Asraf

TRANSLATION

Stage film company Bombay's second Master piece

Paak Daaman or Shaheed Naaz

Directed by Rustom Modi

Story, Dialogues and Lyrics penned by Late Agha Hashar Kashmiri

The Shakespeare

Film 12792 feet 15 parts dated 20th October 1940

Actors

Mohd Ishaq - as Jahaandar. Jung	Ghulam Mohd - as Safdar
Feroze Dastur - as Jameel.	Abu Bakar - as Drunkard
K pawar - as Bhangedi	Sonba - as Afyumi
Maneka Hyderabadi – as Sayeeda	Meera Devi – as Razia
Leela Hyderabadi – as Naadira	Faqir Mohd – as Guardian
Mehboob – as Baldy Director	KM Pawar – Music

Krshna Bai – Dancer Officer

Ghulam Hussain – as

Master Ali Hussain – Tabla Jaltarang

Master Ahmed Hussain -

Buniyad Hussain – Singer Banker

Art Director – Rusi K

Dances by KM Pawar & Master Chota, Patel

Photography – SD

SYNOPSIS –

Once upon a time there was a baadshah (king) by name Jahaandaar. He was a noble and honest ruler. He had the habit of go-round the city dressed as a faqir to find out the welfare of his people. He did not want his absent felt. So, in his absence he made one of his close courtier Safdar Jung to occupy his place. Safdar Jung was a cruel and an immoral person. He deserted his wife Naadira and did not take care of her.

A young and handsome man Jameel living in the same city was in love with a young girl Razia. They became very intimate but, suddenly Jameel abandoned her. Razia was disappointed and waited for many days for his return, but that did not happen. She approached Safdar Jung with an appeal that Jameel outraged her modesty and is absconding. On the orders of Safdar Jung Jameel was apprehended and imprisoned. Later, Safdar Jung ordered his execution.

Jameel had a sister Saeeda, a breath-taking beauty. On seeing her Jameel broke down and asked her help. She approached Safdar Jung with a plea that her brother did not commit any grave crime. These incidents are common with young and

innocent hearts. It is better for the king to order that they should marry and settle down in life. She requested that Jameel's execution be stayed. Safdar Jung was dumbfound at the beauty of Saeeda. He was willing to help if she could entertain and spend a night with him.

Saeeda rebuked at this proposal. She offered to part with all her wealth for the release of her brother Jameel but, not at the expense of her chastity and modesty. Safdar Jung asked her to think over and get back to him. Jameel comes to know about this and request his sister to accept Safdar Jung's proposal. Saeeda became furious, she shouted, shame on such a brother. I would rather prefer die but cannot afford blemish on my chastity.

Saeeda was deeply frustrated at the developments. On her way home an old faqir asked her for alms. He appeared to be a very pious man, a man of bright countenance. She, for some strange reason felt like telling him everything which was going on in her mind. The faqir asked her, daughter, you look very perturbed. Let me know what your problem is. I shall feel happy if I can be of some help. Saeeda poured out the entire story to faqir.

The faqir took Saeeda into confidence by letting her know his identity. He asked her to find out the whereabouts of Naadira, the estranged wife of Safdar Jung and bring her. Naadira was traced and brought before the faqir. The faqir planned the plot to corner and expose safdar Jung of his evil plans.

As planned Saeeda goes to Safdar Jung and tells him that she is willing to please and entertain him but requested that there will be no lamps or candles in the room. The room needs to be totally dark. Her proposal was acceptable to Safdar Jung. In the dark of the night Naadira enters Safdar Jung's chamber wearing a veil, entertain him with wine and fulfills his lust. Safdar Jung

was pleased and in a state of intoxication he thinks it was Saeeda who pleased him.

The next morning Saeeda stood before Safdar Jung for the release of her brother Jameel. Naadira steps forward along with her. Naadira's presence was unbearable to Safdar Jung. Why are you here? Asked Safdar Jung. Naadira tells him that it was she who entertained him last night. There was a commotion in the durbar. The faqir, who was present in the audience steps forward and took off his wig in front of the audience. The faqir was none other than the king. All cheered at the king. The king explained the plight of Saeeda and Safdar Jung's evil plans. It was the king who exchanged the ladies.

What happened next is anybody's guess – Will Safdar Jung be punished for his misdeeds? Will Jameel be released and united with Razia? Will Naadira get united with her husband? All these needs to be seen on the silver screen.

REVIEWS –

The small budget movie proved great at the box office. The movie was appreciated for its story and the way it was presented on the screen. The movie was a great entertainer for the old timers who had seen this as a Parsi theater drama. The movie had good dances and great music.

Maneka Hyderabadi and Leela Hyderabadi were stage actresses of the Parsi Urdu theater in the 1930's. They had played their roles several times on stage and knew all their dialogues byheart. They had played small roles in films but went unnoticed.

PEHLI NAZAR - 1945

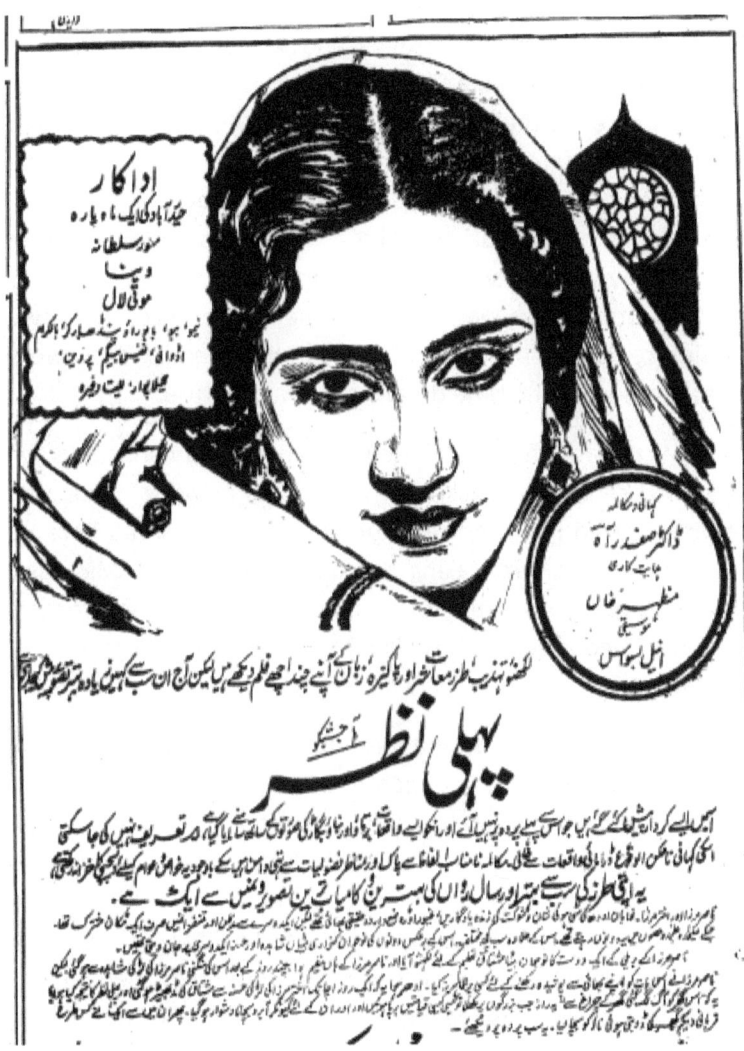

Figure 51 Film Pehli Nazar synopsis from Urdu magazine. Author's collection

SYNOPSIS –

 This is the story of Mirza brothers of Lucknow and their daughters. Nasir Mirza and Akhtar Mirza were own brothers of a respectable family of Lucknow. They were happily living together in their big haveli. Suddenly something sparked between their families and they separated. The mansion was partitioned. The two brothers became neighbors. Nasir Mirza had a daughter Shahida and Akhtar Mirza too had a daughter Husna. They were bosom friends from their childhood. Despite the two brother's separation and their differences, the two cousins remained bosom and inseparable friends. They were together most of the time dreaming of their future.

Nasir Mirza had a friend in Bareli. His young and handsome son Mushtaq came to Lucknow for higher studies and was accommodated in his house. During his stay Mushtaq became friendly with Shahida. Taking this opportunity, Nasir Mirza got him engaged to his daughter Shahida. Since, the two brothers were not in good terms, he asked the matter to be kept in strict confidence.

Strange occurrences do happen in life. One day Mushtaq happen to see Husna, the daughter of Akhtar Mirza. It was a co-incidence that Husna too had seen Mushtaq at the same time. A feeling of intense love developed in both. They both started dreaming of each other. Mushtaq became so mad of Husna that he decided to break his engagement with Shahida. This incident created an ugly scene in Nasir Mirza's household. Shahida was deeply upset. She was feeling guilty all the time for not letting Husna know about her engagement with Mushtaq.

The matter soon spreads like fire in Akhtar Mirza's household. Husna, on learning about Shahida's engagement with Mushtaq was perturbed. She felt responsible for breaking up their engagement. For Akhtar Mirza, nothing was more important than the respect and honor of the house, Husna was afraid her father may kill himself rather suffer humiliation. She silently consumes poison and end her life. The two brothers were deeply moved for the terrible loss of Husna, they realize their mistake and forget their bitterness. Mushtaq marries Shahida.

Figure 52 Nasir Mirza in film Pehli Nazar from Urdu magazine Author's collection

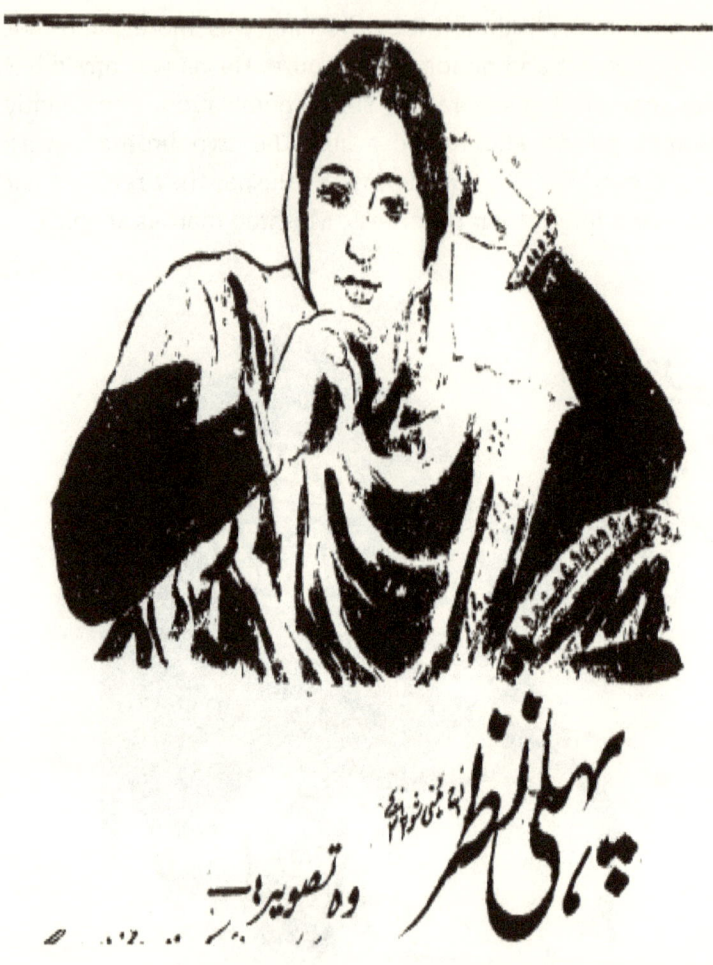

Figure 53 Begum Mirza in film Pehli nazar from Urdu magazine. Author's collection

Figure 54 Veena in film Pehli Nazar fron Urdu magazine. Author's collection

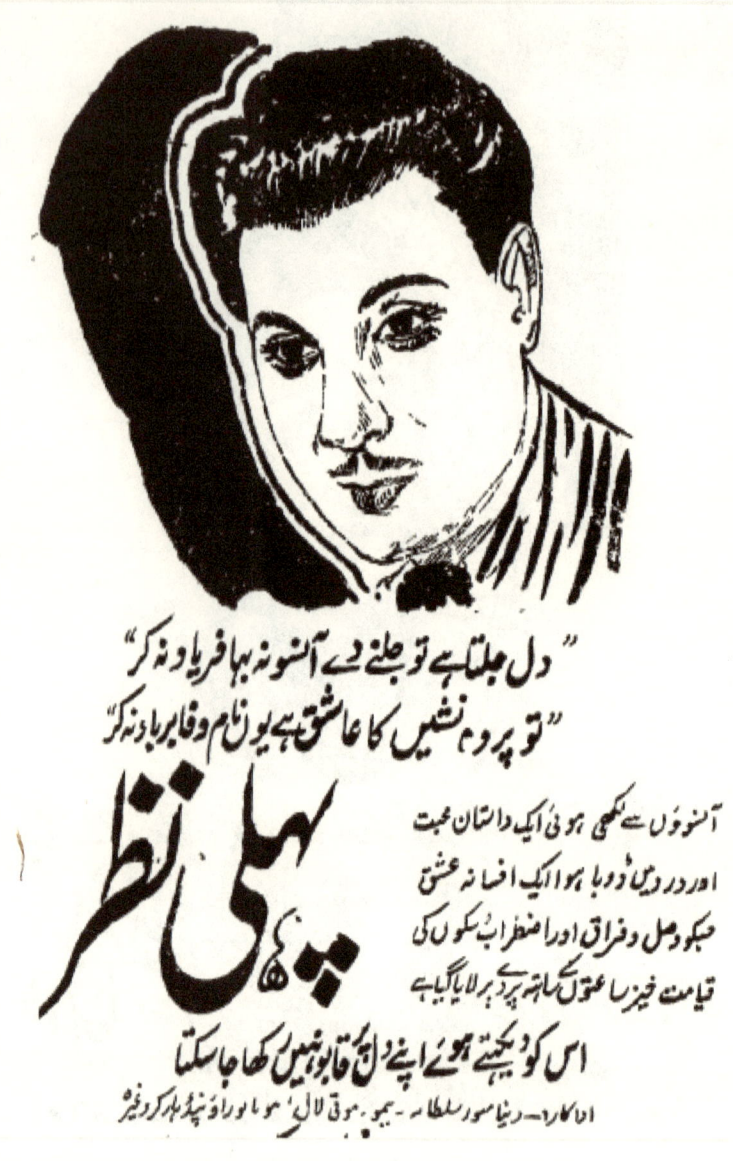

Figure 55 Film Pehli Nazar describing the song dil jalta hai to jalne de. Author's collection from Urdu magazine

REVIEWS –

Many newspapers and movie magazines praised the movie. Some of them felt that the tragic death of Husna could have been avoided, Pehli Nazar was one of the most popular movies depicting Muslim culture. The storyline, dialogues and lyrics in refined Urdu language of Lucknow and the melodious music made this movie a memorable one. Motilal and Munawwar Sultana were at their best. Mazhar Khan's able direction, Dialogues and lyrics by Safdar Aah and music by Anil Biawas were the highlights of the movie.

PHOOL – 1945

Figure 56 Film Phool a story of enduring love, bravery and loyalty from Urdu magazine. Author's collection

Film Phool a story of enduring love, bravery and faithfulness. Image from an Urdu magazine – Author's collection.

INTRODUCTION –

Service to community is service to God. Fulfilment of a commitment for the cause of community are the two important features of this movie.

SYNOPSIS –

The story revolves around a Muslim family and its surroundings. Safdar and Akhtar are two brothers. Safdar is a deeply religious person who wanted to build a mosque. He has a beautiful daughter Shama, like her father she was a devout Muslim. Akhtar is a lazy person, but his wife is arrogant and ill-tempered. They have two sons Zahid and Sharif. Zahid, like his mother is stupid and ill-tempered. They have a nephew Salim, who is a medical doctor. Salim and Shama are in love with each other. Safdar wants her daughter Shama is married to Salim but, Akhtar's wife is scheming to get Shama married to her good for nothing son Zahid. Salim has a Hindu sister Rekha, nothing much is known about her family. Both Shama and Rekha are bosom and inseparable friends.

The marriage between Salim and Shama was scheduled. On the day of the marriage Salim suddenly reminded of his duty to the community and join the khilafat movement in the Balkans. Before leaving he presents Shama with a flower. Heart-broken, Safdar dies without completing building a mosque. Shama feels deserted and finds comfort in the company of Rekha. Shama is determined to complete the mosque left unfinished by her father.

In the Balkans a dancer Laila falls in love with Salim. Finding Salim indifferent she takes the help of a hakeem and drugs him.

Salim gets amnesia and forgets his past. Salim falls a prey to Laila's plans and goes along with her dancing on the stage. Laila was touring various countries conducting her dance shows and Salim simply followed her. Laila finally reach India and was performing dance shows at major cities. At one of the Salim was spotted by the family members. He was taken home, but to their great dismay Salim fails to recognize Shama.

Shama was deeply upset when Salim failed to recognize her. Akhtar's wife succeeds in getting Shama's consent of marrying Zahid by offering her to complete the mosque which was left unfinished. Sharif did not like the way Shama was convinced to marry Zahid using mosque as a leverage.

Salim falls on the stage and injures his head. He suddenly recovers from his amnesia, remembers his past and spots all his family members. Salim and Shama gets united. In a strange development Zahid, the villain was struck down by lightning and killed near the mosque.

REVIEWS –

The reviews were great. Filmindia, the leading film magazine in English wrote the following – Director K Asif hits the headlines in Phool. Picture draws huge crowds at Roxy. Twenty-three-year-old K Asif is easily the youngest director in India. In his very first assignment 'Phool 'Asif had hit the headlines with a melodramatic vengeance that has compelled senior directors to look for their laurels. The production values are excellent. The dialogues are beautifully written, perhaps the best Kamal Amrohi has given so far. The music by Ghulam Haider is however, is very poor. He is too jazzy throughout. The most surprising aspect of the movie is the good direction of K Asif.

From the players Yaqub gives an excellent performance in the role of Sharif. Prithviraj looks dignified in the role of Salim. From the girls Sitara gives the best dance of her career on the screen. It is a beautiful bit, correct in interpretation of the Kathak school. Veena does not particularly attract in the role of Shama. Suraiya is steadily coming up. She has a sympathetic role of a Hindu sister of a Muslim hero. Durga Khote does her usual best as the shrew of the story. In any case Phool is a good picture to see.

Most film magazines and newspapers in Urdu praised the movie, it also mentioned that this was the first time in the history of Indian cinema 14 famous stars acted together in a movie. The movie had excellent dances by Sitara Devi. The inclusion of a Hindu character in the movie was very much appreciated by the public. A reviewer wrote that it was the dream of Emperor Akbar that both Hindu and Muslim communities live in harmony. K. Asif had rightly taken this idea and included in the movie.

Of the two leading ladies Suraiya had a longer role as Rekha, the Hindu sister of Salim. She rendered couple of solos and a duet with Amir Bai Karnataki. Veena as Shama had a very limited role.

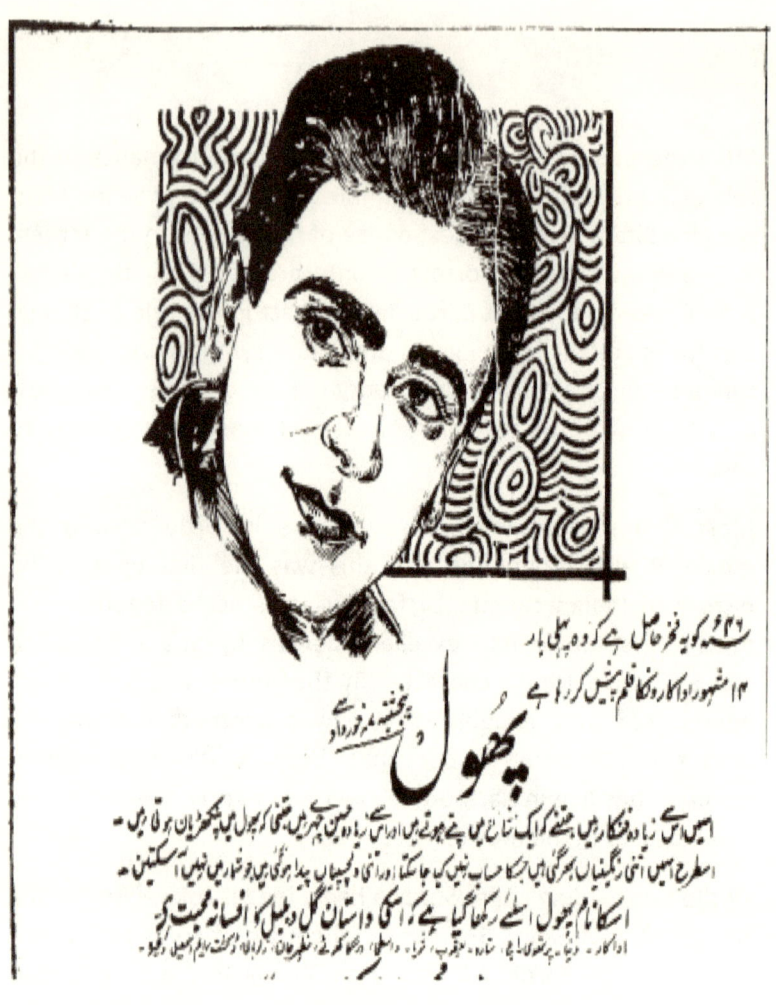

Figure 57 Prithviraj Kapoor as Salim in film Phool from Urdu magazine. Author's collection

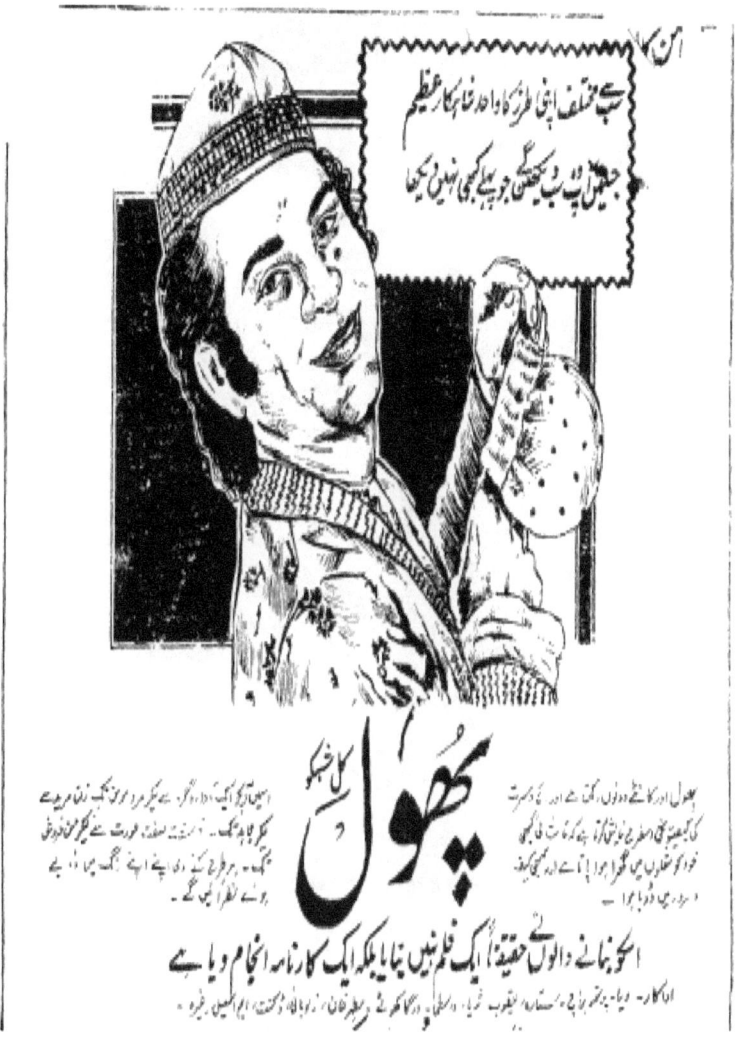

Figure 58 Film Phool Yaqub as Afsar from Urdu magazine. Author's collection

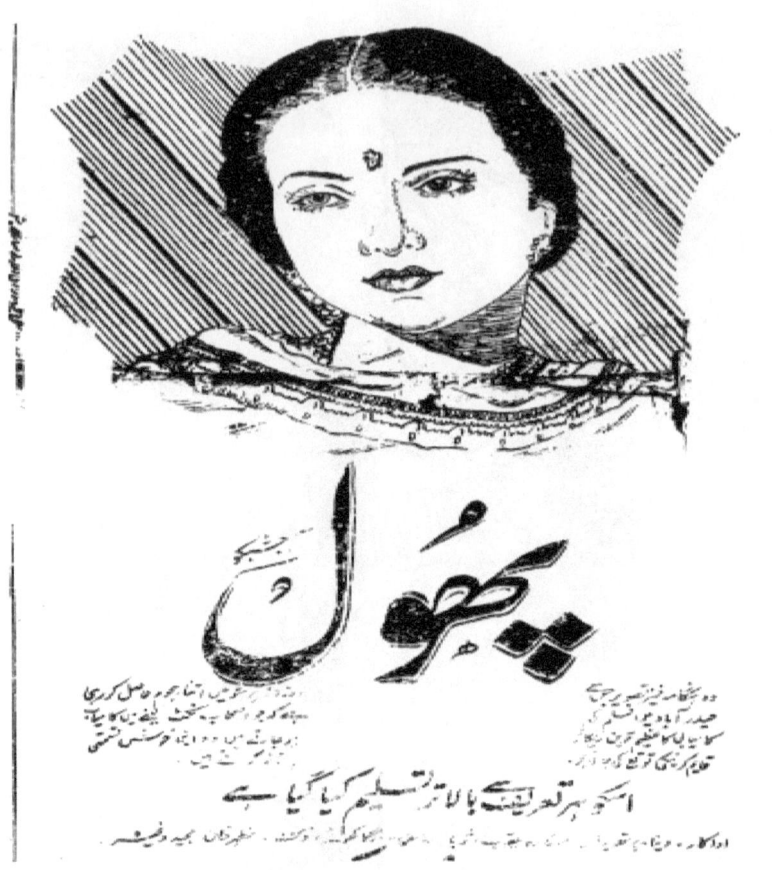

Figure 59 Film Phool Suraiya as Rekha from Urdu magazine. Author's collection

CORRECTION –

The article K Asif's Phool a reminiscence of the khilafat movement in my book Music and Arts in Hyderabad Deccan the

characters of the actors need to be corrected as follows. Veena the heroine as Shama, Suraiya as Rekha and Yaqub as Afsar. The author apologizes for the mistake.

QAIDI – 1940 (MUFLISI KA SHIKAAR)

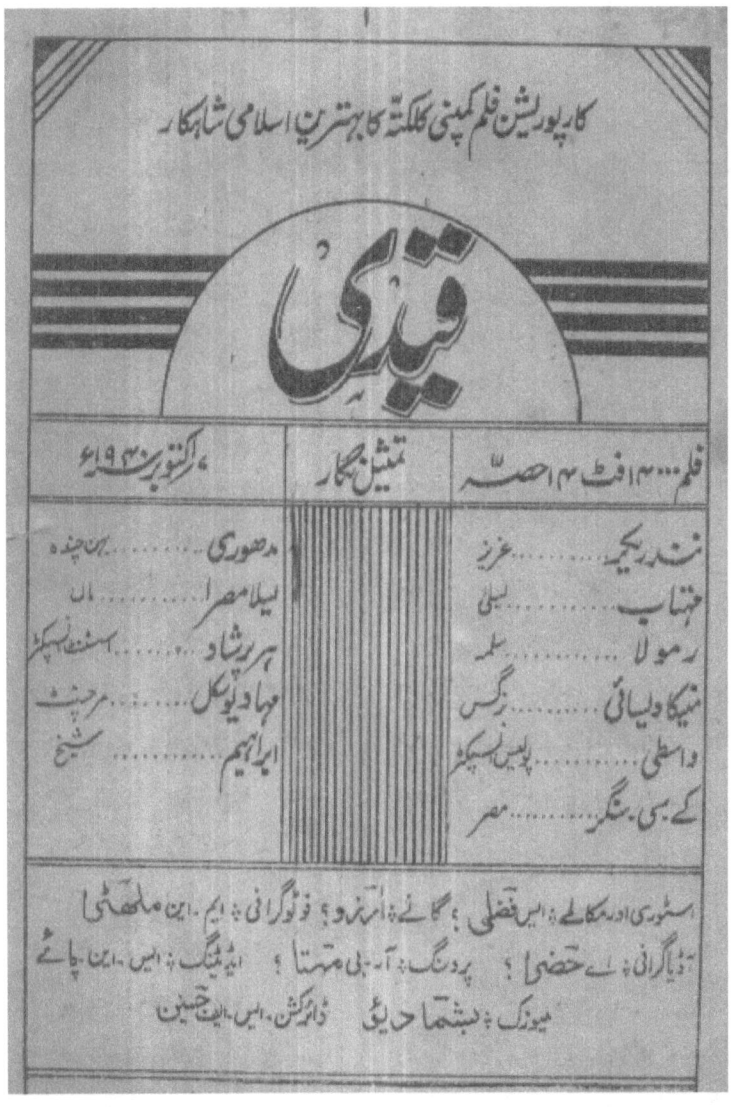

Figure 60 Film Qaidi Urdu script from Lahore courtesy Rashid Ashraf

TRANSLATION

Corporation film company Calcutta's best Islamic master piece

Qaidi

Film – 14000 feet 14 Reels

Actors

Nandrekar -- Aziz Chanda Madhuri – Sister

Mehtab ---- Laila Mother Leela Misra --

Ramola ----- Salma Assistant Inspector Harprasad --

Monica Desai - Nargis Merchant Mahadev Sakal --

Wasti - - - - -- - Inspector Ibrahim - - - -- Sheikh

KC Singar - - - Misr

Story-Dialogues S Fazli , Lyrics – Arzoo, Photography-MN Mulhati

Audiography – A Hazra, Processing - RB Mehta, Editing - SN Pai

Music – Bhishm Dev Direction - SF Hasnain

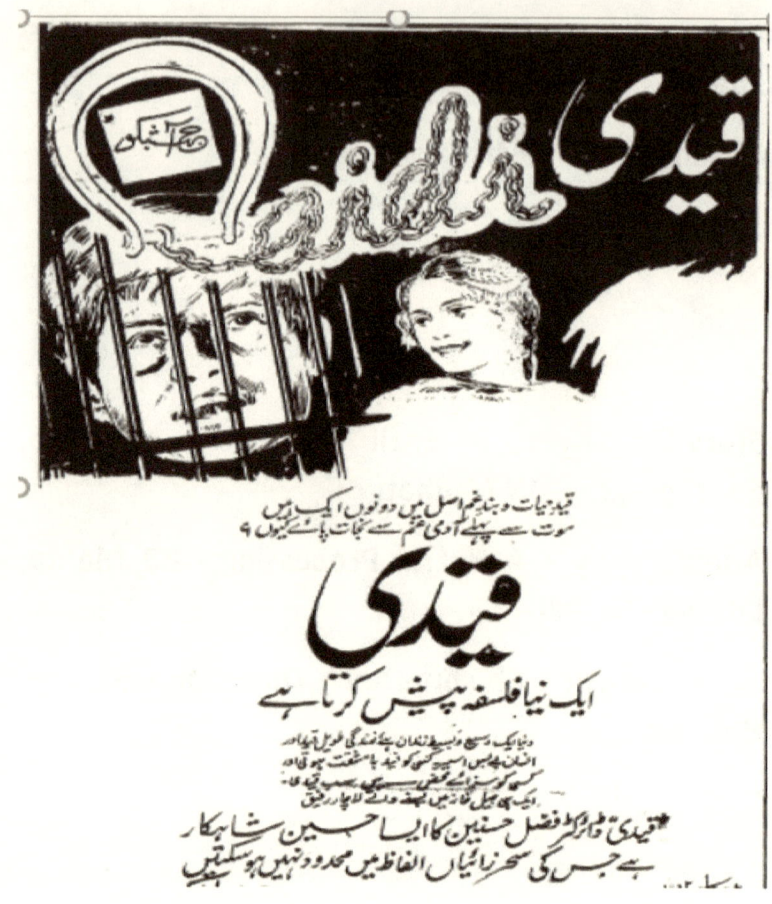

Figure 61 Film Qaidi from Urdu newspaper. Author's collection

NOTES –

The Ghalib's couplet

qaid-e-hayāt o band-e-ġham asl meñ donoñ ek haiñ

maut se pahle aadmī ġham se najāt paa.e kyuuñ

The prison of life and the bondage of grief in-reality are one and the same, therefore why would one find escape from grief before death ends life.

The movie was based on this philosophy.

SYNOPSIS –

The sound of **Azaan** (The call for prayer) from the minarets of the mosque is heard all over the locality. Many are heading towards the mosque. Nearby, an old lady in **Sajda** (prostration) in her house is murmuring – O Lord, we sinners, what big mistake did we make that we are being punished. Whatever was given has been taken away, we are unable to bear this hunger day after day. If this was your wish, it was better you made us poor from the very beginning. My son is dying from a disease for want of medicine. The elder one is BA and is unable to find a job. Our hopes lie on you. Please give us strength and patience to bear the hunger.

The youngest one Chanda, a daughter is repeatedly asking for food. The old lady (Mother) is consoling her. Your elder brother has gone to the market, bear the hunger for a while, he will be back shortly.

Aziz, the eldest son had gone to get some loan. He meets the Sheikh on the way, who asks him why he is not coming to the mosque these days. Aziz tells him Allah listens only to the rich people. Sheikh assures him to have faith in Allah. Aziz returns home empty handed only to find his younger brother dead. He wants to sell his sherwani to meet the immediate need of a **Kafan** (shroud) for his brother's burial. Unable to get the money gets frustrated and chokes a rich man to death. He was arrested by the police

. Aziz plea for mercy but he police does not listen. He was sentenced for 10 years in prison. The mother and daughter had no option but to take to streets begging for food singing – **baba jiye tera parivar, dhela, damdi, paisa kaudi - - -**

In the prison he was doing all sorts of hard work, grinding wheat, breaking stones, digging in the garden. he learns from the havildar that his mother was hit by a car and died. The whereabouts of his sister were not known. Meanwhile, the chief enters, and he asks him when can he be free? **Song – kaise ho chutkara babu,kaise ho chutkara, hum bhi qaidi tum bhi qaidi - - -**

The chief tells him that he will be released from the prison soon. He was thinking about his sister Chanda. One day while watering the plants in the garden he comes across a girl by name Chanda, who ask him for few flowers. When the prison guard objects for cutting of flowers, he gets enraged and assaults him. Chanda tells him to run away from the scene of the crime. The police chase him.

Aziz enters the nearby mosque. He requests the Sheikh to allow him to hide in the mosque. **This is the house of God Aziz, everyone has a place here. Do you now believe the power of God?** The police inspector and his assistant wait outside. Aziz escapes from the back door. The police chase him. He finds himself in a place, Laila the dancer is dancing and singing – **saghar liye hue ho ke khanjar - - - -**. She hints at the presence of the police looking for him. He escapes, running fast, exhausted he sleeps on the doorstep of a house. The owner Merchant, a rich man identifies him as Aziz. His niece Salma, nurse and takes care of him. On recovery he comes to know Merchant is a leader of a big gang of dacoits. Merchant want's Aziz to take over his place as he had grown old. Aziz accepts after hesitation. At a function Aziz is introduced to the gang, Nargis a dancing girl in his camp performs a delightful dance.

Aziz becomes a seasoned dacoit, loot banks, kill many rich people, many widowed and orphaned, but he was also very charitable. He gave away half of his loot to his colleagues. Police were in constant chase for him, but every time they find him, Laila finds a way of escape for Aziz. The bonds of friendship between Aziz and Laila make the police inspector feel they were in love, but they were not. Salma who was in love with Aziz thought the same way, little did anyone knew they were siblings separated by ill fate. Aziz knew very well that Laila was not a dancer by profession, similarly Laila knew that Aziz was not a dacoit by profession. Circumstances made them to accept what they were. Salma dreamt of marrying Aziz but for him life was uncertain with police chasing him.

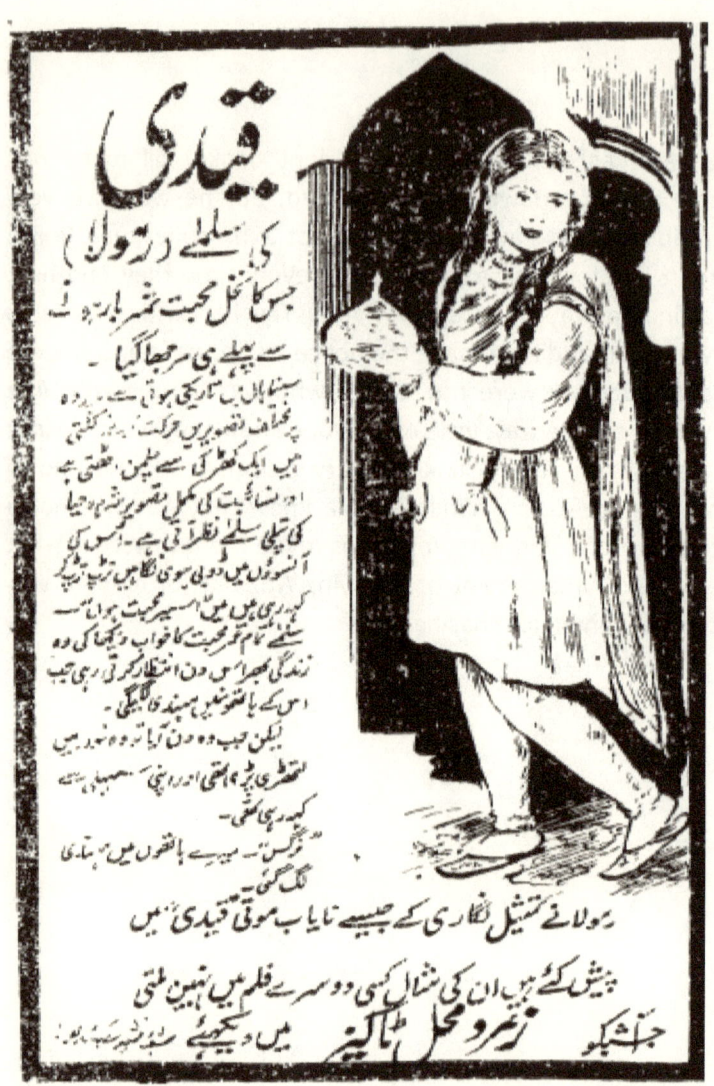

Figure 62 Ramola as Salma in film Qaidi from Urdu newspaper. Author's collection

Laila was tired of being a dancer, she felt it was a prison. She wanted to be free and spend time in contemplation and devotion to God. She goes to Salma and handover all her jewels as a gift and ask her to be happy by marrying Aziz. Police

inspector who was closely watching reach the spot and finding Aziz asks him to surrender at gun point. Laila immediately comes in front of him and was shot. She falls in the arms of Aziz. She has only few moments to live. She mutters, my elder brother had gone to bring a shroud for my dead brother and did not return so far, my mother was run down by a car and died, it is my time now to go. Aziz realizes Laila was none but her little sister Chanda. They hug each other. Laila dies in her brother's arms.

Aziz, on hearing the Azaan (call for prayer) from the nearby minarets and runs towards the mosque. The assistant inspector open fire thinking he is trying to escape, and Aziz falls on the floor. The Sheikh and the police inspector reach him. The inspector regrets the action of his assistant. He asks Aziz as to why he did not ask his permission to offer Namaaz (prayer). Aziz answers in a feeble voice – I am going to another world, the world of God where your rules are not applicable.

REVIEWS –

A maiden venture by Fazli Bros from Calcutta. A Muslim social full of sorrow. On its release it was thought it will fail at the box office but, did well. The tragic story was well compensated with many delightful dances by both Mehtab and Monica Desai. The music by Bhishm Dev Chatterjee was excellent though, none of the songs were recorded. The Ghalib's ghazal **dil hi to hai na sang-o-khisht - - -** was used as a background song. It was the most popular number from the movie.

Mehtab excelled in the role of Laila. Nandrekar and Ramola acted fairly well. Wasti as the police inspector justified his role.

RASHIDA-1935 (TURKI HOOR)

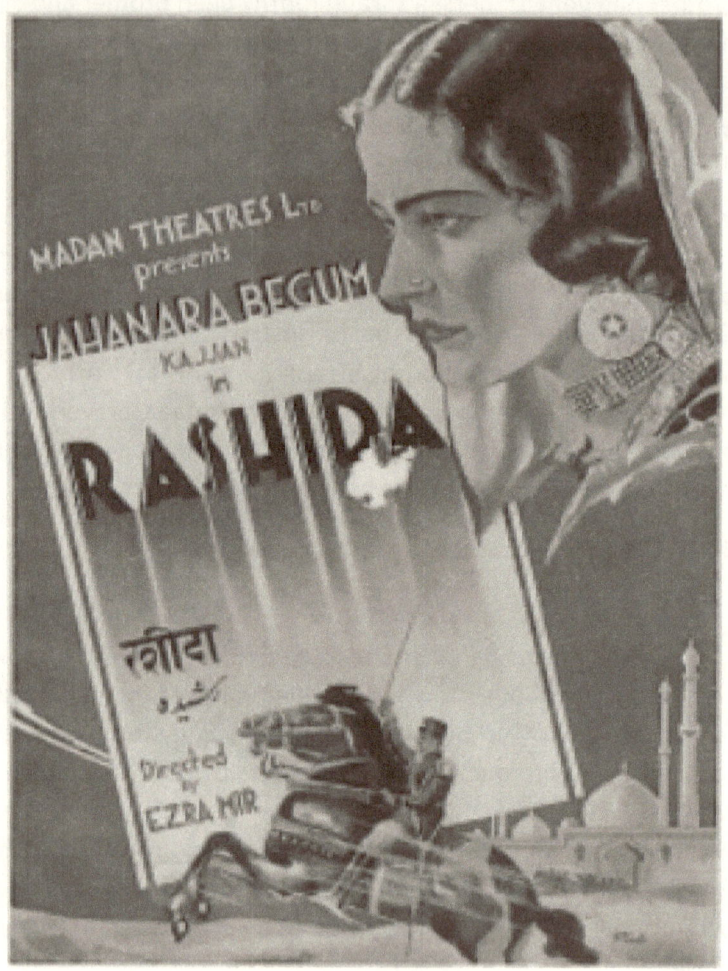

Figure 63 Film Rashida booklet cover courtesy Rashid Ashraf

CAST-

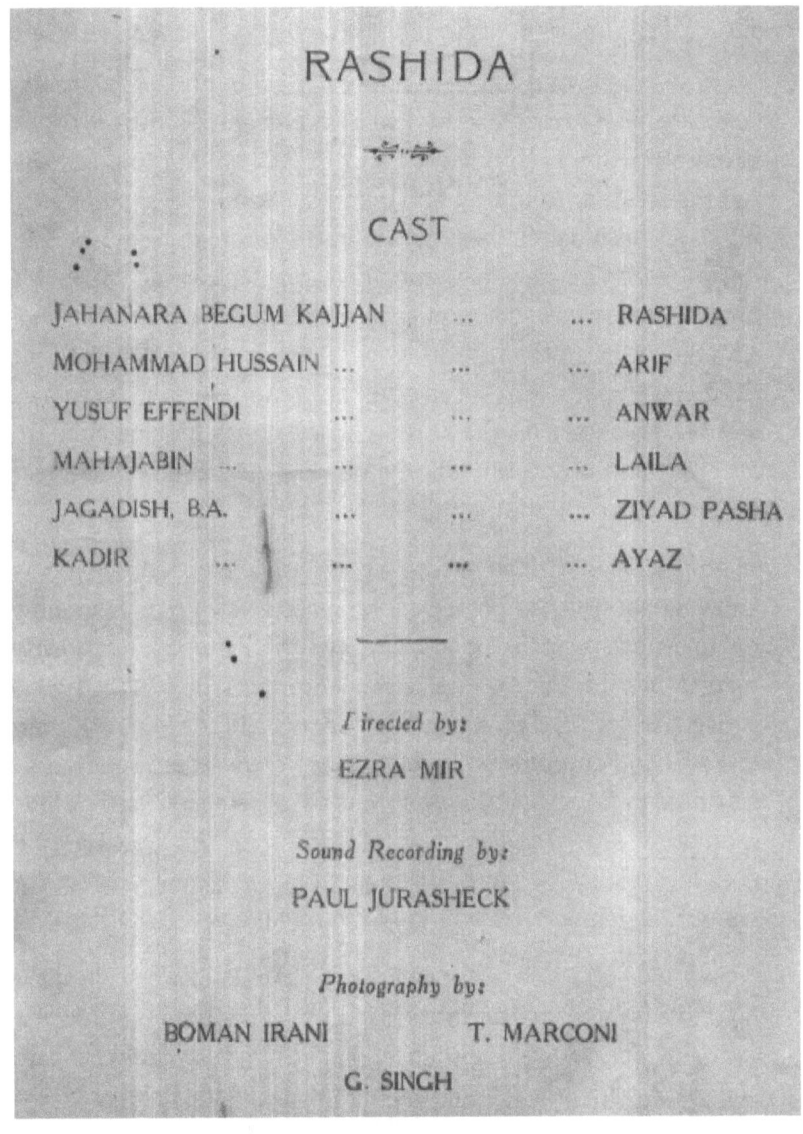

Figure 64 Film Rashida's cast details from booklet courtesy Rashid Ashraf

SYNOPSIS –

Captain Anwar a young and energetic bachelor was rejoicing in an Armenian hotel when he receives orders to move along his regiment at a short notice to put an end to a riot. He felt it necessary to inform about this sudden development with his sister Rashida. On hearing the news Rashida was upset, but Anwar consoles her. Rashida prays for his safety. Arif, his brother-in-law advise him to keep off three evil vices – drinking, gambling and flirting. Arif who is living with a wealth of Rs70,000 Rupees in his iron safe is a man who only preaches without practicing it. Anwar is on his way after bidding adieu to his sister and brother-in-law. On his way he meets a flower girl by name Laila and they get mutually attracted to each other.

Ziyad Pasha, a ruffian is the owner of a gambling den. On knowing about Arif's prosperity he plans to swindle his money. He takes the help of Ganim, an unfaithful friend of Arif who escorts him to Ziyad's den. Ziyad entertains him with drinks, dance and music. He also let him peep into his harem. Arif then loses a huge amount in the gambling. He was then escorted to his home by Ziyad and Ganim. It was past midnight, Rashida was waiting for Arif. On seeing Arif fully drunk for the first time she goes into a state of shock. On seeing this Fareed Bee enters the scene and rebukes his son-in-law. Arif falters and falls to the great dismay of Rashida.

An unpleasant incidence takes place. This time Ganim brings the gambling den to Arif's residence, makes him fully drunk, cheats and makes him lose a large sum of money in gambling.

Slow and steadily Ganim was leading Arif on the path of ruin. Ayaz, the faithful servant of Arif noticing his master is being cheated in gambling tries to strangle Ganim. Arif did not like his

servant's interference and tries to hit Ayas with a heavy jug. At this moment both Rashida and Fareed Bee enter and question Arif as to what was going on. On seeing them Ganim runs away from fear. Arif was enraged for the interference and now Rashida's intrusion was unbearable. He shouts at Rashida to leave his house or simply bear with him. Rashida had two options, the comfort and riches at her father's house and a husband who promises suffering and hardship. Rashida true to the Indian womanhood chose to be with her husband.

Arif's fortune reduced to Rs 30,000, Ayaz, to save his master from ruin steals Rs 25,000 and manages to keep it safe to return him later. On a second occasion he was caught, despite Rashida's plea he was sent to prison.

Anwar and Ziyad were at the Armenian hotel. Laila comes in to sell the flowers. Ziyad molests her. Anwar comes to her rescue. Ziyad was badly insulted and pledged to take revenge.

Later, Anwar meets Laila and comes to know that Rashida is grinding wheat in order to make a living. Arif is spending her earnings in drinking. Anwar meets Rashida and ask her to break off with Arif who is unable to take care of her. Arif heard them talking and shouts at Rashida and order Anwar to leave his house. Anwar, before parting from Rashida leaves a small of guineas with her.

Ziyad and Ganim find Arif at the wine shop and contrive an evil plan to avenge the insult caused by Anwar. Ganim pays the bartender to serve plenty of wine to Arif and keep him engaged drinking. Ganim goes to Rashida and tells her that Arif had met with an accident and she should follow him. Rashida on reaching Ziyad's place discovers the ruse and struggles for her purity. On a tip from Laila Anwar rushes on his horse. In the fight that followed Ziyad is killed and Rashida is protected.

Arif, back from the wine shop finds the bag of guineas and suspects Rashida of faithlessness. He accuses her and in a fit of mad anger hits her on her head with a stick. Rashida falls to the floor bleeding. Anwar and Laila enter, finding lying on the floor bleeding Laila concludes her dead and rushes to the police. Anwar clears the misunderstanding.

Rashida comes to her senses and lies to the police about the bleeding cut on her head. Arif realizes his mistakes and begs for forgiveness. Ayaz returns from prison and brings with him Rs 25,000 which was stolen from Arif's safe. Both Rashida and Arif start a new life. Anwar and Laila get married.

REVIEWS –

Jahan Ara Kajjan as Rashida was portrayed as a true Indian Muslim woman. Despite suffering constant insults, humiliations and ill treatment by her husband she remains a true and devout wife which ultimately restores normalcy to the disturbed household. There are no dances by Kajjan but three soulful songs. Mahjabeen as the flower girl Laila played her role well and rendered a song. Yousuf Effendi as Captain Anwar justified his role as Rashida's brother.

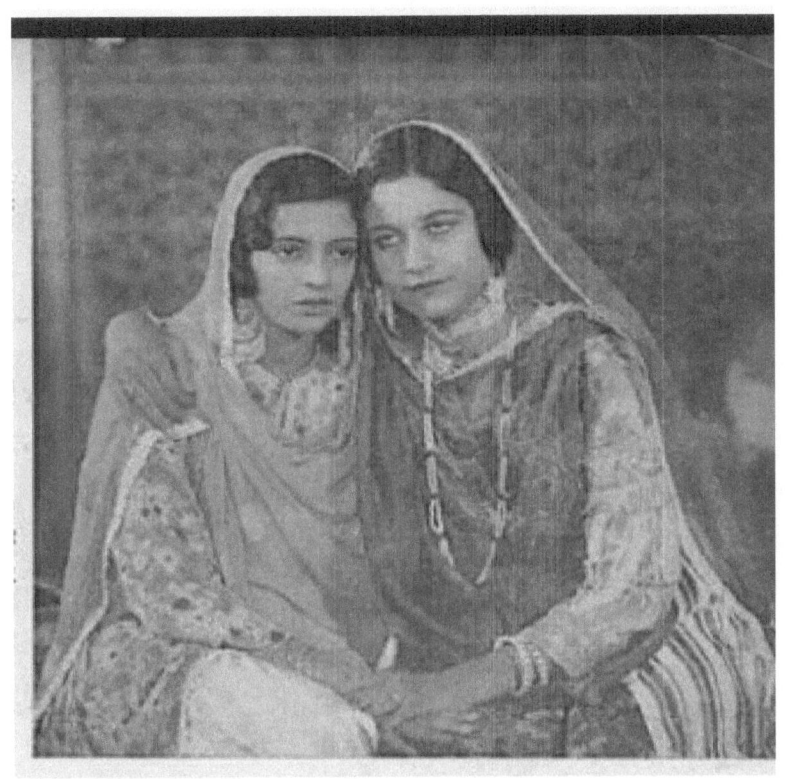

Figure 65 Mahjabeen & Kajjan in Rashida courtesy Rashid Ashraf

CRITICISM –

The movie was a moderate success. The movie had too much of drinking and gambling scenes. The turkey cap with a crescent moon and a star was in-appropriate. The direction of Ezra Mir was severely criticized for the many short comings in the movie. The photography was very poor. Jahan Ara Kajjan looked very sick, but she rendered two good songs.

REHANA – 1946

G.A. THAKUR presents "REHANA"

Director	Harbans
Story by	G. A. Thakur
Scenario ,,	Harbans
Dialogues ,,	Ahsan Razvi
Songs ,,	Tufail Hoshiarpuri
Music ,,	Qadir Faridi
Product on chief	Ishwar K. Jawa

Technicians:—

Photography	M.R. Raja
Sound recording	A.Z. Beig
Stills	T. Mathra
Settings	Ditta & Sant Singh
Art Director	S. H. A. Shah
Make up	Jagat Kumar

Assistants:—

Directors	Mohd. Hussain & Badri Singh
Production Manager	Rajbans
Photography	Pinto & Pereira
Sound recording	S. K. Chander & Kartar Singh
Art Director	Ramzan
Make up	Nizami & Prem

CAST

Manorama	Rehana
Salim Raza	Nasir (king)
Pran	Saulat
Ramesh	Grand Vazir
Roofi	Dancer Zarina
Majnu	Gulkand

New faces

Farida	Sultana
Leela	Shamim
Begum Parveen	Nazakat
D. D. Asha	Jabir
M. Feroze	Naib-i-Basra
Krishna	An old woman

& others.

Produced at
THE UPPER INDIA STUDIOS Ltd.,

Figure 66 Film Rehana details from booklet courtesy Rashid Ashraf

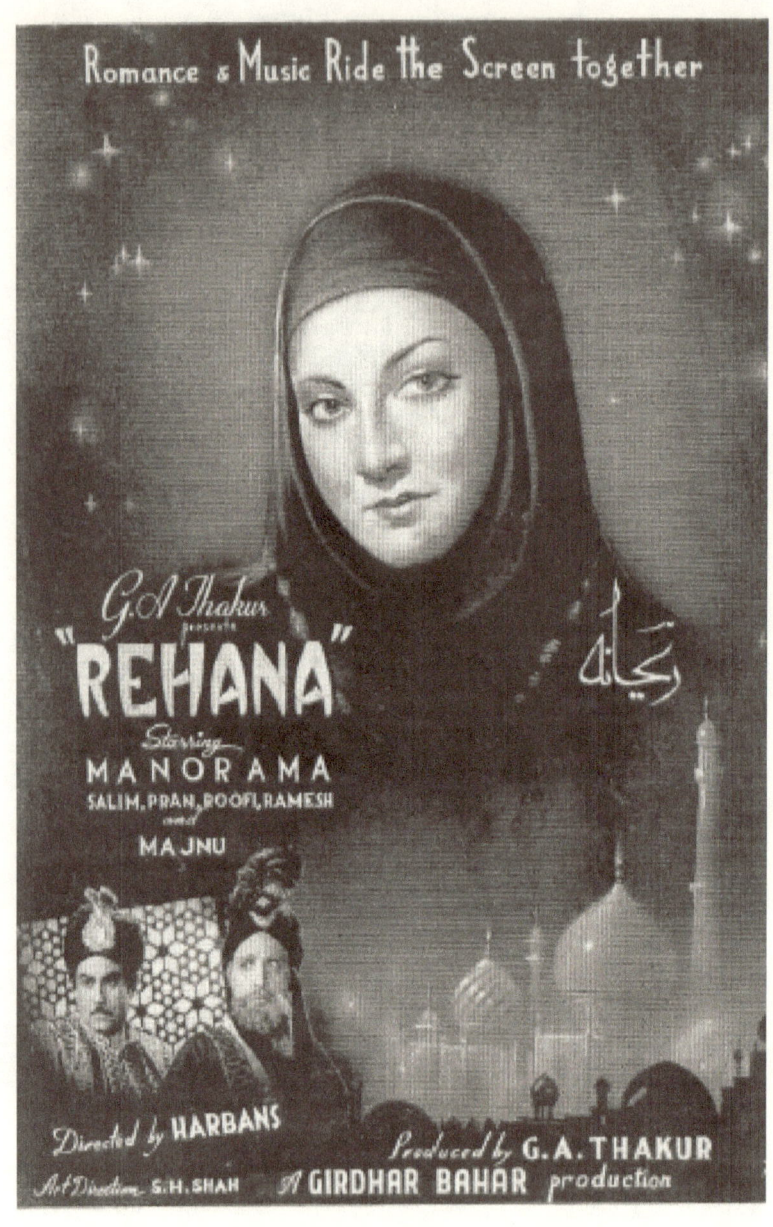

Figure 67 Film Rehana booklet cover courtesy Rashid Ashraf

SYNOPSIS –

This is the story of the King of Baghdad Nasir falling in love for a beggar girl Rehana. Once upon a time there was a beggar girl Rehana living on the streets of Baghdad. She was blessed with a melodious voice. She used to sing and beg for the cause of the poor. One day the King heard Rehana's melodious song and was entranced.

King Naser offered his love to Rehana, but she refused by saying 'There cannot be anything common between a beggar and a King your Majesty'. The King was so mad in love for Rehana that he disguised himself as a beggar and won the heart of Rehana.

The Grand Vizier (Prime-Minister) spread a rumor that the King had become mad running after a beggar. He was planning to make his son a successor to the King. He planned a rebellion.

Rehana was molested by some soldiers and the beggars advised her to meet the King with a complaint. Rehana visits the King's court and find the beggar she was in love with was none other than the King. Rehana was so much moved for the love of King that she agreed to live with the King in the palace. Surprisingly, she lost her voice and was unable to sing. Her voice was meant for the beggars and not for the King. The rebels were becoming strong. Rehana thought, in the interest of the kingdom and the beggars it is better she leaves the palace. One day without telling the King she leaves the palace.

The king was surprised as no one had the information as to where she disappeared. The king goes in search of her and convince her to return to the palace. The group of beggars too

encouraged her to follow king's advice. The large group of beggars extended their support to the king and praised him for his honesty, simplicity and generosity. The rebels too were convinced at the gesture of their king. Thereafter, Rehana and the king lived happily in the palace.

Figure 68 Film Rehana image from Urdu magazine. Author's collection

REVIEWS –

The film was released on Ramadan 1947 which coincided with the Independence Day of India. The movie was a moderate success at the box office. The music by Qadir Faridi and the songs by Dilshad and Zeenat Begum were the highlights of the movie. Lal Mohammad was originally chosen for the music but was replaced by Qadir Faridi.

SALMA – 1943

CAST AND CREW

HIND PICTURES
"SALMA"

Cast

Sitara	Salma
Ishwarlal	Dr. Masood & Dr. Manzur
Yaqoob	Yaqoob
Urmila	Suraiya
Majid	K. B. Abdul Majid
Azra	Raziya
Anwari	Suraiya's Mother

Technicians

Story	Munshi Dil
Screenplay, Dialogues & Songs	Hasrat Lacknavi
Cinematography	Kumar Jayawant
Audiography	B. N. Sharma
Editor	Vithal Bankar
Production Incharge	Sharif / Janardan Sharma

Music: Master GOBINDRAM

Directed by: NAZIR

Figure 69 Film Salma booklet cover courtesy Rashid Ashraf

Figure 70 Film Salma synopsis from Urdu magazine. Author's collection

SYNOPSIS –

This is the story of two young girls Salma and Suraiya of Cawnpore, who grew up together as close friends from their childhood and dreamt of being together as eternal friends. Their childhood has now transformed them into young and beautiful girls eligible for marriage. Salma's father Abdul Majid was keen in getting her daughter married. The search for a suitable husband for Salma had separated both the innocent friends. Salma's marriage was fixed with Dr Masood of Allahabad. After the marriage when Salma was moving over to Allahabad Suraiya asked her if she would remember her even after marriage. There upon Salma promised that she will remember her till her last breath. Salma kept her promise, but it happened in a very strange way, hard for anyone to guess.

Salma wrote many letters to Suraiya but could not get a reply to any of them. Suraiya's selfish brother Yaqub had seen that Salma's letters did not reach his sister. Meanwhile, Suraiya got engaged to Dr Manzur, a resembling brother of Dr Masood. On the day of engagement Suraiya reveals Dr Manzur her deep sense of love for her friend Salma. Dr Manzur tells her she can meet her after marriage.

Strange things do happen. On the day of his marriage Dr Manzoor meets with an accident and pass away. Yaqub tells her sister Suraiya that Dr Manzur had cheated her and left the town. It was a big shock for Suraiya, she faints and looses her memory. Her parents were advised to take her to Allahabad for treatment under Dr Masood who was a specialist.

Suraiya was slowly regaining her memory under the treatment of Dr Masood. One day she started muttering **'Salma, my dear friend where are you, come to my rescue'** Mistaking Dr Masood for Dr Manzur for his resemblance, she asks him to marry and make her meet her friend Salma. The perplexed Dr Masood learns about the entire story from Suraiya's parents. Dr

Masood tells Salma about the strange behavior of his patient. Her chances of recovery will be good if she can marry the person she wanted to.

Salma, on coming to know about Suraiya felt sorry for her. She wanted to help her in whatever way she could to bring back her friend to normalcy. Salma was a deeply religious person, **' panch waqt Namazi '** (**a person who pray five times a day**). One day, while offering Namaz she went into a state of trance. When she got out of it she found the answer to her quest. Islam does permit her husband Dr Masood to have a second wife. What is wrong if he marries Suraiya to give her a new lease of life. After all we were good friends from our childhood and still can live under one roof sharing the husband.

Salma firmly decides that Dr Masood should marry her dear friend Suraiya. She wants to see her happy. Dr Masood does not accept this proposal in the beginning. He loved Salma dearly and bringing another wife would simply ruin their married life. Salma persuade Dr Masood and finally he agrees.

Suraiya recovers fast after marrying Dr Masood. She was happy to see her good friend Salma living in the same house. They speak about their childhood days and spend their time happily on the terrace. Suraiya is happy in the company of Dr Masood. A big transformation had taken place in Salma's life after Suraiya's marriage with Dr Masood. Her love for earthly existence has now slowly shifted to Godly love. Love for the supreme. The True love. **Ishq-e-majaazi has transformed into Ishq-e-haqeeqi.**

She had sacrificed her happiness for the sake of her good friend Suraiya. Her objective being fulfilled she decided to go on a Hajj pilgrimage and later she became a **dervish.**

REVIEWS –

The movie was very popular and ran for many weeks. The theme of the movie was appreciated by the masses. Apart from this the movie had a great music by Pt Gobindram

Figure 71 Film Salma details from Urdu magazine. Author's collection

What extent a woman can do to help her friend is superbly presented in this movie. A captivating movie of self-sacrifice

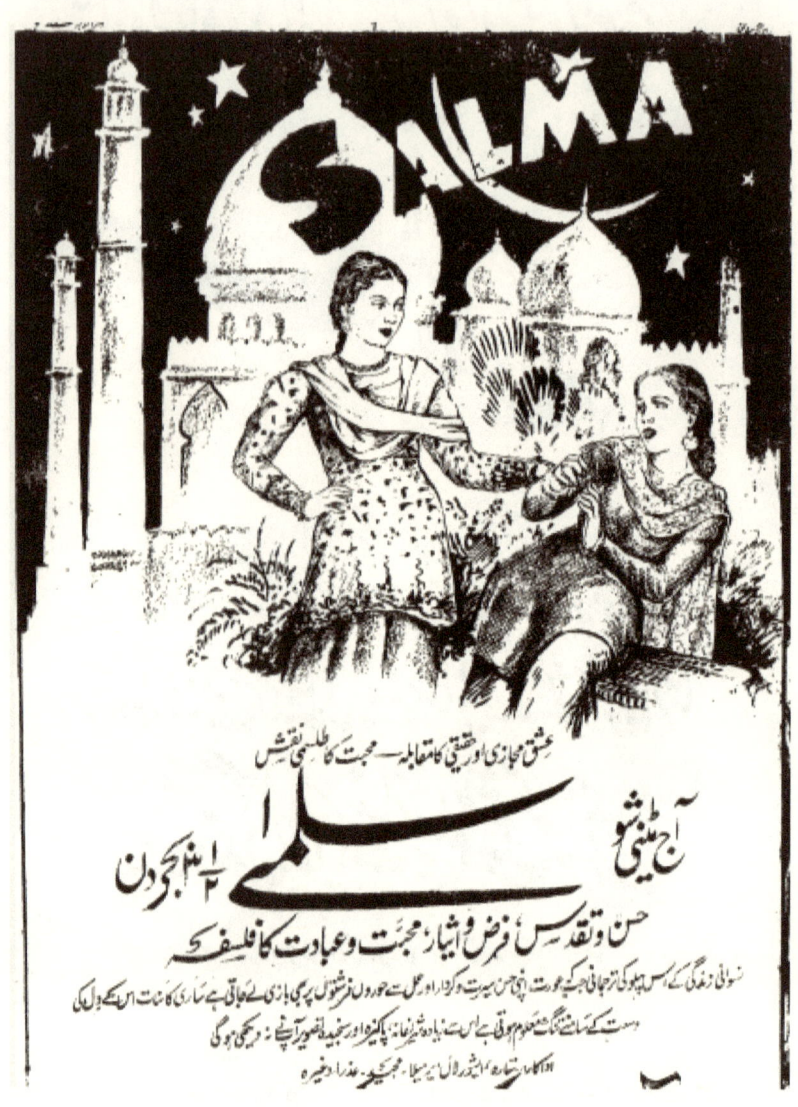

Figure 72 Film Salma friends on balcony. Author's collection

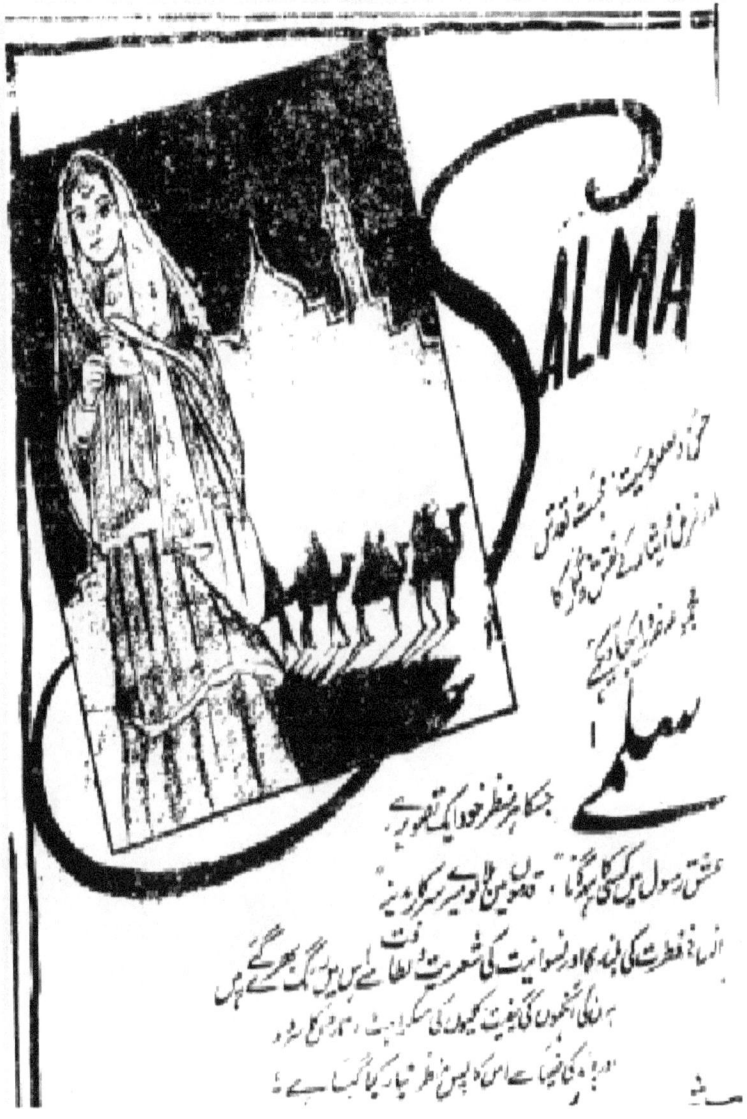

Figure 73 Film Salma, Salma becomes a dervesh. Author's collection

Salma becomes a dervish – qadmon men bulalo mere Sarkar-e-Madina Image from film magazine Author's collection.

SHAHANSHAH BABAR - 1944

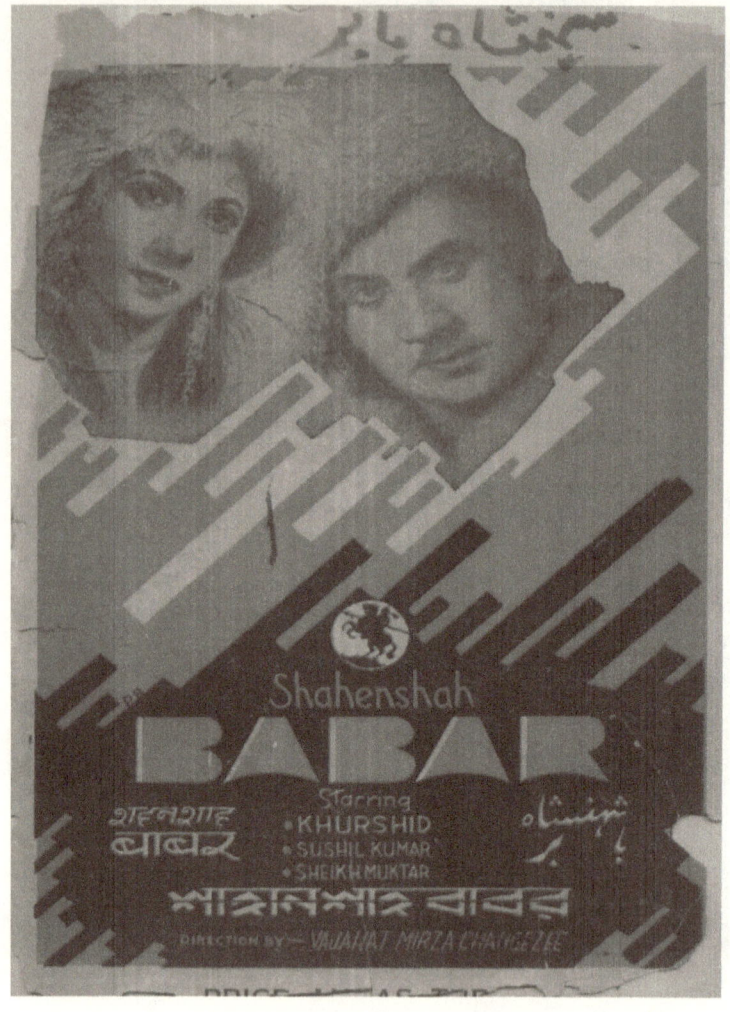

Figure 74 Film Shahanshah Babar booklet cover. courtesy Rashid Ashraf

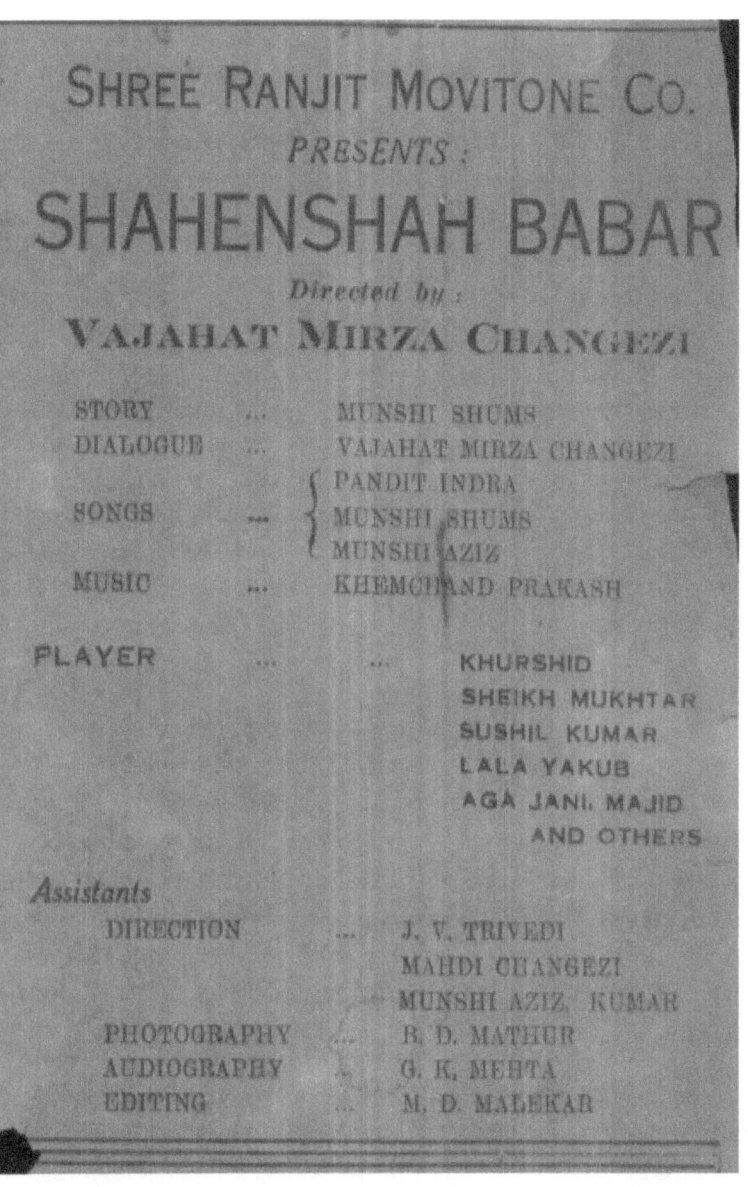

Figure 75 Film Shahanshah Babar details from booklet courtesy Rashid Ashraf

SYNOPSIS –

This is the story of Babar who would be the future Emperor of India. The story dates to the 1526. Babar's mighty army was feeling tired of their long march through icy hills and marshy valleys. They were also sore of privations. They refused to move any further. There were whispers of mutiny, but Babar was undaunted, he continued to march and finally defeated Sultan Ibrahim Lodi in the battle of Panipat. He was crowned the Emperor of India.

India was a golden bird. The easy court-life following hard on the heels of a long rough camp-life brought dishonesty and dissensions within his army circles. So many faces turned away from duty, many people turned to luxury. One person who stuck steadfast to his duty and his sense of loyalty was his faithful Sardar Sheikh.

Sardar Sheikh had a daughter named Hamida. The young and attractive Hamida was in love with the Prince-Royal Humayun. Prince Humayun too was attracted towards her and returned her love. They were dating each other. The secret love affair of Prince Humayun and Hamida reached Emperor Babar. Babar was perturbed about this affair. India was a new country, with a different climate and atmosphere. There was discontent everywhere in the army and many secret enemies surrounding him. He thought the time was not right for Humayun to marry Hamida.

Babar summoned his son Humayun and without questioning him asked him to promise that he will sacrifice his love for the sake of the kingdom. Humayun, make your heart as strong as a stone and forget your love Hamida. Humayun was stunned at his father's strange wish and without a word promised Babar of his wish.

Sardar Sheikh was heart-broken. He could not reconcile his love for his daughter and his loyalty to his Emperor left along with his daughter Hamida to his native Fargana outside the borders of India.

Humayun, though had accepted the request of his father, in the interest of the political unity of the kingdom could not forget his love for Hamida and he fell ill. Despite the best medical attention that Babar could provide Humayun's condition grew worse.

At last Babar had to go to Sheikh in person and bring Hamida along with him sanctioning Humayun's love for Hamida. Humayun's condition was worsening. Now, Babar had to make a biggest sacrifice any person could make. Babar was able to save Humayun's life but, with what sacrifice is something to be watched on the big screen.

HISTORICAL FACTS –

During the medieval times there was a wide belief that a malady or illness could be transferred from one person to another or to an inanimate object by prayers and donations. One of the most powerful proof that the rite existed can be deduced from the story of Babar and Humayun.

It is recorded in the Humayun Nama, in extreme hot weather with his own internal organs burning from a prolonged illness, a much-weakened Babar circled the bed of his son Humayun thrice praying out loud – if a life can be exchanged for a life, I, Babar give my own life in exchange for my son. While Humayun's health gradually improved, Babar's health deteriorated and died a few months later.

REVIEWS –

The film did well at the box office. Sheikh Mukhtar in the role of Babar and Wajahat Mirza as the director won the praise from the movie lovers. Khursheed who played the role of Hamida played her role very well and rendered lovely songs. The movie had lovely music by Khemchand Prakash, who was a regular Ranjit staffer.

A large section of audience felt that the picturization of Babar approaching Sardar Sheikh and bringing back Hamida, leaving the critically sick Humayun was something distancing away from the history. This was probably done as a dramatization of the film.

شیخ مختار

پہلی بار آپ نے "ایک ہی راستہ" میں ایک چور گرہ کٹ کے روپ میں دیکھا تھا اور دیکھتے ہی ہم تسلیم کرنے پر مجبور ہو گئے تھے کہ ایک اداکار پردہ پر نظر آیا ہے۔ جو اداکاری کی پوری فصل اپنے میں رکھتا ہے۔ پھر "بہن" میں نظر آیا تو مزید اپنے آپ کو چوٹی کے فنکاروں کی صف میں شمار کرنے پر مجبور کیا۔ پھر "روٹی" میں ایک اجڈ انسان کا بھر پور بہروپ بھرا اور اس بار بھی اپنی طرح تعریف کا مستحق خود کو قرار دیا۔ لیکن اب

شہنشاہ بابر

میں شہنشاہ بابر کی شجاعت و دلیری سے کچھ پار ہے، بہادری و جوانمردی سے لڑ رہا ہے، ایمانداری و عدل گستری کا درس دے رہا ہے۔ ایثار و قربانی کی تصویر بن کر ابھر رہا ہے۔ کون ہے جس نے شہنشاہ بابر ایک بار بھی دیکھا ہے، اور شیخ مختار کی اداکاری اور جذبات نگاری کا معترف نہ ہو گیا ہے۔

آئیے آج اسے غور سے دیکھے کہ متبادل تاریخی تصویرے اور ہندوستانی صنعت فلم سازی کی بیش ...

Figure 76 About Sheikh Mukhtar. Author's collection

TRANSLATION

Sheikh Mukhtar was shown playing the role of a thief for the first time in film 'Ek hi Raasta' which made viewers to accept that the actor did possess all the qualities of an actor. Later in

film 'Bahan' his acting skill made him join the list of great stars. In film Roti he played the role of a tribes-man and became famous but, this time is seen playing the role of Shahanshah Babar. A movie full of heroic deeds and selfless sacrifice.

Figure 77 Wajahat Mirza Changezi details. Author's collection

TRANSLATION

The progressive minded writer Wajaht Mirza first directed the film Jawani for National studios which receive praised, Shahanshah Babar is a proof of step ahead of his progress in reminding the forgotten things of history.

Figure 78 Film Shahanshah Babar Khursheed's song. Author's collection

Film Shahanshah Babar image, praising Khursheed's song –
'Mohobbat men sara jahan jal raha hai,
zamin to zamin asmaan jal raha hai'. Author's collection.

Figure 79 Film Shahanshah Babar Author's collection

Film Shahanshah Babar from film magazine praising Khursheed's songs and Sheikh Mukhtar's acting. Author's collection

SHALIMAR – 1946

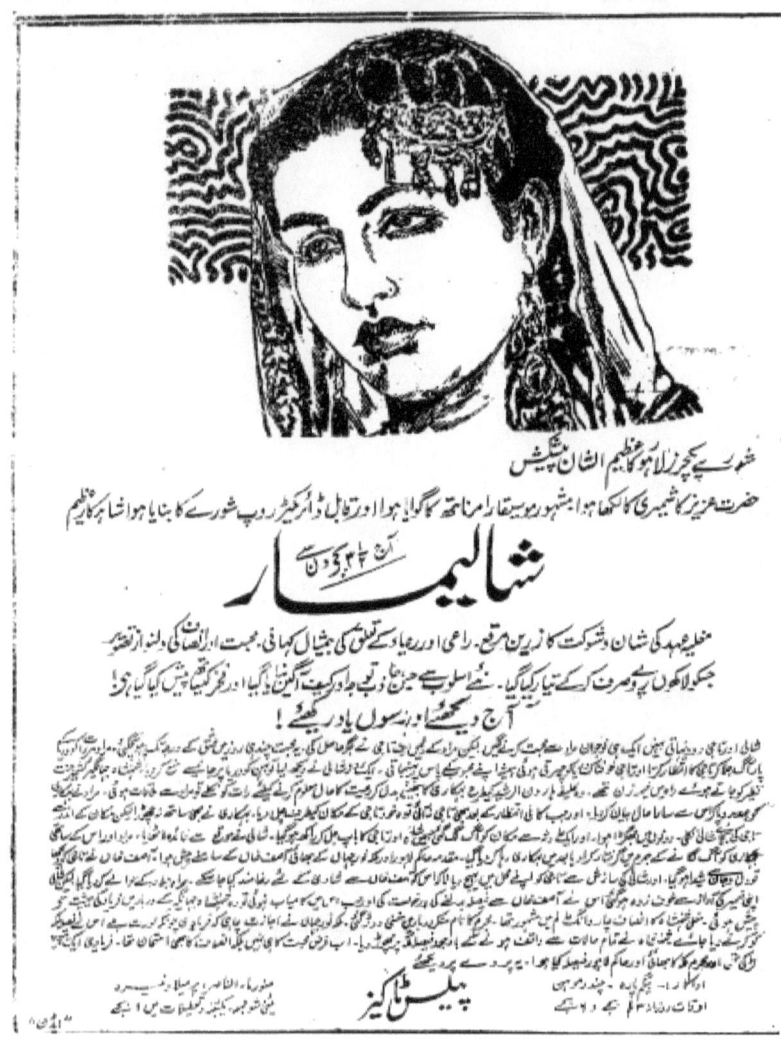

Figure 80 Film Shalimar synopsis from Urdu newspaper. Author's collection

INTRODUCTION –

One of the great features of the Mughal history is the judgement of Emperor. Adl-e-Jehangir was one of the first movies to be made in 1934. It was followed by film Pukar in 1939 which was the most acclaimed movie of its time. Shalimar followed a lapse of seven years in 1946 with altogether a different approach. This time the verdict was not delivered by Emperor Jehangir but Empress Nurjehan.

SYNOPSIS –

Emperor Jehangir along with his wife Nurjehan was travelling to Kashmir and had camped in a village. A young village girl approached him with an appeal. The Empress was embarrassed on hearing it as the appeal was against Asif Khan, her brother, who was governor of Lahore.

Two young village sisters Shaani and Taaji were in love with a young man named Murad, but he was in love with Taaji and not Shaani. Murad would make a bonfire every evening near the river side and Taaji would cross the river and meet him. This was not agreeable to Shaani. One day she locked up Taaji to prevent her from meeting Murad. Murad, as usual made a fire and was waiting for Taaji to come. An old faqir approached him and Murad told hin his love affair with the young village girl Taaji. After a long wait and no sign of Taaji crossing the river Murad himself crossed the river and headed towards her house. The old faqir followed him.

On seeing Murad, Shaani came out to greet him. Murad asked for Taaji, a quarrel ensued between them and accidentally the house caught fire. Taaji ran away from the house but her old father was charred to death in fire. Finding this as an opportunity Shaani got both Murad and the faqir arrested. The

faqir was later released. Shaani appeals to Asif Khan, the governor of Lahore for justice.

Asif Khan was stunned at the beauty of Taaji and he falls for her. He plots with Shaani and succeeds in sending Taaji to his palace but Shaani repents her foolish action. Her conscience does not permit, a deep inner voice was haunting her of her mistake. She knew well that Murad was innocent and loved Taaji dearly. She approaches Asif Khan to free Taaji and Murad. Asif Khan declines her request and Shaani appeals to Emperor Jehangir for justice.

FAQIR AS A WITNESS –

It was common practice in the olden days for kings to go around the city dressed up as a commoner or a faqir to find out the welfare and feelings of the people. The faqir in this case was none other than Emperor Jehangir himself, who spoke to Murad and crossed the river along with him and witnessed the quarrel and the accidental fire in which Shaani and Taaji's father was charred to death

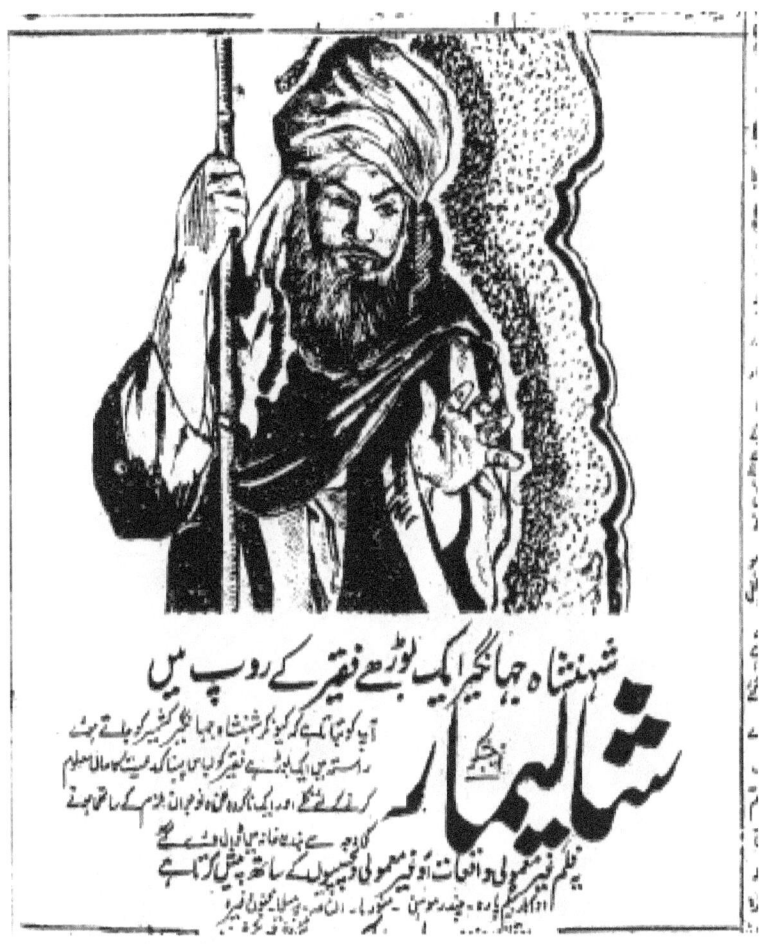

Figure 81 Film Shalimar Emperor Jehangir as a faqir from Urdu magazine. Author's collection

NURJEHAN'S REQUEST –

Nurjehan was perturbed on hearing Shaani's plea. Her brother Asif khan was involved and Emperor himself was present at the Shaani's house along with Murad. She requested Emperor Jehangir to leave this case for her. She would handle this case

183

and see proper justice is done. Emperor agrees for this proposal.

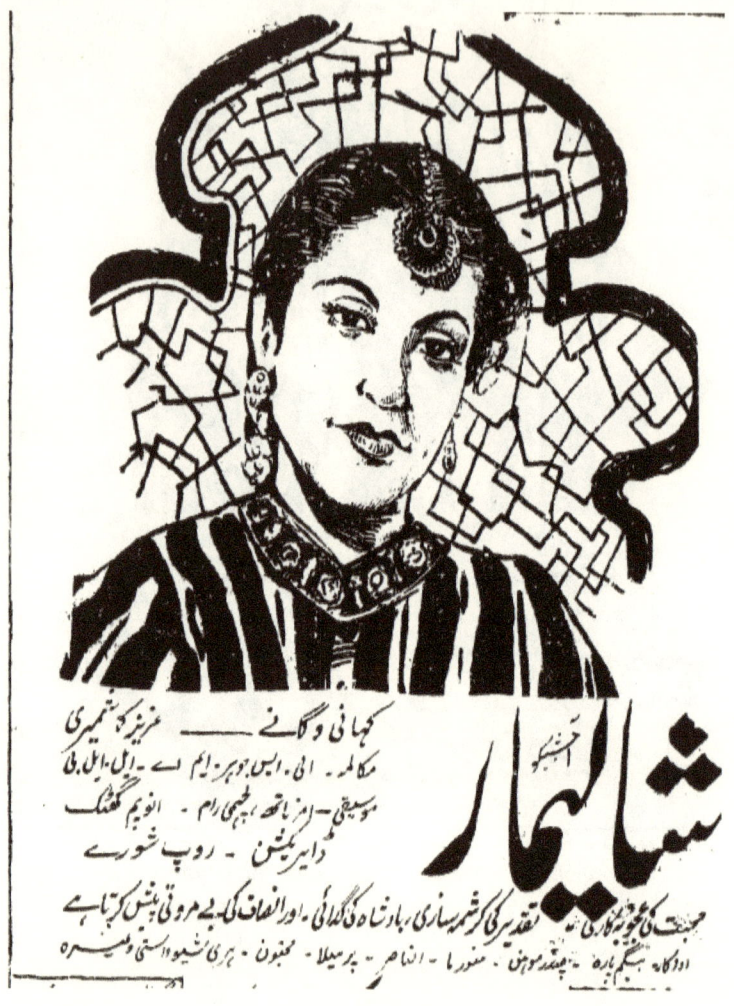

Figure 82 Film Shalimar Empress Nurjehan delivering verdict. Author's collection

What was her verdict? Did she prove Murad and Taaji innocent? How Asif Khan was saved and what was the verdict for Shaani.

Did she pardon or punish her is to be watched on the silver-screen?

NOTES-

It was a star-studded movie with Chandramohan, Begum Para, Al Nasir, Manorama, Pramila, Majnu and Hari Shivdasani. The movie was quite popular at the box office but could not beat film Pukar.

The story and lyrics by Aziz Kashmiri were praise worthy. Inder Sen Johar, MA, LLB, made an entry as a dialogue writer. The dialogues in Urdu were appreciated by the public. Pt. Amarnath was initially signed to score the music but, he fell sick and passed away before the movie was released. Lachhi Ram and Anupam Ghatak completed the score.

SHAMSHEER-E-ARAB – 1935

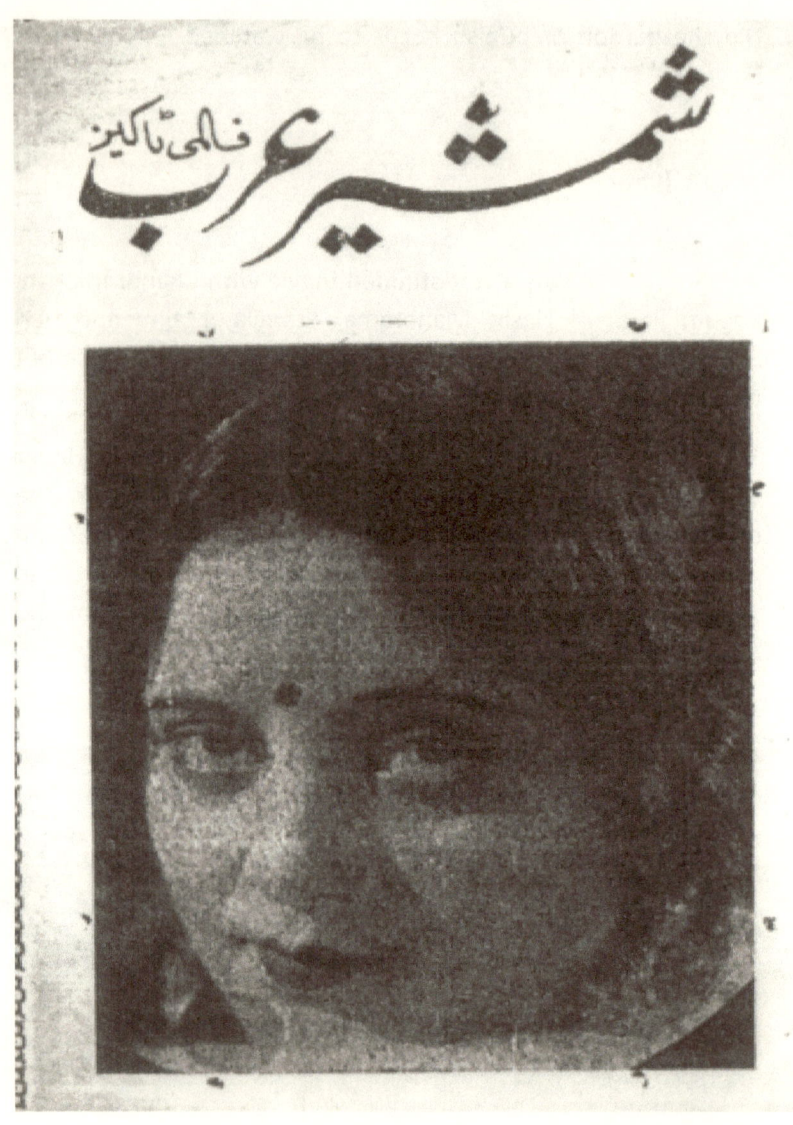

Figure 83 Film Shamsheer-e-Arab booklet cover courtesy Rashid Ashraf

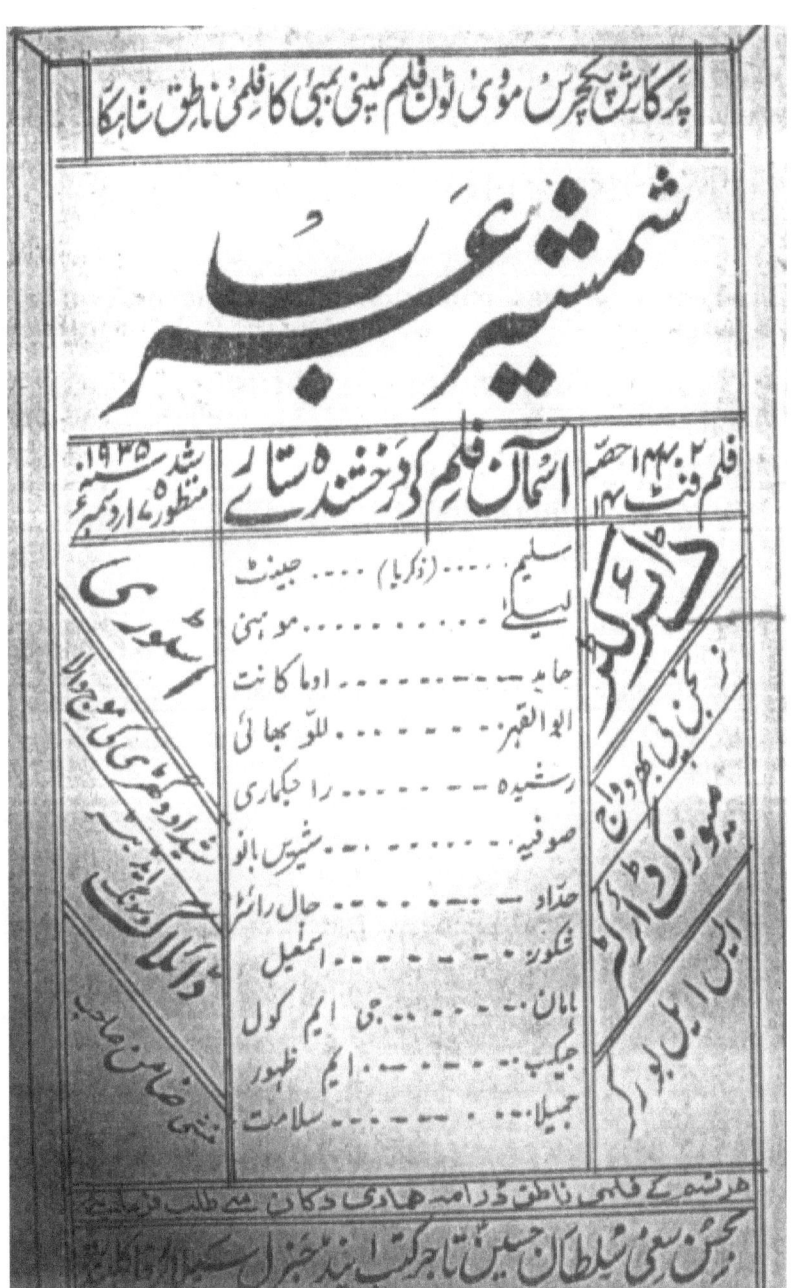

Figure 84 Film Shamsheer-e-Arab Urdu booklet, courtesy Rashid Ashraf

TRANSLATION

Prakash pictures movie-tone film company Bombay presents	
Shamsheer – e - Arab	
Film 14406 feet – 14 reels – Date approved 18th December 1935	

Dazzling stars of Asman film company

Salim	Jayant (Zakaria)
Laila	Mohini
Hamid	Umakant
Abu Al Qahar	Lallu Bhai
Rasheeda	Rajkumari
Soofia	Shirin Banu
Haddad	Jal writer
Shukur	Ismael
Hamaan	GM Kaul
Jacob	M Zahoor
Jameela	Salamat
Director	**Niranjan P Bharadwaj**
Music Director	SL Borkar
Story & Dialogues	Munshi Zamin Saheb

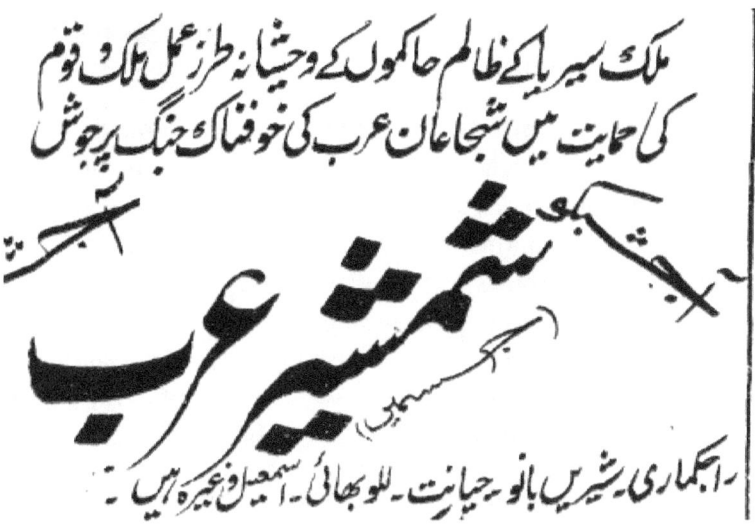

Figure 85 Shamsheer-e-Arab from Urdu newspaper. Author's collection

INTRODUCTION –

The movie was about chivalry of an Arab youth who fights to free the villagers from the hostile neighboring kingdom. In the process he saves the honor of his Amir and wins his sweetheart. The movie was released in March 1936.

SYNOPSIS –

Abu Al Qahar was an Amir of a small province near Syria. He had a young and beautiful daughter Laila. Laila was in love with a handsome youth Salim. Salim was a man of adventure. He was an excellent swordsman and was also good at martial arts. He was admired for his bravery and helpful nature. A group of poor farmers approach and tell him that some wild beast is attacking and carrying away their cattle and goats. He approaches Amir to help them in this matter. Amir got wild – why did you not kill the animal, if you have the brave Arab blood in your veins go and kill the wild animal. You should

be punished for coming to me for this tiny thing. The Amir ordered 25 lashes on his back as a punishment.

Salim's mother comes to know about this. She reminds Salim, we come from a family of brave soldiers, do not bring disgrace. She orders him, go and kill the wild animal which is creating a panic among the farmers. Salim along with his trusted friend Hamid leave the house. As they were walking ahead, they were confronted by tribesmen. It was surprising, as they appeared suddenly from nowhere. They wanted to sacrifice Salim and Hamid to the devil **Iblis.** Hamid was a tricky guy. They both escaped from the grips of the tribesmen and headed further.

They meet a mendicant and learn from him that the commander of the neighboring kingdom Haddad had invaded our province and had taken the entire village a hostage. Haddad wants to marry Laila. Abu Al Qahar, the Amir had agreed to give Laila in marriage to Haddad. The news was something surprising. Salim and Hamid quickly went around to assess how many enemy soldiers are present, how to fight and drive them away to free the villagers. It was not an easy task. Salim was planning on mobilizing able men to fight the Haddad's army.

Salim and Hamid soon reach home and learn from his mother that Laila is very unhappy about her father agreeing to give her in marriage to Haddad. Haddad had sent one of his servant-maid Soofiya, to dress up Laila suitably for the marriage. Laila was confident that Salim would return and marry her, but, if that did not happen, she had hidden a small dagger inside her dress to kill Haddad on the night of marriage. Salim's mother blessed him and ordered to leave immediately with few able men suitably armed to fight Haddad's army and free the villagers.

Salim was an intelligent guy. He knew Haddad will be busy preparing for his own marriage, his soldiers would be in

merriment. Salim and his men attacked Haddad's army in a surprise. Haddad and his men were unprepared. By the time they came out with their weapons much damage was already done. They managed to kill few of Hadda's soldiers and opened the doors for the villagers to come out and join them in their fight. There were many able- bodied men who took whatever they could grab to fight Haddad's men. The gallantry exhibited by Salim and his men was so great that the whole area was filled with dead bodies of enemy soldiers.

Haddad came out and there was a fierce fight with Salim. Salim's swordsmanship was superb. Haddad could not stand before him. There was no escape route for him as he was surrounded by Salim's men. He fell to the ground couple of times and was finally killed. The Badshah came out in a hurry from his tent, one of Salim's men threw a spear at him and was killed. There was cheering everywhere, all villagers freed, long live Salim echoed though out the village. The mendicant came to greet Salim.

Abu Al Qahar heard about Salim's adventure. He happily gave his daughter Laila in marriage with Salim. Salim's mother was very happy about her son's chivalry. Abu Al Qahar announced that Salim should be made the Badshah of the Haddad's territory. Salim expressed his gratefulness and asked Abu Al Qahar to take charge as the new Badshah. Salim made Abu Al Qahar a Badshah who was previously an Amir. Hamid married Laila's maid Rasheeda. Finally, it was a happy ending.

SULTANA – 1934

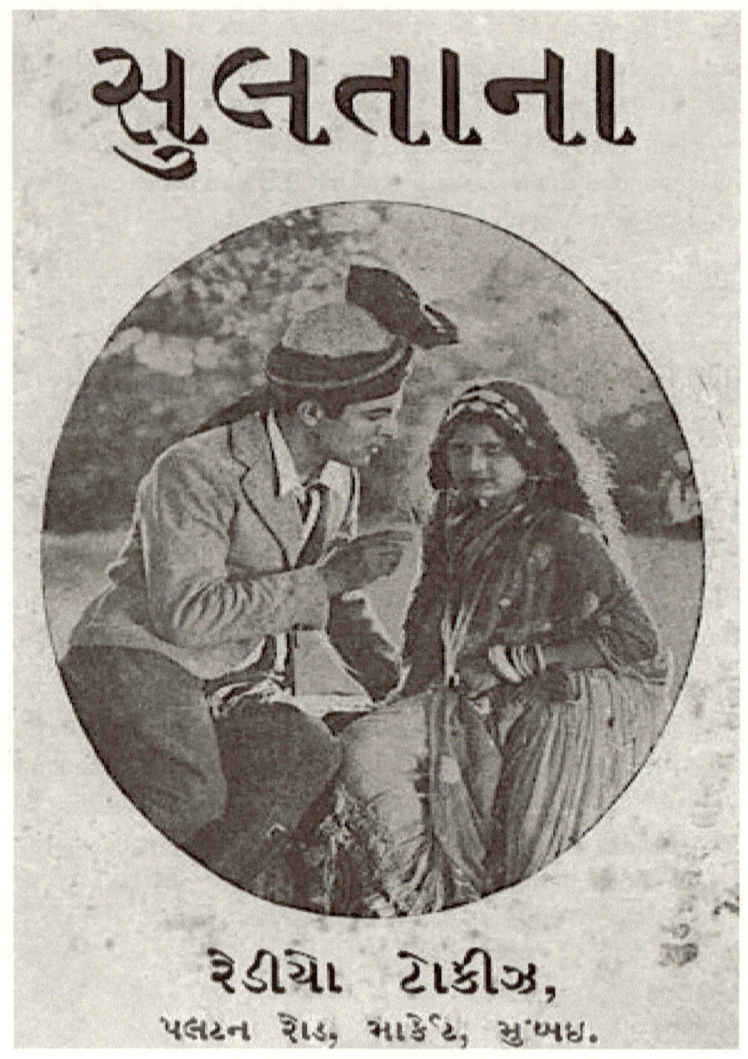

Figure 86 Film Sultana booklet cover courtesy Rashid Ashraf

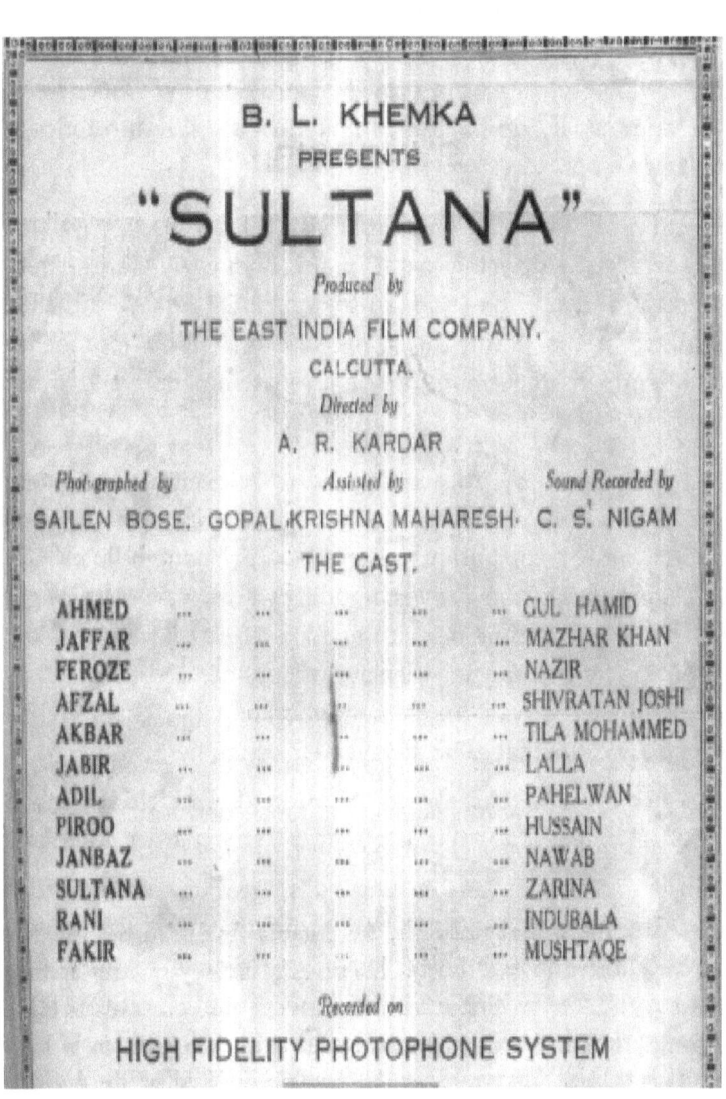

Figure 87 Film Sultana cast from booklet courtesy Rashid Ashraf

SYNOPSIS -

Two gypsy street vendors Jaffar and his henchman Akbar, after their business in the streets of Calcutta return to a tavern for a night's rest. A young and beautiful dancer was entertaining a crowd of drunkards in the tavern. Jaffar and Akbar, during the drunken bout rob the dancer's jewels.

The next morning, Jaffar and Akbar visit the zoo park. They find a three-year girl sleeping in the pram, finding her father busy talking to his friend they kidnap the child. On finding the child missing from the pram, the grief- stricken father approaches police help. The police comb the entire city and no trace of her could be found.

Eleven years pass by, the child grew to a lovely young girl of great beauty. She was named Sultana in the gypsy camp. She was unaware of her parentage and her real name, which was Saida. She thought the gypsies amongst whom she was brought up all these years to be her kith and kin. The gypsies now eked out a living by the dancing displays of Sultana. However, in the gypsy camp there was one person who knew her antecedents. His name was Rahmat, who always befriended her.

One day when Sultana was giving a dance performance in the streets of Premnagar, a charming youth Ahmed throws a ring at her in admiration of her dancing skills. Their eyes met, and it was a love at first sight. Ahmed, from that day was deeply absorbed in the thought of his lady love. He deputes his faithful servant Janbaaz to find out the whereabouts of the pretty dancer. Ahmed learns from Janbaaz that she is known as Sultana.

Sultana was in reverie after seeing Ahmed and was thinking about him sitting in her tent. To her great surprise Ahmed appears before her. Sultana was confused that someone in the

camp might notice and asks Ahmed politely to leave the place. Meanwhile, Jaffar, who was nurturing a secret love for Sultana express his love for her. She rejects his advances and slaps him. Upon finding a ring on Sultana's finger Jaffar gets enraged and reports the matter to the chief. The chief warns Sultana.

Meantime, Ahmed's father Adil comes to know about his son's love affair with a gypsy girl. Adil warns his son to desist from making love with an unknown low rank girl, but Ahmed does not listen to his father. The enraged Adil drives his son out of his house. Feroze, the father of Sultana spends his time in despair. One day one of his friends Afzal informs Feroze that he had seen a girl in the gypsy camp with the exact details and birth marks of the kidnapped daughter Saida. Feroze and Afzal set out to trace the girl. When they reach nearby gypsy camp, they were captured by Jaffar and his men and locked up is a room.

Ahmed makes a surprise visit in the tent again. Sultana was surprised at her sweet heart's visit and asks him to meet at midnight near the ruins. They both spend a happy time together. Jaffar secretly enters Sultana's tent and finding her missing raise an alarm. He gathers couple of men and goes in hunt for Sultana. Jaffar and his men find Ahmed and Sultana together. A scuffle ensues in which Ahmed is seriously injured. Jaffar escorts Sultana back to the camp. There after she was kept under close guard of Rahmat.

Adil's wife comes to know that her son Ahmed is in captivity of the gypsies. She spends sleepless nights due to the absence of her son. She pleads with her husband to forgive their son Ahmed and bring him back home. Adil feels it is time he should act to rescue his son from the gypsies and takes the protection of the police.

The police enter the gypsy camp. A fierce fight ensues, Jaffer takes Sultana and try to flee, but Ahmed chase him. Jaffer get

killed and Sultana rescued. In the fight that ensued many gypsies were killed. Ahmed reaches home with Sultana. Adil was very unhappy but, at this moment Rahmat comes forward and reveal the entire story of kidnapping Sultana. Adil was pleased that she does not belong to a low rank family. Feroze and Afzal reach the scene and they identify Sultana by her birth marks.

Sultana and Ahmed unite and lead a happy life.

REVIEWS –

Three great heroes Gul Hamid, Mazhar Khan and Nazir with dancing and singing stars Zarina and Indubala had made this a memorable movie. AR Kardar's direction was appreciated by the public. Simple dialogues in Urdu and good songs made this a very popular movie of those days.

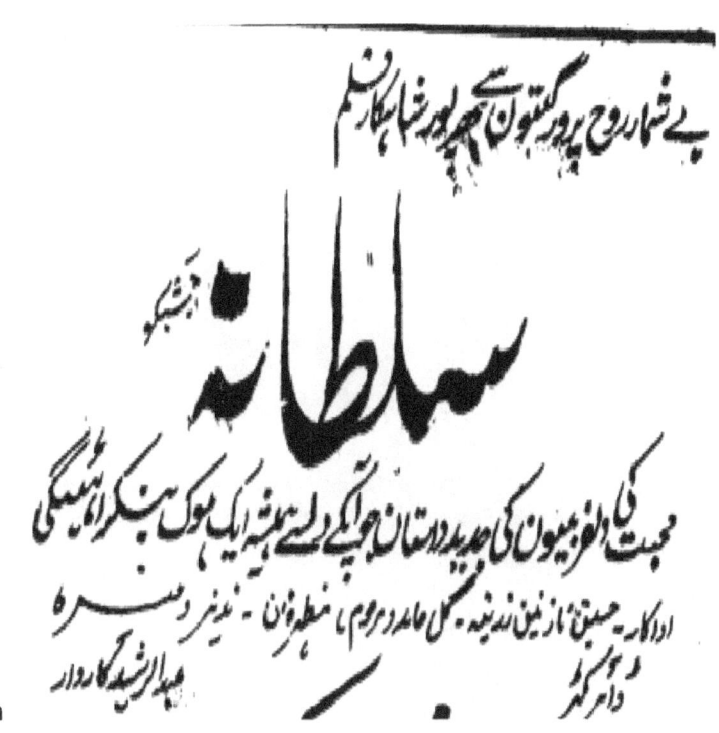

Figure 88 Film Sultana image from Urdu daily Author's collection

YASMIN – 1935 AKA – BAWAFA ASHIQ

YASMIN OR BAWAFA ASHIK

Direction :— H. K. Shivdasani
Assts to Director :— D Manek
Photography :— Gordhanbhai Patel
Audiography :— Y. S. Kotkare
Dialogue & Songs :— Gauri Shankerlal Akhtar
Music :— Chandiram

Production Management:—I. A. Hafesjee

Produced at the
SHREE KRISHNA STUDIOS, Bombay
under the personal supervision of
P. Atorthy.

— THE CAST —

Yasmin	Ratan Bai
Zubieda	Amir Karnatki
Rashid	Siddiqi
Naboo	Gope Kamlani
Shaukat	M. Mirza
Gias Begg	D. Manek
Behram	Hamid
Hamid	Alexander

AN EASTERN ARTS SUPER PRODUCTION

Figure 89 Film Yasmin booklet cover courtesy Rashid Ashraf

SYNOPSIS –

Ghayas Baig was a farmer, who in his youth had made a fortune on farming. As he grew older, he was incurring losses. His health was failing due to heart disease. He had a young and beautiful daughter Zubeida. Zubeida was friendly with a young and handsome man Rasheed, who was a son of her father's friend Zafar Khan. Ghayas baig was worried about her daughter's marriage. He wanted her to get married to a person from a respectable and well to do family.

As he was thinking about his daughter, someone knocked at his door. He opened the door and was happy to find Mirza Shaukat Baig standing before him. He was a good friend of him. He moved over to Egypt and made a good fortune in his business. He was staying as his guest in his house. He thought it will be good if he can get Zubeida married to him. While staying as a guest Shaukat Baig got attracted to Zubeida, but he did not like her close association with Rasheed, He expressed this to Ghayas Baig. Ghayas Baig warned Zubeida to keep away from Rasheed.

The love between Rasheed and Zubeida had reached such a level that they could not stay away from each other. Rasheed planned to run away with Zubeida before she was married to Shaukat baig by force. He along with his friend Nabbu enters Zubeida's bedroom at night. As they were preparing to run away Ghayas baig woke up and tried to prevent them from running away. During the tussle, Ghayas Baig who was ill with heart problem falls on the ground, injuring his head he dies. Taking advantage of the situation Shaukat Baig throws the blame on Rasheed and get him arrested. His friend Nabbu along with some more of his associates get him freed.

Rasheed and Nabbu enter a gypsy camp. On seeing the handsome Rasheed, the queen of the gypsies, Yasmin welcome him with a beautiful dance. The sardar of the camp Behram feels jealous about Yasmin getting close to Rasheed, but

Yasmin, does not care about this. Rasheed goes to Zubeida but Shaukat Baig along with his men lock him up in a strong room. Yasmin comes to know about this from Nabbu. She along with her men get him released.

Shaukat Baig approaches Zubeida and express his love for her and remind her the promise her father made him but she refuses to marry him. Upon which, Shaukat Baig started molesting her. Nabbu reaches on time and Shaukat Baig runs away. Behram was very unhappy about Yasmin getting closer towards Rasheed. Yasmin drives him away and Rasheed is chosen as the sardar of the gypsy camp. This insult was unbearable to Behram, who along with some men take Yasmin and Rasheed captive and set fire around them. Nabbu with his followers reach on time and save them.

Shaukat Baig was forcefully taking Zubeida through the jungle. Hameed was a soldier from the gypsy camp. He was mad after Zubeida and wanted to get hold of her. When he saw Shaukat dragging her, he stops them. A fight ensues between Shaukat Baig and Hameed in which Shaukat Baig gets killed. Zubeida was exhausted and fainted. Hameed brings Zubeida in an unconscious state into the gypsy camp.

Rasheed takes Zubeida in her hands and bring her back to normalcy. This act was unbearable to Hameed, who wanted Zubeida returned to him. A fight takes place and someone from the gypsy camp throws a dagger at Rasheed. On seeing this Yasmin comes in-between to rescue Rasheed.

What happens next - Will Yasmin save Rasheed or get killed. What happens to Hameed? Do Rasheed and Zubeida get married is something for the audience to see on the big screen.

REVIEWS –

This was a highly successful movie. Many artists from New Theaters, Calcutta like Rattan Bai, Premankur Atorthy and Hafeezji moved over to Bombay. Rattan Bai played the role of Yasmin which received lot of praise. Two songs in her voice were recorded. This was one of the first movie of Amir Jan Karnataki and she got recognition as a good singer, but, unfortunately no songs were recorded in her voice.

The movie had other plus points, meaningful dialogues in Urdu, excellent direction, good photography and excellent music by Chandiram.

ZAHR-E-ISHQ – 1933

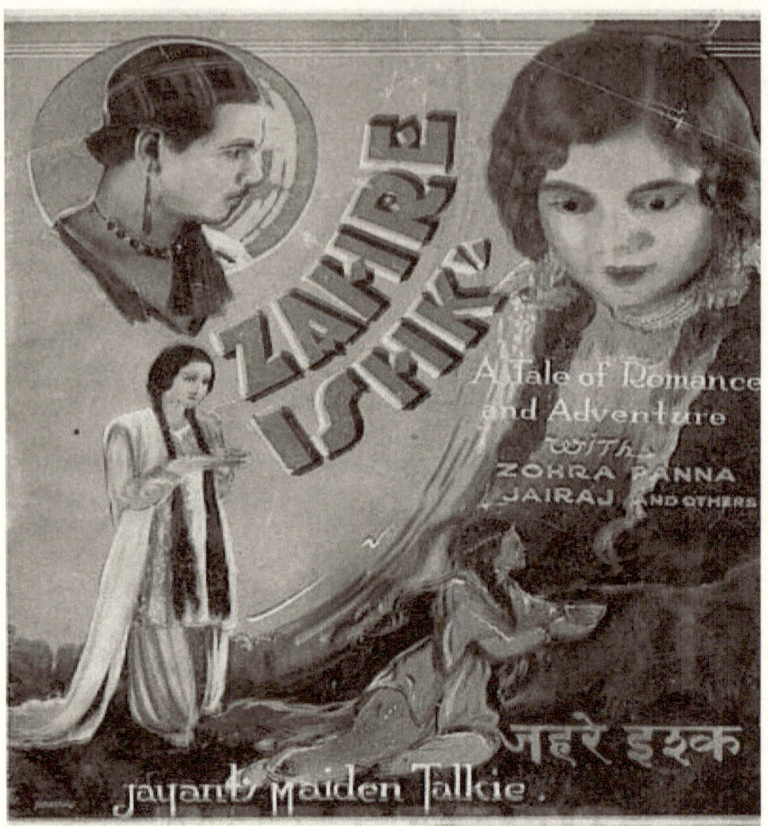

Figure 90 Film Zahr-e-Ishq booklet cover courtesy Rashid Ashraf

SYNOPSIS –

The province of Khorasan was famous for rich businessmen and traders who would cross the Khorasan desert to transport their merchandise. The desert passage was also a place for treacherous bandits. Hasan was one of the most feared bandit chiefs of this area. A merchant was crossing the desert along with his wife and a young boy. The caravan halted for a break in the evening. Hasan attacked them, killed the merchant and carried away the young boy. Khatija, the wife of

the merchant tried to hit Hasan with a stick. He forced her to the ground, in the tussle she held his shirt. Hasan managed to pull and escaped. A torn piece of Hasan's shirt was left in her hand. A grief stricken Khatija walked towards the town and reached the house of her friend Hasina, whose father Khusru was a greedy merchant settled in the town for a long time. Hasina heard the entire story from Khadija and was planning the way to get the young boy back.

While Hasan was a treacherous bandit, his wife Rahima was very pious and God- fearing lady. Rahima, who was known to Hasina came to meet her. She learnt the story from Khatija and recognized the piece of torn shirt. She took the piece of shirt, promising her to trace back her son. On returning home Rahima was praying God to bestow some good sense on her husband. When Hasan returned home, Rahima asked him to return the looted wealth and the boy to Khadija. He got angry at his wife, strangled her and threw her in a well that was dry.

Hasan and his accomplice Nuru trapped the boy in a cave. When they came, they found a stranger taking the boy along with him. They both followed him. The stranger, whose name was Rahim took the boy and handed over to a pious faqir. Both Hasan and Nuru followed them but, when they reached the faqir's hut they were over- powered by the miraculous power of the faqir. Rahim was astonished at the miraculous power of the faqir. He asked him if there is a way to bring back a cruel person like Hasan. The faqir replied – it is only the love of God and Truth that can correct a cruel person. Rahim thought of a way to make Hasan a good man. He got a beautiful portrait of Hasina and placed it in Hasan's cave.

The Vazier sahib along with his wife Salima begum was visiting Khusru's house. Hasina was taking care of them. The Vazier saheb was a hunchbacked and one eyed. Hasina made fun of

him and Salima begum was deeply annoyed, left the place angrily determined to find an ugly person as Hasina's husband.

Hasan fell in love with the portrait of Hasina. He approached Hasina and expressed his love, but she would not care for him. Nuru kidnaps Hasina on the orders of Salima begum. Hasan, on coming to know about it, saves Hasina's life risking his own. The risk was so great that he fell unconscious and was about to lose his life. Rahim came to his rescue and saved him. Hasina was deeply moved with this incidence and fell in love with Hasan. They both decided to marry, but Khusru does not approve. Hasan and Hasina decided to end their lives together by consuming poison but, at that very moment the Shah of Khorosan arrives and asked Khusru to consent to the marriage.

Khusru had his own evil plans. He told the Shah that according to the last wishes of Hasina's dead mother the suitor must bring the golden henna from Mt. Suleiman. Hasan was on his way to Mt. Suleiman. It was a very difficult exploration. Hasan succeeded in getting the golden henna but, he was robbed by Nuru and his men sent by Vazier. The Vazier presents the golden henna to Khusru who agrees to give Hasina in marriage to him. The disappointed Hasina consumes the poison 'Zehr-e-Ishq', Hasan arrives a moment later, he explains Khusru how the golden henna was stolen from him. It was too late, on finding Hasina dead Hasan too consumes the poison and dies.

REVIEWS –

The movie was very popular. The highlight of the movie was great acting and singing by Miss Zohra as Rahima and Miss Panna as Hasina. The photography and direction were very good. The melodious music by Prof BR Deodhar was another factor in the success of the movie.

BIBLIOGRAPHY

Film booklets mostly in Urdu from Lahore and Hyderabad Deccan

Urdu magazine Shama Delhi

Filmindia Bombay

Film – Urdu fortnightly magazine published from Hyderabad - Deccan

Urdu newspapers from Hyderabad Deccan and Lahore.

TABLE OF FIGURES

Figure 1Film Afzal aka Hoor-e-Haram booklet cover Courtesy Rashid Ashraf 31

Figure 2Film Alibaba booklet cover courtesy Rashid Ashraf 34

Figure 3Film Alibaba from Urdu newspaper Author's collection 35

Figure 4Film Alibaba from Urdu nespaper Author's collection 38

Figure 1Film Afzal aka Hoor-e-Haram booklet cover Courtesy Rashid Ashraf ... 34
Figure 2Film Alibaba booklet cover courtesy Rashid Ashraf 37
Figure 3Film Alibaba from Urdu newspaper Author's collection .. 38
Figure 4Film Alibaba from Urdu nespaper Author's collection .. 41
Figure 5Film Alibaba from Urdu newspaper Author's collection .. 42
Figure 6 Film Anarkali from Urdu newspaper Lahore courtesy Rashid Ashraf ... 45

Figure 7 A scene from film Anarkali courtesy Rashid Ashraf47
Figure 8 Film Arab ka Sitara booklet cover courtesy Rashid Ashraf...49
Figure 9 Film Arab ka Sitara Amirbai Karnataki the famous singer as heroine from an Urdu newspaper. Author's collection.........51
Figure 10 Film Bade Nawab Saheb booklet cover courtesy Rashid Ashraf ...52
Figure 11 Film Bade Nawab Saheb describing a movie based on Islamic culture and etiquette from Urdu newspaper Author's collection ..53
Figure 12 Urdu newspaper announcement dated August 11 1944 Author's collection ..56
Figure 13 Film Bhaijan cast from booklet courtesy Rashid Ashraf ..58
Figure 14 Film Bhaijan synopsis from Urdu magazine Author's collection ...59
Figure 15 Film Bhaijan a movie filled with Muslim culture, society, manners and etiquette. Author's collection.................62
Figure 16 Indurani in film Bulbul-e-Baghada from Urdu film magazine. Author's collection..63
Figure 17 Happy days - Bulbul and Rasheed in film Bulbul-e-Baghdad. Author's collection..64
Figure 18 Yaqub as daku Rasheed in Bulbul-e-Bghadad from Urdu magazine. Author's collection...65
Figure 19 Film Bulbul-e-Bghadad Bulbul trying to escape from Urdu magazine, Author's collection..66
Figure 20 Film Bulbul-e-Baghdad Rasheed arresting Daku Rasheed from Urdu magazine. Author's collection67
Figure 21 Film Bulbul-e-Baghdad Bulbul and Rasheed get united from Urdu magazine. Author's collection68
Figure 22 Film Dil booklet synopsis in English & Urdu courtesy Rashid Ashraf ..70
Figure 23 Film Dil synopsis from Urdu newspaper. Author's collection ...71

Figure 24 Film Dil a movie filled with Islamic values. Author's collection ..72
Figure 25 Film Dil announcement 24th May 1947 the movie is being shown in color..73
Figure 26 Film Fashion from Urdu newspaper. Author's collection ..74
Figure 27 Film Fashion description of the movie from Urdu magazine. Author's coolection ...75
Figure 28 Farida in film Fashion from urdu magazine Author's collection ..77
Figure 29 Razia in film Fashion from Urdu magazine. Author's collection ..78
Figure 30 Film Fashion, Farida the villainous character played by Sabita Devi from Urdu magazine. Author's collection80
Figure 31 Film Hoor-e-Baghdad booklet cover courtesy Rashid Ashraf...84
Figure 32 Film Ismat synopsis from Urdu magazine. Author's collection ..88
Figure 33 Film Ismat cast in Urdu Author's collection89
Figure 34 Film Ismat Mehtab on left Nargis on right. Author's collection ..90
Figure 35 Film Ismat the power of prayer from Urdu magazine. Author's collection..91
Figure 36 Judgement of Allah aka Al-Hilal booklet cover courtesy Rashid Ashraf ..94
Figure 37 Judgement of Allah aka Al-Hilal cast courtesy Rashid Ashraf..95
Figure 38 Yaqub in Judgement of Allah aka Al-Hilal courtesy Rashid Ashraf ..98
Figure 39 Kumar in film Judgement of Allah aka Al-Hilal courtesy Rashid Ashraf ..99
Figure 40 Images from Film Judgement of Allah aka Al-Hilal courtesy Rashid Ashraf ..100

Figure 41 Film Masoom the story of Abidah from Urdu magazine. Author's collection .. 103
Figure 42 Film Masoom dramatization of Rehana's part played by Miss Ramola from Urdu magazine. Author's collection 105
Figure 43 Naseem Banu in film Mulaqat from Urdu magazine. Author's collection .. 107
Figure 44 Film Mulaqat House Full, from Urdu magazine. Author's collection .. 110
Figure 45 Film Mumtaz Begum booklet cover courtesy Rashid Ashraf .. 111
Figure 46 Film Muslim ka Lal from Urdu magazine. Author's collection .. 114
Figure 47 Film Muslim ka Lal 1941. Author's collection 115
Figure 48 Film Muslim ka Lal from Urdu magazine. Author's collection .. 116
Figure 49 Film Muslim ka Lal from Urdu magazine. Author's collection .. 117
Figure 50 Paak Daaman Urdu script courtesy Rashid Asraf 120
Figure 51 Film Pehli Nazar synopsis from Urdu magazine. Author's collection .. 126
Figure 52 Nasir Mirza in film Pehli Nazar from Urdu magazine Author's collection .. 128
Figure 53 Begum Mirza in fllm Pehli nazar from Urdu magazine. Author's collection .. 129
Figure 54 Veena in film Pehli Nazar fron Urdu magazine. Author's collection .. 130
Figure 55 Film Pehli Nazar describing the song dil jalta hai to jalne de. Author's collection from Urdu magazine 131
Figure 56 Film Phool a story of enduring love, bravery and loyalty from Urdu magazine. Author's collection 133
Figure 57 Prithviraj Kapoor as Salim in film Phool from Urdu magazine. Author's collection ... 137
Figure 58 Film Phool Yaqub as Afsar from Urdu magazine. Author's collection .. 138

Figure 59 Film Phool Suraiya as Rekha from Urdu magazine. Author's collection .. 139
Figure 60 Film Qaidi Urdu script from Lahore courtesy Rashid Ashraf .. 140
Figure 61 Film Qaidi from Urdu newspaper. Author's collection .. 143
Figure 62 Ramola as Salma in film Qaidi from Urdu newspaper. Author's collection .. 147
Figure 63 Film Rashida booklet cover courtesy Rashid Ashraf 149
Figure 64 Film Rashida's cast details from booklet courtesy Rashid Ashraf .. 150
Figure 65 Mahjabeen & Kajjan in Rashida courtesy Rashid Ashraf .. 154
Figure 66 Film Rehana details from booklet courtesy Rashid Ashraf .. 156
Figure 67 Film Rehana booklet cover courtesy Rashid Ashraf .157
Figure 68 Film Rehana image from Urdu magazine. Author's collection .. 159
Figure 69 Film Salma booklet cover courtesy Rashid Ashraf ...161
Figure 70 Film Salma synopsis from Urdu magazine. Author's collection .. 162
Figure 71 Film Salma details from Urdu magazine. Author's collection .. 166
Figure 72 Film Salma friends on balcony. Author's collection .167
Figure 73 Film Salma, Salma becomes a dervesh. Author's collection .. 168
Figure 74 Film Shahanshah Babar booklet cover. courtesy Rashid Ashraf .. 169
Figure 75 Film Shahanshah Babar details from booklet courtesy Rashid Ashraf .. 170
Figure 76 About Sheikh Mukhtar. Author's collection 174
Figure 77 Wajahat Mirza Changezi details. Author's collection 175
Figure 78 Film Shahanshah Babar Khursheed's song. Author's collection .. 176

Figure 79 Film Shahanshah Babar Author's collection..............177
Figure 80 Film Shalimar synopsis from Urdu newspaper. Author's collection..179
Figure 81 Film Shalimar Emperor Jehangir as a faqir from Urdu magazine. Author's collection...182
Figure 82 Film Shalimar Empress Nurjehan delivering verdict. Author's collection..183
Figure 83 Film Shamsheer-e-Arab booklet cover courtesy Rashid Ashraf..185
Figure 84 Film Shamsheer-e-Arab Urdu booklet, courtesy Rashid Ashraf..187
Figure 85 Shamsheer-e-Arab from Urdu newspaper. Author's collection ...188
Figure 86 Film Sultana booklet cover courtesy Rashid Ashraf.191
Figure 87 Film Sultana cast from booklet courtesy Rashid Ashraf ...192
Figure 88 Film Sultana image from Urdu daily Author's collection ...196
Figure 89 Film Yasmin booklet cover courtesy Rashid Ashraf .197
Figure 90 Film Zahr-e-Ishq booklet cover courtesy Rashid Ashraf ...201

www.ingramcontent.com/pod-product-compliance
Lightning Source LLC
Chambersburg PA
CBHW030622220526
45463CB00004B/1387